World War II
in American Art

ALSO BY ROBERT HENKES

Latin American Women Artists of the United States:
The Works of 33 Twentieth-Century Women
(McFarland, 1999)

Portraits of Famous American Women:
An Analysis of Various Artists' Renderings of 13 Admired Figures
(McFarland, 1997)

Native American Painters of the Twentieth Century:
The Works of 61 Artists
(McFarland, 1995)

The Art of Black American Women:
Works of Twenty-Four Artists of the Twentieth Century
(McFarland, 1993)

Themes in American Painting:
A Reference Work to Common Styles and Genres
(McFarland, 1992)

American Women Painters of the 1930s and 1940s:
The Lives and Work of Ten Artists
(McFarland, 1991)

World War II in American Art

by ROBERT HENKES

Foreword by Edward Reep

McFarland & Company, Inc., Publishers

Jefferson, North Carolina, and London

Library of Congress Cataloguing-in-Publication Data

Henkes, Robert.
World War II in American art /
by Robert Henkes ; foreword by Edward Reep.
p. cm.
Includes bibliographical references and index.
ISBN 0-7864-0985-1 (softcover : 50# and 70# alkaline papers) ∞
1. Painting, American — 20th century.
2. World War, 1939–1945 — Art and the war.
3. Art and war. I. Title: World War 2 in American art.
II. Title: World War Two in American art. III. Title.

ND212 .H466 2001 758'.994053'0973 — dc21 2001034246

British Library cataloguing data are available

Manufactured in the United States of America

Cover image: Tom Lea. *That Two Thousand Yard Stare* (1943).
Oil on canvas. Army Art Collection, U.S. Army Center of Military History.

McFarland & Company, Inc., Publishers
Box 611, Jefferson, North Carolina 28640
www.mcfarlandpub.com

To all those who fought and died
for democratic principles during World War II

and to all those left behind who endured
the loneliness and emptiness that followed

Acknowledgments

First and foremost I thank the United States armed forces—the Army Center of Military History, the Navy Combat Art Collection, the Merchant Marine Academy, and the Air Force Art Collection.

Second, my thanks go to Mr. Edward Reep for his major photographic contributions, and to all the museums and art galleries including the Whitney Museum of American Art, the Metro-politan Museum of Art, the Cummer Museum of Art and Gardens, the Art Institute of Chicago, the Newark Museum, the Madison Art Center, the Sheldon Memorial Art Gallery, the Museum of Modern Art, the DC Moore Gallery, D. Wigmore Fine Art, and the Brooklyn Museum of Art.

Thanks go also to Greg Waskowsky and Todd Zimmerson, who have always been sources of encouragement.

Contents

Foreword

Robert Henkes, an accomplished author as well as an artist, herein presents a thorough examination of war and its widespread ramifications as expressed by artists. Through his talent as a writer and his knowledge as an artist and critic, he is able to present his readers with observations that are accurate, sensitive, and rewarding. Further, one need only scan his comprehensive table of contents to recognize that this book wrestles with the deepest of moral issues. I am grateful to Robert Henkes for allowing me to expand upon his topic.

I wish to amplify the role and contribution of the war artist, or any artist who may wish to present some universal comment about war. To depend only upon religion, symbolism, or any number of philosophical or psychological premises may not reveal the complete story. Leaning upon allegories is often misleading. Superficial heroics, misunderstood intuition, or the shadows in one's own heart may cloud the way.

As a war artist-correspondent during World War II, I had as my mission to document or paint the war as I saw, felt, and reacted to it. I was fortunate to win a Guggenheim Fellowship for my efforts — painting both on the field of battle and in rear areas where sober reflection was possible. After returning home, I went further and produced more elaborate and complex statements. Alas, I soon tired of the effort. Five years of war

had been more than enough for me. I contacted the Guggenheim people, and they advised me to paint whatever I wished.

War is not a pretty thing. Those who have never experienced combat on the field of battle imagine conflict in so subjective a manner that it holds little meaning for me. There is no way for anyone to understand what it is like to aid a wounded comrade or to be with gallant men willing to sacrifice their lives for a fellow soldier they hardly know. There is no way to adequately describe the sight of a wounded little man bravely continuing the struggle while beside him a superb physical specimen trembles in his boots. There is blood, there are tears, there is fear, and there are love and compassion. None of this is easily invented.

Why is this so? The answer is relatively simple: without experiencing warfare personally, one may never understand what is involved. When artists imagine war without having seen it, their work becomes murky or mythological with a blend of fantasy and fable — perhaps at best a hope or prayer, at worst, hokum.

I have dwelt on the significance of the artist's work in combat. It is rarely heroic. It arrives in small pieces, not unlike the tesserae that ultimately forms the full mosaic.

It is not my intention to detract from artists who have created magnificent images of war and its ravages. My sole purpose is merely to explain

an aspect of war art that may have been only lightly touched upon in this narrative.

It is true that artists working on the battlefield do so under great strain with rigid limitations that force them to concentrate on the moment. There is no time for pretense, less time for embellishment, and room only for the raw truth unfolding before their eyes. The result is a commentary that endures—the stuff that remains long after the commemorative images glorifying one cause or another vanish.

I would rather own an artist's sketch of his ragged and miserable comrades at Valley Forge than the exalted painting of George Washington, improbably standing at the front of his rowboat while crossing the Delaware.

Edward Reep

Introduction

Just as the Great Depression of the 1930s served as a motivating force for the American artist, an equally dramatic stimulus was offered by World War II. Although the Depression subsided, satisfaction and contentment were short-lived, for in their place came the horrors of war.

The shock of being forced into a world war inspired Americans to work together. Just as the Depression of the thirties had reaffirmed democracy, World War II created an atmosphere of urgency, a full-scale unity of America's peoples. Factories burst with energy, furnishing the war effort with guns, planes, ships, tanks, and ammunition; women manned machines; screenplayers entertained the troops worldwide; children assisted in gathering materials for recycling; and artists painted the devastating scenes of universal conflict. The bombing of Pearl Harbor had threatened the very roots of democracy, creating a feverish pitch of determination to conquer the enemies. America had become a unified front against the threat of Fascism and Nazism.

The artists who gained popularity and fame in the Depression were asked to paint the great war. Others were commissioned by corporations to paint war events at the scene. Although the commissioned art varied in quality, the Chrysler Corporation, the Upjohn Company, the Abbott Laboratories, the S.C. Johnson Company, and others—including *Life*, *Time*, and *Fortune* magazines—merit the applause of the American people for supporting the creation of an historic and artistic record.

Great art demands reflection on the part of the artist in order for a profound message to be communicated. Focusing on the immediate scene or the current event and simultaneously recording it in artistic terms frequently leaves the painted event lacking in the drama or solitude that it merits. As a war art correspondent, the American painter was often unreflective and insensitive to the task at hand. In fact, several depictions of the war effort seem surface-painted, as though the artists forgot or ignored the intensity of the events and the pain they would leave behind. Several artists simply persisted in the styles of the day, using the techniques that resulted in superficial expressions. For example, the watercolorist Ogden Pleissner depicted the Normandy invasion as if it were a Minnesota landscape. On the other hand, some artists made surprising departures from their usual styles, just when their special techniques might have served them well: Aaron Bohrod's meticulous rendering of details witnessed in his clown and Chicago scenes were omitted from his depictions of war-torn Europe. Still other artists seem bent on the financial rewards rather than a service to democracy. Overall, however, the artistic venture of recording the war and its effects on humanity became a democratic yet individualistic achievement never to be forgotten.

Benton Spruance's painting *Souvenir of Lidice*

1

(1943) dramatically portrays the suffering and intense agony of prisoners of war. It directly relates to the crucifixion of Christ and the two thieves. Many other artists turned to religious themes during and following the war; for example, Thomas Hart Benton's 1945 version of the crucifixion depicts Christ being machine-gunned by the governments of the Axis powers. Such themes persisted for decades; in the sixties, Nicholas Sperakis compared the crucifixion with Goya's *The Disasters of War* series. Clearly the suffering created by World War II led many to seek spiritual answers and guidance.

A heartrending portrayal, *Farewell* (1942) by Raphael Soyer, pictures the uncertainty of the return of a loved one whose venture into war would haunt those left behind.

The survival unit, although physically torturous and grotesque, is introduced by William Sharp in an agonizing portrayal of fear. In *The New Order* (1937), the five condemned men about to be executed reveal facial expressions of hate, anger, resignation, anguish, astonishment, and fear. The artist's personal experience as execution bait may well have been the stimulus for *The New Order*.

Other approaches to the survival theme are seen in Sol Wilson's compassionate work *The Twelfth Day* (1942) and in Karl Schrag's dramatic etching *Persecution* (1940). The survival theme was a popular subject for the artist because it provoked emotional responses. In the suspenseful *Nearing the End* (1943) by Charles Quest, a family exits their native country in tears on a hopeless journey into the unknown. Other approaches depict the war widows, the fatherless, and the orphans who roam the earth in despair.

World War II prompted the artist to record the homefront activities as well. Entertaining the troops in USO tours, dances, and concerts, working in defense plants, gathering food and clothing for the wounded, or rationing food and gasoline for the sake of the armed forces were some of the events recorded.

The action of battle, hand-to-hand combat, and the ensuing devastation of human flesh and material structures were brilliantly handled by the war artist. Mitchell Siporin's prisoners of war, Joseph Hirsch's survivors, Philip Evergood's symbolic futilism, and William Pachner's agonizing victims of concentration camps made war appear as the dehumanizing devastation that it was. Much of the terror was painted after the defeat of Hitler and Mussolini and the surrender of Japan.

The Depression served as a springboard for artists whose works survived and whose calling served the war years equally well. There are several overlaps of the decades of the thirties and forties. Such artists as Paul Cadmus, Philip Evergood, Ben Shahn, Raphael Soyer, George Grosz, and Edward Hopper gained popularity during the thirties but sustained it throughout the forties. Others—like Umberto Romano, Abraham Rattner, Joseph Hirsch, and Fletcher Martin—gained fame during the forties and stretched it into the fifties and sixties.

From the shocking attack on Pearl Harbor through the bitter years of war, American artists were motivated to record, in their own expressive terms, the tragic possibilities of the defeat of democracy. Yet they also recorded hope—for victory, for democracy, for the triumph of the human spirit. Their expressions are with us today, still shaping the consciousness of our artists and our nation.

CHAPTER 1

Acts of War

Depictions of the action of war provoke an emotional response from viewers. Audiences may readily acknowledge the action and react in varying degrees of anticipation and anxiety. The artist Edward Millman altered his artistic course of action from classicism to realism to abstract expressionism. Regarding his dramatic realistic painting *Kamikaze Attack* (1947), Millman said:

> On December 7, 1944, an amphibious assault force landing the Seventy-seventh Division, with air and naval support, went ashore three miles south of Ormoc, on the west coast of Leyte, in the Philippines. Immediately after our landing, an enemy reinforcement convoy was discovered approaching from the North with strong air cover. A desperate melee resulted, in which the enemy convoy was sunk without unloading; but, from the time our convoy left the beach until darkness, suicide planes dived at our ships constantly. The sky was filled with dirty black splotches of flak, and when enemy planes were hit they left long streaming ribbons of smoke and fire in their wake as they fell into the sea. A few of the flaming planes, as they plummeted downward, fell on the decks or alongside some of our ships, immediately sending up ragged puffs of black smoke and explosive fire topped with bits of wreckage.[1]

Kamikaze Attack focuses on the four gunners whose courageous attempts to sink Japanese fighter pilots are marked in dramatic facial expressions and tense bodily gestures.

Although objectively conceived, *Inferno on Iwo Jima* (1947) is subjectively portrayed by the war artist Mitchell Jamieson. Several action-packed episodes occupy the scene, each of an intense dramatic display of valor and arranged into a union of aggressive acts. Jamieson used the mountain ranges as a setting for the ferocious battles between Japanese and American troops. The monumental environment creates an insignificant imagery of American troops. Jamieson explained his convictions of war and his artistic and moral message:

> The Iwo Jima scene was painted from sketches made on the spot. I arrived in the area too late for the actual fighting at Iwo, but in time to witness the effect and the aftermath. It was from sketches made at this time that the present painting has been made as an imaginative reconstruction, based on factual drawings of terrain on Iwo and the experience of witnessing many combat operations elsewhere. It is

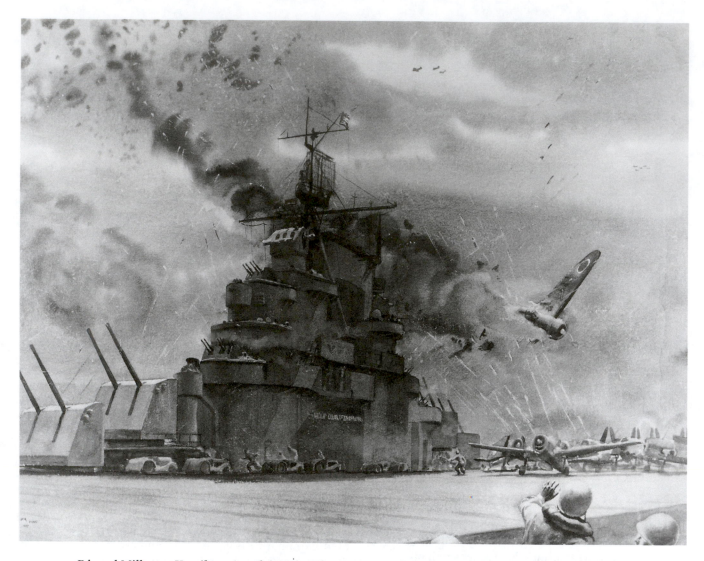

Edward Millman. *Kamikaze Attack* (1947). Oil on canvas. U.S. Navy Art Collection, Naval Historical Center.

typical of the terrain I saw on the northern end of the island, fantastic and weird in the geologic structure and shape of the volcanic rock, to which the Japanese had added their own inimitable system of burrowings, interconnected caves and pillboxes. Every square foot of earth seemed to be torn or pockmarked by shell fire and shrapnel.

The painting shows Japanese tunnels and caves laid bare, here and there, by demolition charges. The mouths of others have been covered up and their occupants buried alive or scorched out of their holes by flame throwers. I have tried to convey a sense of violent conflict going on in a landscape that was already barren and unearthly in its desolation even before war had scorched or twisted it.[2]

The artist Richard Munsell presented a victorious mission of American fighter squadrons over Tokyo. Remove the flying fortresses, and a beautiful abstract explosion of color is witnessed in the flagrant bombing of the Japanese capital. Tranquillity amid the explosive event seems more natural than surreal. The beauty of Fujiyama lies far in the distance. Its cool coloring of blues and purples contrast appropriately with the slashing reds and yellows of the bombings.

The artist partially described his painting as follows: "At the lower right, acrid yellow smoke billows from burning chemicals. Through the smoke is seen the Emperor's Palace, which was destroyed by incendiary fires. At the lower left is

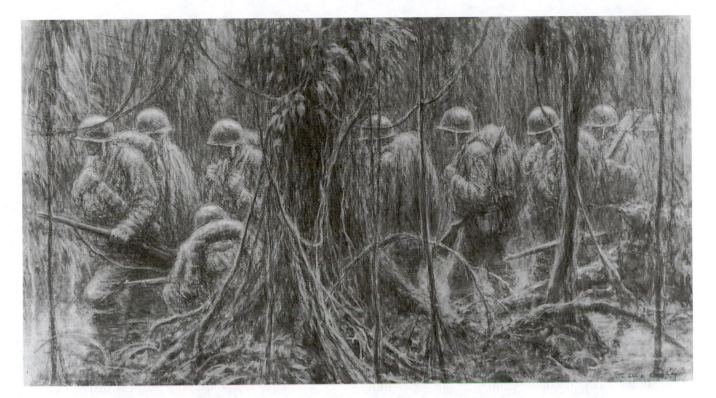

Kerr Eby. *Ghost Trail* (1943). Oil on canvas. U.S. Navy Art Collection, Naval Historical Center.

a flash bomb, dropped for photographic interpretation of bomb assessment. The remote beauty of Fujiyama is imperturbable as all Hell breaks loose below."[3]

The artist Kerr Eby painted *Ghost Trail* (1943) essentially in variations of greens to imitate the colors of the jungle. American soldiers seeking directional advantages during World War II in Guadalcanal look more like prisoners than soldiers. The impressionistic application of color partially hides the trudging soldiers as they furtively move through the dense jungle. There is a visual sensation of three distinct planes: the center, in which the American GI movement occurs; the foreground, which partially protects the American team; and the background, the natural habitat.

The directional movements witnessed in *Ghost Trail* are slackened by the twisting, gnarled tree branches and roots that seem as evident above the ground as below. There is a cautious and stilled atmosphere surrounding the soldiers, whose preoccupation with the clearing of the terrain is as important as the watch for enemy fire. *Ghost Trail*, although horizontal in its compositional structure, is united with appropriately positioned vertical tree branches. The circular-shaped helmets, which form a horizontal segment of activity, are balanced by the rounded shapes of jungle foliage. *Ghost Trail* is a painting of anticipation and anxiety and a preoccupation with the unknown.[4]

In *Operation Soapsuds* (1943; see color section), the artist T. C. Galloway has combined in a single work two seemingly contrary approaches by using an atmosphere phenomenon. A smoke-filled cloud enclosing a photorealist image of a fighter plane contrasts with the semi-abstract vision of a bombed city. The painting is realism in full but introduces a logical sequence of events.

At first glance, one sees an abstract expressionist work not unlike a Rauschenberg collage painting. Nonetheless, the artist was forced to include within each section a portion of the opposing segment of the composition. There is a deliberate division of space conceived long after the on-the-spot witness. *Operation Soapsuds* is a dramatic painting because of the starkness of the brilliant fiery clouds blooming into a black smoky sky.[5]

Other paintings related to *Operation Soapsuds* are *Charge of the Light Brigade* (1944) and *Dawn on the Deck Over Ploesti* (1944). The artist has challenged the viewer to engage in the preparation of an act while simultaneously anticipating a future act. The two acts present a single invasion recording the demolition of a city without the

effects of the bombing. One can only assume, under cover of the huge black cloud, that the bombing was effective. A portion of the city is yet to come under attack. There is a movement in *Operation Soapsuds* because of the predictability of the action. In other war paintings of action, the climax had already occurred and thus relinquished any thought of anticipated action.

The conflict of war has never been more grotesquely expressed than in William Gropper's lithograph of 1944 titled simply *War*.[6] It depicts a savage bayonet attack on a wounded, helpless soldier by an obsessed warrior, showing the aggressive nature of the artist as well as the aggressor. A perfect union of diagonal planes emerges with the outstretched arms of both victim and victor and the tool of death that counteracts the dual slant of the composition. The bayonet piercing the body of the wounded soldier becomes the solidifying factor. Without it, the image would be senseless and meaningless. The brutality inflicted by the aggressor is witnessed in the clinched fists of the killer and the obvious agony of the victim, whose upward movement illustrates a final gasp and cry of pain.

Gropper's artistry is a simple design of two combatants of action and movement. The merciless thrust of the bayonet represents a disease, the killer instinct. The lithograph is raw in its visual appearance. It is the recording of an event that expands beyond reality. Yet war *is* reality — murderous, vicious, uncompromising. It is deadly, ferocious, animalistic and totally inhuman. So to say that war is beyond reality is to say it is unreal, surreal, insane. Gropper's portrayal is that.

The same blast of energy witnessed in *War* is further evidenced in Gropper's painting of the event that shocked the world — the surprise attack on Pearl Harbor. Gropper's version, simply titled *Pearl Harbor* (1942), depicts an American warship split in two by Japanese bombers.[7] The brushwork matches the theme. Harsh, rough, fiery waters surround the half-sunken ship as black smoke and red flames fill the air. Remove the ship's hulk, and the viewer is treated to an abstract expressionist environment. Water and sky join forces to form an electrifying explosion. *Pearl Harbor* is a rare portrayal by Gropper in which the human condition is omitted. However, because of the surprise attack, human lives were lost, with soldiers killed instantly by the explosive blasts.

Even when objectively portraying a dramatic scene, Gropper lets individual personalities emerge. In his painting *Air Raid* (1942), the diminutive sizes of the people fleeing from the explosive scene emotionally depict fear. In spite of the smallness of his creatures, fear is read in the faces and bodily movements. It is as if the artist painted life-size human figures in a state of frenzy and fear and then diminished them into miniature models without losing a shred of the emotions.

The raging fires had created an exodus of human and animal creatures. Gropper does not hint at those unable to flee from the disaster. Although those running from the scene tend to lead the viewer out of the picture plane, the raging fires in the background counteract to create a hidden inquiry as to the whereabouts of others.

Gropper's animosity toward war is represented by his own attack upon canvas. There is seldom relief or a victorious solution. There is only entrapment, fear, and desperation. His works are actions of the moment. There is no prior or aftermath. In Gropper's paintings and lithographs, there is seldom hope.

Battle of Hill 609, a 1943 painting by Fletcher Martin, is a fierce picturization of war close up.[8] The horizontal bombardment of bullets fired in fierce combat reminds one of a Civil War movie. The war itself is the subject matter. The viewer focuses on no single figure but scans the surface and subsequently notes individual soldier images. Numerous trees serve as compositional intersections and as convenient covers from enemy fire.

Compositionally, the viewer is treated to tennis matches of sorts in which bullets fly to and fro. *Battle of Hill 609* is an action-packed view of American and enemy troops engaging in intense battle. Ironically, the objectivity of individual placement of figurative forms becomes subjective as each fighting force blends into a total picture.

Battle of Midway, June 1942, a painting by Griffith Bailey Coale [1942], depicts a memorable scene of World War II.[9] The combat of planes versus ships fills the atmosphere with clouds of flak and burning debris of shot-down planes while the rough waters of the Pacific swallow up a Japanese warship and endanger the remains of an enemy carrier. The artist has pictured favorable response by the American naval forces. The action recorded is panoramic in size and represents on a small scale an extravagant picture of a single event in American history.

Battle of Midway, June 1942 is a horizontal painting. Clouds of black smoke and waves of water perform circular movements to guarantee a

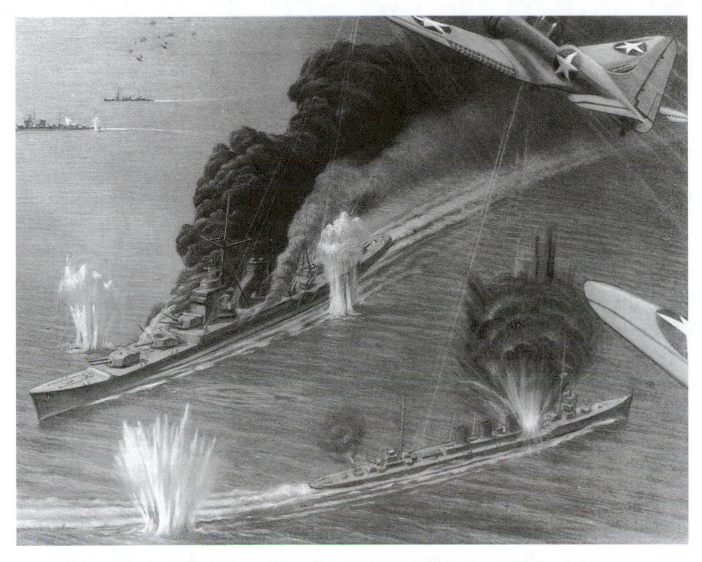

Griffith Bailey Coale. ***Battle of Midway, June 1942*** **(1942). U.S. Navy Art Collection, Naval Historical Center.**

suitable balance between the causes and effects of the naval battle. The effects created by the subject matter are extremely essential to the total unity of the painting. Human emotions are not a part of the painting except for the viewer engaged in witnessing the work.

Robert Benney's thrilling display of a sea and air battle, *The Kill* (1947), flourishes with clouds of black smoke and screens of red fires. The foreground bears the dreaded results of enemy bombings, which compositionally compete with various war tactics crowding the environmental background. The painting depicts a dive-bomber swooping up from a bomb drop on a Japanese carrier. In the background, two Japanese escorting ships have taken hits.

Unlike Benney's war in action, William Draper's *Carrier Defenders* (1944) illustrates a readiness team. Machine-gunners, anxiously awaiting enemy fire or bomb droppings, look skyward as turrets are aimed upward. Composed of nuances of blue with white and black colors highlighting and darkening objects, two differing techniques are applied. However, the composition is unified by color rather than style. Gun crews line the carrier's edge. In spite of the stillness of the situation, there is an anticipation of action. By creating threatening waters and stormy skies, Draper has enlivened the otherwise quiet scene.

Thomas Hart Benton, noted member of the Regionalist Movement during the Depression, reveals in his painting *Score Another One for the Subs* (1945) an activated canvas that reveals human action as well as an active environment.[10] Voluptuous skies hover over an enemy destroyer

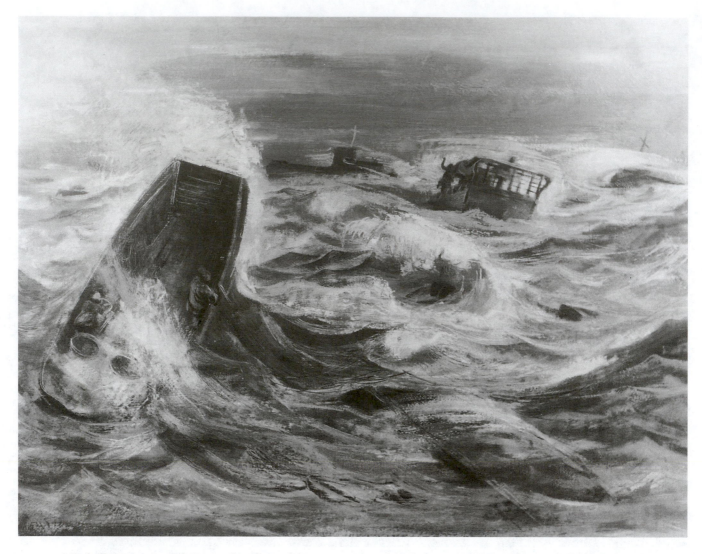

Mitchell Jamieson. *Gale Down the Channel, June 19–22* (1945). Oil on canvas. U.S. Navy Art Collection, Naval Historical Center.

as it explodes in flames. Pillows of black smoke erupt. Onrushing waters created by the elongated submarine add to the dynamic excitement of the scene. Benton established a visual distance of action between the American fire power and its target of attack. The viewer is forced to retrace the visual distance between the two extremities of action.

The typically Benton elongation of human forms is dramatically exposed as torpedoes are loaded and launched against enemy forces. The color blue, which dominates the theme, contrasts to the fiery reds that explode in appropriate areas. The strong diagonal movement of the submarine is amplified and further accentuated by American firings. There are no opposing compositional diagonals that account for the viewer's temptation to exit from the picture frame.

Skywatch (1944), a painting by John LaValle, is considered a semi-abstract silhouette. The absolute and domineering factor is the central ray of light. The strong diagonals piercing the night skies intersect in the upper segment of the painting, forcing the viewer's attention to the source of light. The activity associated with the sky creates an anticipation of discovery, a game of hide-and-seek between the two fighting forces.

The writer Ken McCormick explained: "Around the harbors where the Allies brought in an enormous range of supplies continually, night bombing was a simpler assignment for the Germans, and eluding night fighters looked more possible. So this was where the heavy antiaircraft and searchlight batteries were placed. If a plane was caught in the crossbeams of a couple of lights, more beams would zero in instantly, and then the

lights were impossible to shake. Fighters or anti-aircraft guns would probably make the kill."[11]

The artist Mitchell Jamieson's painting *Gale Down the Channel, June 19–22* (1945) is a dynamic exposure of fear of death. The painting displays a potential hero in his attempts to save a fellow comrade from a torrential storm that erupted without warning. Remove the subject matter of boats and rely totally on the environmental background, and one is faced with an abstract expressionist painting. The turbulent waters surrounding the endangered boats and topped with threatening skies make Jamieson's recording an exciting exploitation of war activities that are not directly connected with enemy forces.

Sweltering waves threaten the very lives of the boats' occupants, Jamieson has used the varying degrees and angles of the waves to unify a rather difficult subject matter. A psychological problem is set up as the boats are seemingly lost amid the rushing waters, but in order to ensure the boats' safety, visibility of these same boats must be ever present. The artist has managed to keep the boatmen afloat for reasons pertaining to the psychological as well as the visual. The viewer is treated to a circular composition, which meets possible deterrents in the swirling waves that reside in the space between the circular movement of the boats. The dark blues and greens also add to the drama at sea.

The newspaper has been a decisive tool for the exposure of war events. Playing a subordinate and seemingly inconsequential role in Paul Cadmus's notorious painting *Playground* (1948), newspaper headlines reading "Denounces Peace Aim/Demands Conscription/War is Goal/ 20,000,000 ... Planes" are cleverly downplayed amid an indecent and immoral environment.

The newspaper has played curious roles in the works of Reginald Marsh, Philip Evergood, and Aaron Bohrod as well as Cadmus. In Marsh's painting *Tessie's Bridal Shop* (1946), the artist introduced one of his transient figures who, in order to thrust onto the picture plane a sense of the unfortunate, displays in insignificant manner the newspaper headline "11 Nazi Leaders Hang in 15 Days/3 Get Life/4 Jailed/5 Freed."[12]

The contrast in lifestyles is like a caste system — the beggar versus the Fifth Avenue cutie. Marsh acknowledged the war via the media. Frequently, such news is partially hidden in his painting; other times, it is pronounced and forced upon the viewer. Marsh preferred to focus on the lives of those around him. In spite of the war in Europe and Japan, the United States as a nation was not physically disrupted. Life was prosperous for most Americans, and Marsh insisted on painting life in America.

His partially hidden acknowledgments of war were further introduced in several other works such as the paintings *Fifth Takes Rome* (1944), *Mad Men of Europe* (1940), *The Bowery* (1952), and *Coney Island Beach* (1947). While viewing *Fifth Takes Rome*, one immediately focuses on the attractive Marsh girl and only gradually notices the newspaper headlines regarding the war in Europe. A similar approach is used by Marsh in *The Bowery*, in which the headline reading "Bomb Burns Out Ghost Town" contrasts sharply with the transients and derelicts considered to be the living dead residing in their own ghost town.

Marsh was a firm believer in accentuating the positive, the positive being the dismal life that surrounded him daily. He preferred to barely mention the war news in favor of a celebration of life, miserable as it was. "Life goes on, and the war is so far away" became Marsh's credo. The poster and the theater marquees became the media for war news when the newspaper became secondary to his cause. Marsh's paintings during the war years were images of American New Yorkers who were seemingly unaffected by World War II.

In contrast, *Antiaircraft Crew in Action* (1944), painted by Dean Cornwell, is an on-the-scene recording of American soldiers in action. The huge antiaircraft machinery propped skyward, forming a diagonal movement, is compensated by the figurative forms of the American soldiers in the foreground.

Action in *Antiaircraft Crew in Action* is twofold: the action of the explosive forces of the guns, and the active movement of those manning the guns. Cornwell has demonstrated the transformation of a realistic event into an artistic portrayal of action. The teamwork is evident, which suggests the subjectivity of the work. One is faced with a single goal, a single action, but with a complex composition.

The viewer becomes a spectator to the action. However, the figure nearest the foreground invites the viewer to participate in the event. By facing the soldier toward an audience outside the picture plane, Cornwell has created a spatial effect drawing the viewer into the scene. The artist was not interested in the emotional reactions of the role-players but in the action itself.

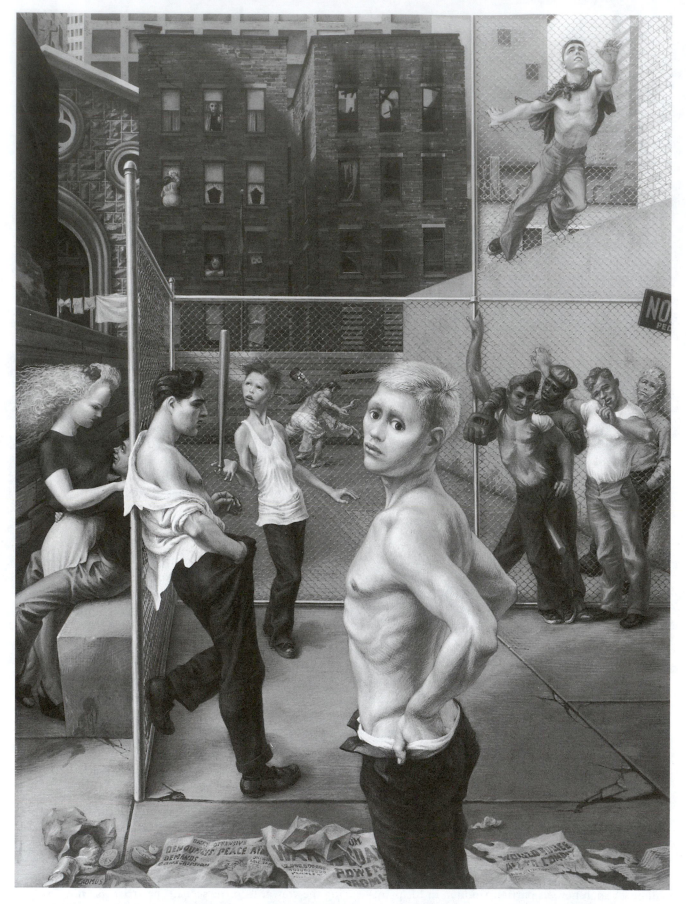

Paul Cadmus. *Playground* (1948). Egg yolk tempera on gesso panel. 23½ × 17½ in. Collection: Georgia Museum of Art, the University of Georgia. Courtesy DC Moore Gallery, New York City.

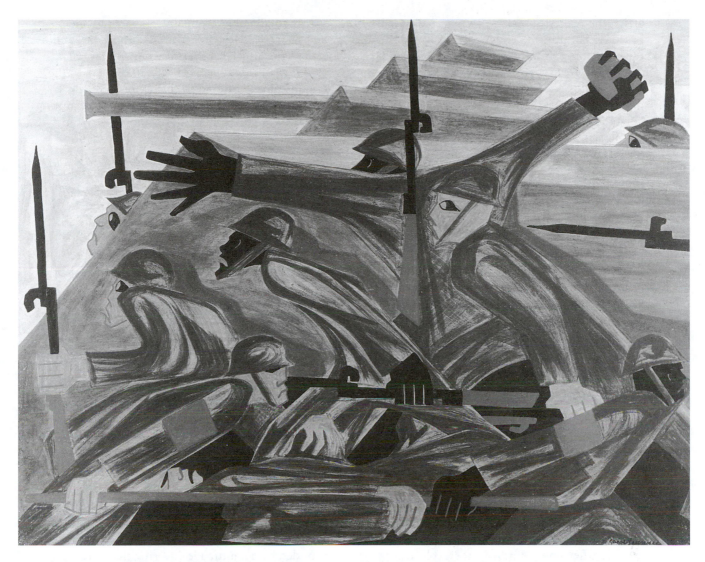

Jacob Lawrence. *War Series: Beachhead* (1947). Egg tempera on composition board. 16 × 20 in. (40.6 × 50.8 cm.) Collection of the Whitney Museum of American Art. Gift of Mr. and Mrs. Roy R. Neuberger. 51.13.

A most fantastic, terrifying atomic blast is portrayed in Philip Evergood's famous painting of 1946 titled *Renunciation*. The title suggests the demolition of the planet Earth, the return to the beginning of time, the total destruction of human life, and in its place the reinsertion of the apeman. The atomic bomb has been recorded as the savior of the world and simultaneously as the murderous cloud of total destruction. The atomic cloud became a symbol of the manifestation of evil. The mushrooming cloud zooming upward destroyed all elements of war, and man no longer existed as human flesh and bone but as a symbol of the evolutionary theory.

Although the atomic bomb was created to end war for everlasting peace, it has been reproduced by other nations and remains a threat to world peace. As an artistic form, *Renunciation* is a superb surreal expression of the significant explosive power that finalized World War II. Its astonishing composition envelops several grotesque revelations that, if enlarged, would introduce several individual paintings.

In spite of the tremendous loss of human lives resulting from World War II, Jacob Lawrence elected to reflect the timelessness of war. In his painting *War Series: Beachhead*, (1947), he depicted the anguish from all wars using the typical wartime paraphernalia.[13] The flatness of three-dimensional form is replaced with nuances of shading. The element of psychological distortion is evidenced in the outstretched arms and the fiercely set jaws of the aggressors. Even though *Beachhead* is considered a realistic painting by the

artist, the reality to which Lawrence adheres is not based on naturalism. The theory that naturalism is the basis for realism may not apply according to Lawrence. Reality is the masking of what appears to be natural. Reality is the shield that protects man from society. To Lawrence, reality is the issue at hand, the problem to be solved, the message to be translated, the theme to be expressed. And reality is the distortion of the natural.

In *Beachhead*, Lawrence has distorted the natural figures of the human condition because of the circumstances surrounding their presence. Distortion also dealt with compositional demands. The overlapping of figures driving forward is visually halted by the vertical positioning of bayonets.

Lawrence has spoken of realism as that which lies behind natural appearances. Actually, the separation of realism and naturalism is a potential matter. Naturalism remains until circumstances cause it to change. Lawrence's disregard for natural appearances is due to the extraneous nature of subject matter that has little to do with the message being sent. Lawrence used aspects of nature to suit his personal needs—compositionally, emotionally, and spiritually. *Beachhead* is a conglomerate view of war in the past, present, and future.

While in the U.S. Coast Guard during World War II, the artist William Lawrence created numerous sketches of the Japanese attacks on Iwo Jima and counterattacks by American troops in the eventual victory. Lawrence portrayed the relentless fierceness of war in the explosive imagery of *Attack on Iwo Jima* (1945), a painting that incorporates three horizontal planes of continual activity. The middle plane acts as the environment of the actual battle. It is surrounded by waves of onrushing waters and bomb explosions. Although objective in its conception, the total panoramic view is resolved as a single unit, a team of three horizontal habitats that blend into one battleground. Smoke, sky, and water are inserted into the picture plane in appropriate areas to create an ever-present battle. Soldiers are pictured fighting the rushing waves of enemy waters in attempts to secure footholds on the island. The realistic portrayal is punctured with numerous bodies too distant to attach any emotional significance to. Although factual in his recording, Lawrence succeeded in presenting a view of the desperation exhibited by the American forces. The atmospheric elements were as much an adverse factor as the enemy itself.

A totally objective painting, factually detailed and realistically recorded, is Griffith Coale's rendition of the attack on Pearl Harbor, *A Day That Will Live in Infamy* (1944). The title refers to the famous phrase uttered to the nation's citizens by President Franklin Delano Roosevelt. The painting is an action portrayal of an on-the-scene panoramic view of the destructive bombardment of American naval forces in Hawaii. It is a particle of the total picture, a slice of destruction that dominates the working surface. Because of its activated exposure, the display avoided the aftershock, the suffering and agony of human lives and the anguish that followed in the hearts of widows whose husbands were buried at sea or whose bodies were never recovered.

The viewer views the destruction as expressed by Coale but can only imagine the human devastation that followed. The seemingly ever-present smoke clouds erupting from the bombardment of naval ships fill the otherwise cloudless skies.

Opposing the panoramic view of Coale's painting is Kerr Eby's close-up view of American GIs in the drawing *Action in the South Pacific* (1943). Sheltered under a foxhole is a mortar crew of American soldiers attempting to repel the enemy. A positive background environment surrounds the negative space of the foxhole. Thus, the positive element in the persons of the three American soldiers is surrounded by the darkness of the cavernous foxhole, which in turn is surrounded by a handmade covering that extends to the limits of the working surface.

There are no effects of the shooting on enemy forces. Nor is there evidence of the damage done to the surrounding environment. There is, however, the action itself executed by the American GIs. Eby has been noted for his accuracy in recording visual events, and the appropriateness of the drawing medium allowed him to intuitively express his emotional reactions as well. *Action in the South Pacific* is such an example.

The war in action often serves the artist as a motivation to more provocative works. It is only after the action diminishes that reflection occurs and allowance is made for the meditative process. What appears in most war correspondents visual recordings is factual truth. The aftershock is usually reserved for the studio and usually results in a permanent expression after several preliminary sketches and hours of contemplation.

Such works as Tom Lea's *Going In* (1944; see

color section) and *That Two Thousand Yard Stare* (1943) reveal the profound anguish and tragedy that occurs within the human condition. *Going In* depicts an American marine bearing the scars of war as the fierce naval battle transpires in the immediate environment. Grabbing a moment of reflection, the marine contemplates the next move while enemy bombs burst around him. The blood and sweat amplify the facial war scars.

That Two Thousand Yard Stare is a startling display of battle fatigue. The marine staring into space, as if all memory had been lost, had faced the enemy once too often. The blank stare is typical of veterans whose visions of death affected their control of reason. The terrifying human expression is not shared by his comrades. Lea has projected a single human being to typify the war's horrors. The semi-subjective expression is backed by a mountainous terrain and a trio of American soldiers resting before another major attack occurs.

Umberto Romano, an Italian immigrant, never served in the armed forces, but his vivid paintings of the effects of war upon humanity are nonetheless deeply dramatic and compassionately intimate inner reflections. As Romano stated in 1944: "Can one blind one's vision? Can one kill one's sensitivity to moans, cries of tortured people? Can one go on painting serene, calm, undisturbed, unemotional paintings in such turbulent, intensely chaotic times?"

He continued: "Turn on your radio, glance at the screaming headlines. Throw open your windows and the air is dense, seething throbbing with pain, sorrow, hatred; full of black hateful passion. It vibrates with destruction of people, nations, races; destruction of culture, destruction of ideologies, destruction of the tortured soul of man. Rest … .peace? There is no peace. Not yet."[14]

Equally protestant is the artist Murray Stern's vicious approach to the theme. He has compared enemy warfare to the sport of football. In a vivid formation of humans transfigured into fleshless skeletons, Stern's football scenes retain the action of conflict, but the result is reminiscent of death. Stern has clarified his position on violence with his grotesque figures of senseless activity not unlike the torturous tactics of the Nazis against the Jews of Europe.

Stern is as thoroughly convinced of the animosity of player versus player as he is of the similar hatred of enemy forces toward one another.

Combat of any sort is a warlike event, according to Stern. It is not competition, as some would like to consider it, but rather an act of defeating an opponent beyond a capacity to rebel.

Stern reminded us of the death camps of Europe installed by the Nazi regime. Stern's vivid images are undoubtedly memories of an unforgettable past. In spite of the spirit of the sport, there remains in the minds of those who are unable to forget the holocaust of the German Gestapo a grim picture etched forever in their hearts.

Abraham Rattner, in a similar manner, used the sport of boxing as an example of war tactics. His ferocious images, displayed in a series of watercolors, are vividly similar to hand-to-hand combat on the battlefield.

Artists are generally nonaggressive. However, they will and do make violence an awareness factor to their audience in order to formulate action.

Umberto Romano's famous painting *Brothers* (1942) is an image of two brothers whose war experiences are momentarily forgotten. The warm embrace reveals the significance of life. The two images become one as Romano compositionally blends the two into an intimate union. The artist has revealed the ruggedness of war wrapped with tender care. The closeness of the subjects to the viewer creates a third party, the viewer.

Comrade reunions are not uncommon during wartime. The sharing from a pause from death, an embrace of victory, or the fear of battle is readily acknowledged in Romano's portrayal. Yet, Romano has over the years made compatible the physical and spiritual elements of man. He has been partial to the subject matter of clowns, war, and Christ, and each portrayal can be interpreted in any of the three areas. Christ has been portrayed as a clown and as a victim of war. *Brothers* sustains a spiritual factor, and although physical in appearance, it renders a religious commitment to the war effort.

Perimeter Patrol (1944), a display of anxious moments for a crew of three American soldiers, is realistically recorded. Added as an artistic element is the detailed brush that surrounds the trio of enemy-seekers. The dangerous mission is often disrupted by sniper fire. Tense moments exist in Michael Crook's version as the group of American GIs anticipate the unpredictable. Although action is being sidelined or delayed, Crook has sustained

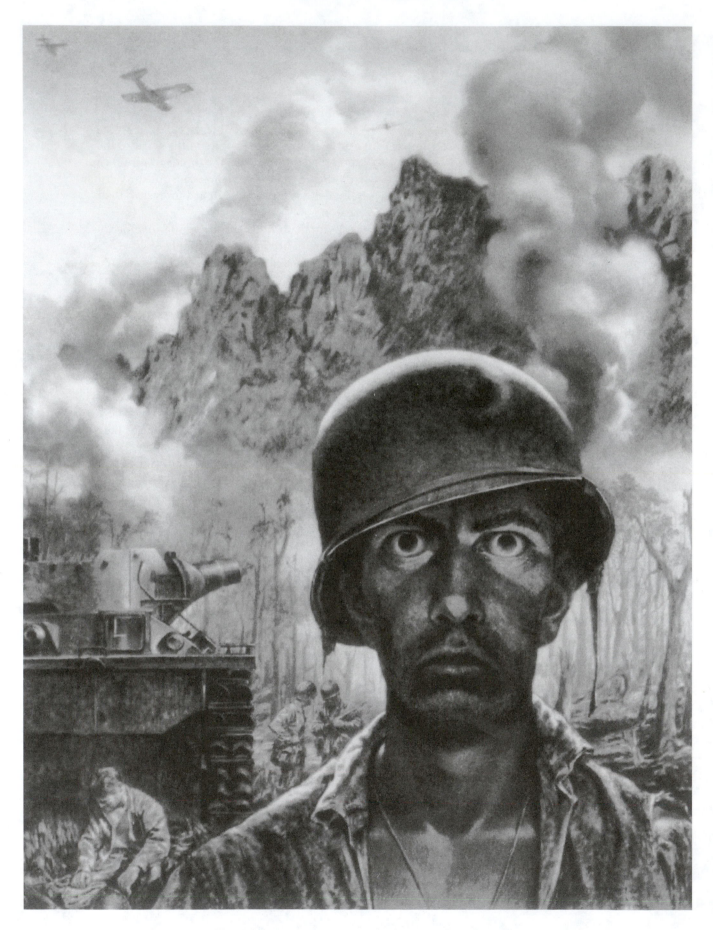

a controlled form of excitement because the action is yet to occur.

Compositionally, the lead soldier's deadly weapon directs the viewer to the right edge of the canvas, but attention quickly veers to the middle figure who aids the third GI through a murky swampland. The tall reeds of foliage camouflage any snipers while serving compositional needs as well.

Crook has extended the reed formation onto the bodies of the three soldiers thus meshing the role-players with the environment. Even though their similar headgear forms an invisible diagonal cutting across the painting, each helmet is rendered slightly differently to avoid a monotonous focus. A brilliant sunlit sky introduces sharp shadows and highlights, creating dramatic effects and visual movements of colors and shapes. In spite of elements of objectivity, personal concerns are registered in the facial expressions of comradeship.

The acts of war sometimes reside within the inner recesses of the mind. Such is true of Edna Reindel's fantastic *Recollections of an Apple* (1945). Although she was commissioned by *Life* to do a series of paintings depicting the role of women in war defense plants, her stunning works reflecting the fear of the atom bomb remain an astonishing achievement. During the same period of years in which she achieved notoriety with such works as *The Praying Mothers* (1949), *Hiroshima* (1949), and *Angels Wept at Los Alamos* (1949), she painted the grotesque yet beautiful, in its rendition, *Recollections of an Apple*.

The painting represents a dream, a nostalgic view of beautiful forests spiraling heavenward. Its base seems anchored in a mushroom image resembling an atomic cloud covered with a plant-like surface. From the upper left a lovely angelic creature zooms with saber drawn for a deep infliction into the beastly ogre. The grotesque form, although exquisitely rendered, is a personal creation of the artist and consequently subject to speculation and misinterpretation. To comprehend the meaning of a surreal expression is difficult, to say the least, and in the case of Reindel's *Recollections of an Apple*, segments of reality are positioned in an unreal manner. The apple, cut open, invites unlimited speculation. The obsession one has regarding intimate thoughts is often just

that, an obsession, with no direct meaning to reality, and consequently to append reason to its presence is futile.

For Freedom, an intimate view of war in action, was executed by Samuel Greenburg in 1942. The woodcut reveals highlights and shadows appropriately placed to form a trio of soldiers jammed into a limited working surface. Greenburg focused on the head and hand formation, eyes glazed with fear and bayonets fixed for action. Although the dramatic image needs expansion for total appreciation, it is a fearsome portrayal of combat. The compact unity creates an intense emotional reaction without a pause for reflection. One wonders about the emotional response of the audience if the work were produced on a large scale.

In another sense, Greenburg's intimate view of combat creates a form of anticipated anxiety. His use of a limited supply of bodily features demands immediate emotional reaction. There is no interference by extraneous items, as the parade of intensities, each individually, coils in the facial framework of determination. There is a grimace of fear, a realization that death is near. It is this unknown factor of the future that makes *For Freedom* the dramatic portrayal it is. There is no sign of battle or suffering, only the potential of tragedy.

The unusual display of helmets and hands resembles the Pop version of art so prevalent during the 1970s. It also relates to the Op version of repetition of similar images. Its salvation from the nonobjective school of thought is due to the brisk application of pigment. *For Freedom* is a personal reflection of war without the bloody agony of combat.

I Couldn't Hear Nobody Pray, a 1943 lithograph by Ruth Starr Rose, depicts a quintet of paratroopers descending onto enemy territory. Beacons of light spotlight the American soldiers endangering their lives as they descend. Meanwhile, messages are sent by code to Allied forces. There is a spatial element that enhances the two-dimensional surface. Aside from the usual recessive and advancement of shape and color, a third dimension occurs in the descent of the paratroopers. Thus, the viewer's visual attention shifts from the foreground of the decoder to the background to the spacious sky of paratroopers. Palm trees

Opposite: **Tom Lea. *That Two Thousand Yard Stare*** (1943). **Oil on canvas. Army Art Collection, U.S. Army Center of Military History.**

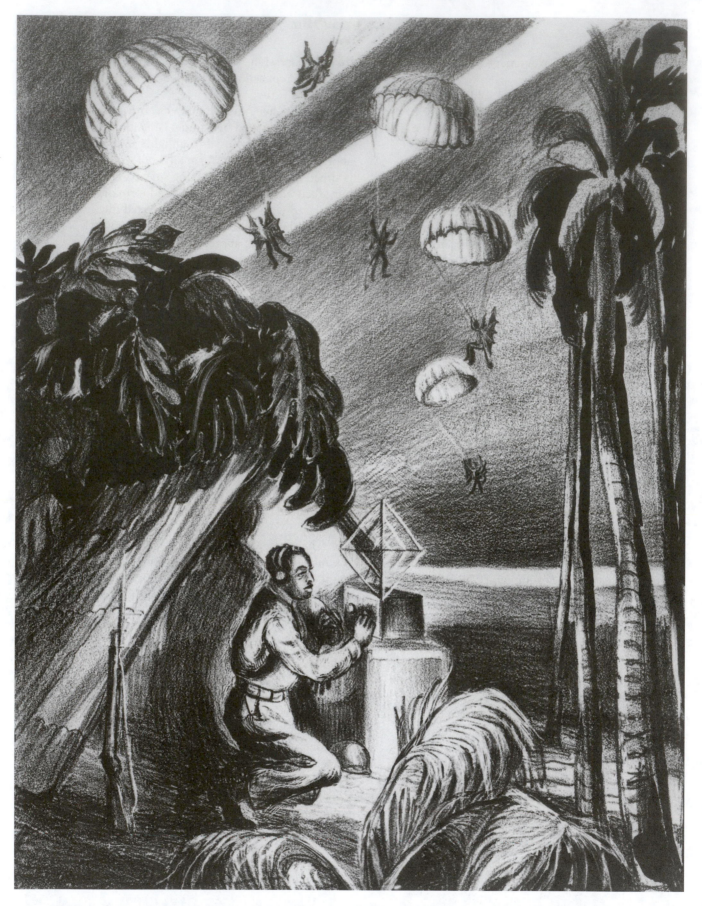

Ruth Starr Rose. *I Couldn't Hear Nobody Pray* (1943). Lithograph. 33 × 25.4 cm. Collection of the Library of Congress, Washington, D.C.

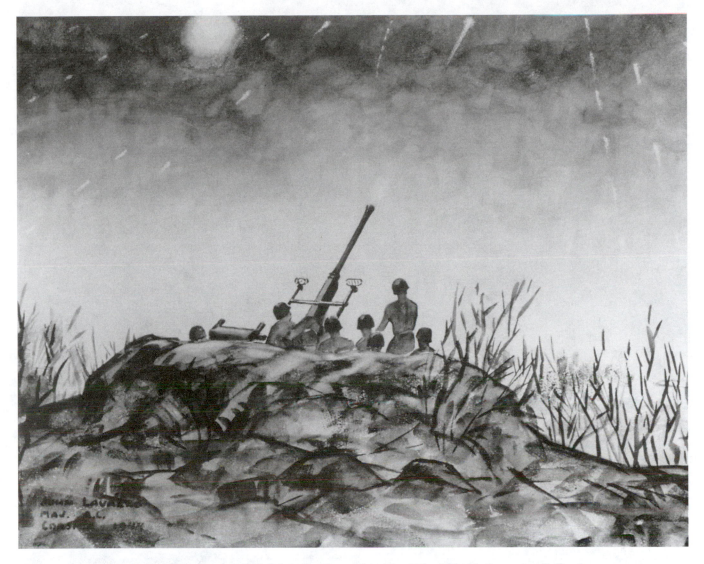

John Lavalle. *Smoke, Flares and Flak* **(1944). Watercolor. 19 × 25 in. U.S. Air Force Art Collection.**

grow tall, dominating the right side of the expression and thus identifying the locale as the South Pacific Islands. The balance of the highlights and shadows is overpowered by the anticipation of death. The descending paratroopers' lives are threatened by the beacon rays of light. Rose has responded eloquently to an unusual war scene while presenting an aesthetic experience to her audience.

Although Henry Simon's 1943 work *The Three Horsemen* is reminiscent of a famous football backfield, the lithographic theme had far greater and dramatic effects on the human race. The immediate and most obvious symbol is the German cross, which is centrally located and which identifies the theme of World War II. The three handsome steeds gliding through a cloudy sky bear the ruthless and murderous personalities of the enemies of democracy: Hitler, Hirohito, and Mussolini, the dictators of Germany, Japan, and Italy.

Hitler's notorious gesture forms the forward gallop through a symbolic destruction of the world. The cloudlike form surrounding the three terrorists creates a positive/negative background. Thus, the entire composition is activated without the three spatial planes echoing each other's angular shapes. In addition, the distribution of darks and lights sustains the viewer's attention long after the disappearance of the lithograph itself. Indelible scars are etched into one's memory. And for those who fought for democracy during World War II, such imagery is even more terrifying.

John Lavalle activated two major areas in his 1944 painting *Smoke, Flares and Flak*. Routine and

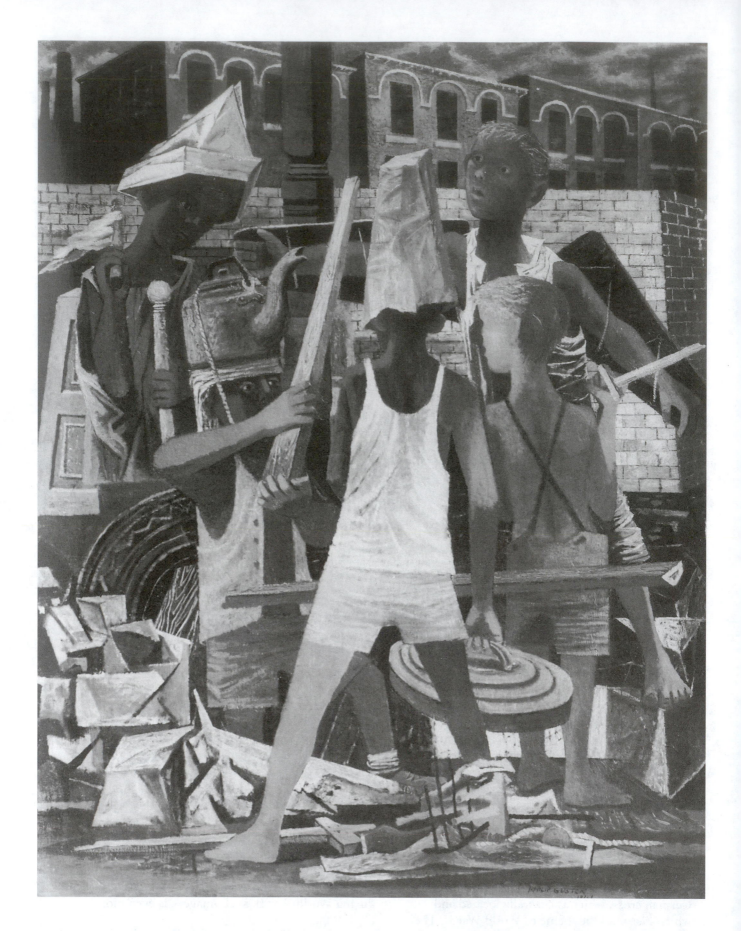

Philip Guston. *Martial Memory* (1941) Oil on canvas. 40⅛ × 32¼ in. (101.9 × 81.9 cm.) Eliza McMillan Fund. 115:1942. The Saint Louis Art Museum (Modern Art). ISN 7577.

commonplace areas such as sky and land are made provocative by creating action within. The gunners occupying a central position form a third horizontal plane while joining together the foreground and background.

The use of crisscrossing lines representing a rough terrain and the transparent use of the watercolor medium unite to form a textural environment. The viewer becomes a spectator to the event, an active viewer to an incident yet to occur. The American soldiers as a gunnery team fire at stimuli outside the picture plane. Although the aircraft are the targets of the firing squad, their presence remains beyond the limits of the painting. Thus, the active forces represent the subject matter. Remove the gunners, and a mound of dirt and sky remain. And so, the total purpose of the artist is eliminated. However, Lavalle has combined the American soldiers with a compatible habitat. Thus, the removal of one segment of the whole would destroy the painting. *Smoke, Flares and Flak* is a simple painting of a perilous venture.

The rugged terrain utilized in the foreground sustains the viewer's interest within a major portion of the painting. The stalwart diagonal thrust of the massive gun upward toward enemy planes has left the gunnery team otherwise unguarded. Yet, the real activity reigns in the vast sky area because of the uncertainty and because of the anticipation of the unknown. Perhaps the action alone frees the gunner from fear, but it is the idle moments, the rest periods, the hesitations, that create the fear of death.

Lavalle did not reveal facial expressions. The soldiers are positioned at a distance from the forefront of the painting. *Smoke, Flares and Flak* is both objective and subjective in the emotional tone of color.

A composition is a personal approach. Each artist determines his or her own position. The view portrayed depends on circumstances of both the subject matter and the artist. Caution and fear become factors in tense situations. Such is true of *Smoke, Flares and Flak*.

Occasionally, artists will play the role of the soldier in combat by acting the role of a war game performer. However, the subject matter is seldom adult, as witnessed in such paintings as *Martial Memory* and *If This Be Not I*, both executed during World War II by Philip Guston. In *Martial Memory* (1941), war is a boyish attempt to win a game, not of bloodshed or injury but rather of youthful wit. Young warriors armed with sticks and garbage-can lids, reminiscent of the dueling instruments of the medieval age, plot a scheme of enemy attack. Human figures are grouped closely together, intermixed with appropriate paraphernalia that may serve as protective shields.

The youthful congregation is surrounded by hints of Magritte and de Chirico environments, creating mysterious and eerie circumstances. *Martial Memory* is a complex arrangement of human and material details that are objectively conceived and carefully and appropriately positioned. The viewer is treated to a childhood memory, altered to avoid the brutality of war.

The complexity of design also reflects the anxiety of a youthful age within a perilous habitat. Guston has placed the viewer outside the picture plane but near enough to participate if action was to occur. The young warriors don paper bags as helmets and wield sticks for swords and garbage-can lids for shields. In spite of the inactivity of human figures, an excitement is generated by the intricate overlapping of human forms and objects. The anticipation of excitement is further generated by movements that have yet to occur.

Similar in composition, emotional tone and eerie surroundings is Guston's 1945 painting *If This Be Not I*. Young boys again grace the canvas, hiding behind mask and costume. Although objectively conceived and arranged in logical order, it sustains abstract overtones. Because of the evening setting, Guston has relied on artificial light sources to coordinate visual highlights and shadows. Each youthful figure wears an individually shaped paper hat. Faces are either masked or hidden from view, thus avoiding identity. Guston neglected to give a reason for obscuring the personal characteristics. Although *If This Be Not I* lacks the brutality of war, its playful interplay of childhood memories is a nostalgic view of memories forgotten.

The same can be said of Guston's display of images of emaciated human bodies jammed into the tightly knit vertical painting *Porch II* (1947), reminding one of prisoners of war, barricaded behind bars of wood and steel. The holocaust is recalled as the human condition seems destined for death row.

Guston's total use of the working surface automatically eliminates negative space as

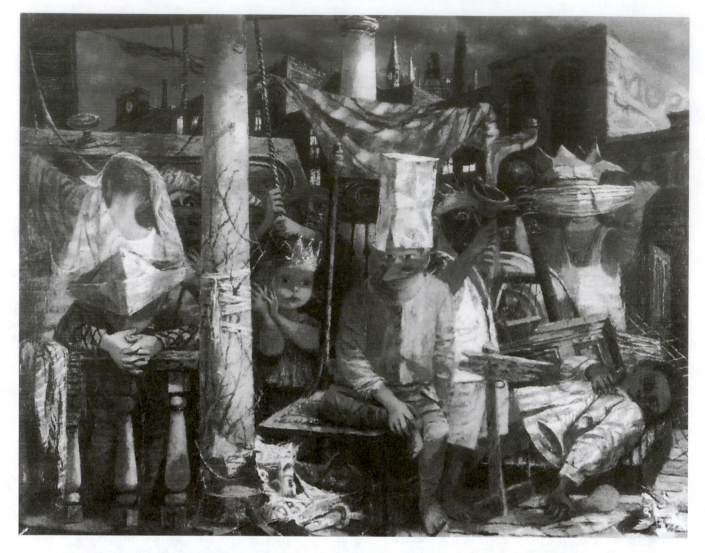

Philip Guston. *If This Be Not I* (1945). Oil on canvas. 42⅜ × 55¼ in. Washington University Gallery of Art, St. Louis. University purchase, Kende Sale Fund, 1945.

identifying environment. Therefore, the viewer has the option of determining the habitat. *Porch II* ranks with his spiritual episodes of recording the various versions of the passion of Christ. *Porch II* is a relative of his famous painting *Deposition*. Faces are distorted, reflecting the horrors of suffering representative of World War II as well as the spiritual agonies of the Crucifixion.

Leon Miller's 1942 woodcut *Aggression* is a provocative abstract portrayal of the essentials of warfare including the human condition. Using the total working surface, Miller presented a subjective of the war in process. The overlapping of dark and light geometric shapes representing the elements of war constitutes an intriguing combination of the human and the material.

In a sense, *Aggression* displays the horrors of war. It is difficult to distinguish one force from the other. Aside from the eerie display of gas masks, bayonets, grenades, cannons, and barbed wire, one envisions a hand-to-hand combat between two forces.

There is no tonal middle ground in *Aggression* as black and white shapes clash in a well-conceived and well-executed composition. The complexity of overlapping and the interpenetration of bodily segments with the background environment form an abstract. The normal recession of black and advancement of white is disregarded in Miller's imagery. The theory is automatically sidelined because the two extremes of color intermix to create an apparent nonobjective abstract.

Aggression demands advanced study because bold black and white areas compete with linear details that serve as both decorative design and

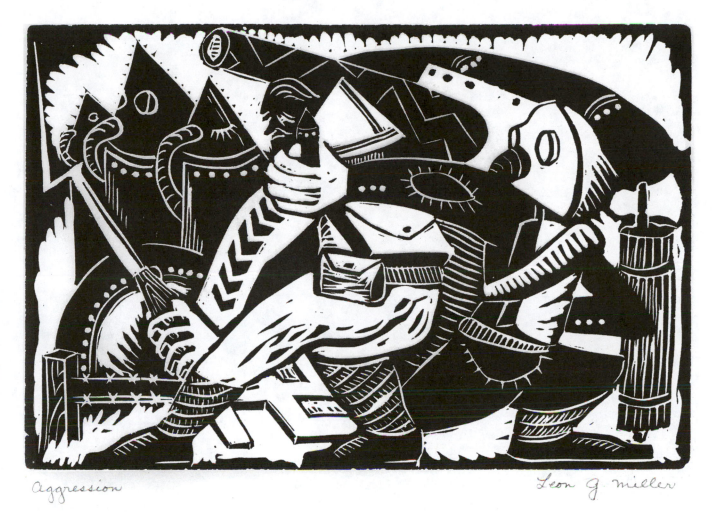

Leon Miller. *Aggression* (1942). Woodcut. 15.3 × 23 cm. Collection of the Library of Congress, Washington, D.C.

compositional structure. It is a gathering of war's objects of destruction arranged to create a symbolic journey into the unknown. The intricate interweaving of line and shape creates a provocative visual journey upon a limited working surface. It is this compactness of visual images that constitutes the contents of *Aggression*.

Acts of war extend beyond the war itself. The war rages within relatives of those lost in battle. It is witnessed in the faces of widows, whose lives were changed forever. And the artist continues to reveal what happens when aggressive nations and individuals hold human life in ruthless disregard.

CHAPTER 2

The Wounded

Joseph Hirsch's architectural painting of wounded American soldiers aboard a hospital ship combines the visual with the psychological aspects of the war injured. In *Mercy Ship* (1944), the wounded seem rested, occupied with the mundane acts of napping, reading, and idle conversation.[1] Individual concerns focus on the safe return home. Hirsch split his canvas horizontally into three planes: the sky, the ship's mast, and the ship's deck on which the wounded reside. The turbulent sky casts a foreboding atmosphere over the wounded soldiers. The artist introduced several individual compositions, which, if enlarged, would incorporate dramatic and frustrated human conditions. Instead, Hirsch preferred to record a full view of the wounded while focusing on the ship itself as the environmental habitat. To avoid a centrally split canvas, the artist tilted the ship's mast slightly in creating irregular sky shapes, which in turn helped to dramatize the subject matter of the wounded.

In another Hirsch painting, the artist preferred the aftermath of war rather than the action itself. In his eloquent painting titled ironically *Company in the Parlor* (1944), the artist concentrated on medics and surgical teams in their care of the wounded. The exquisite rendering of color and textural detail enhances the structural ruins that constitute the environmental background. A single soldier checks the horizon for enemy planes as the medics load the occupied stretchers into

incoming ambulances. Others remain on duty as minor injuries are treated on the scene.

The composition is equally divided between the ruins of a dismantled structure, which housed plasma bottles and a household crucifix, and the soldiers themselves, fervently tending the injured and yet fully aware of the precious moments of freedom from enemy fire. Hirsch has treated his theme objectively, refusing to identify individual soldiers but rather treating the theme as a unit of cooperation. To avoid a muted sky during battle, Hirsch introduced splinters of charred wood, which cling in unorthodox positions to the remaining structure of the once elaborate building. The overlapping figures occupying much of the lower segment of the canvas form a horizontal activity of human endeavor. Several individual compositions, if enlarged, could readily develop into several distinct paintings. Hirsch was careful to avoid obvious positioning of objects so that a restless yet stilled atmosphere prevailed. Much activity occurs, yet a quietude persists as medics work hurriedly and efficiently. *Company in the Parlor*, as ironic as the title may suggest, is nonetheless deadly serious in the performance of duty.

William Johnson served his country by painting scenes of the war effort and the homefront. In his flatly patterned work *Station Stop, Red Cross Ambulance* (1942), nurses and medics load the wounded into ambulances.[2] An armed

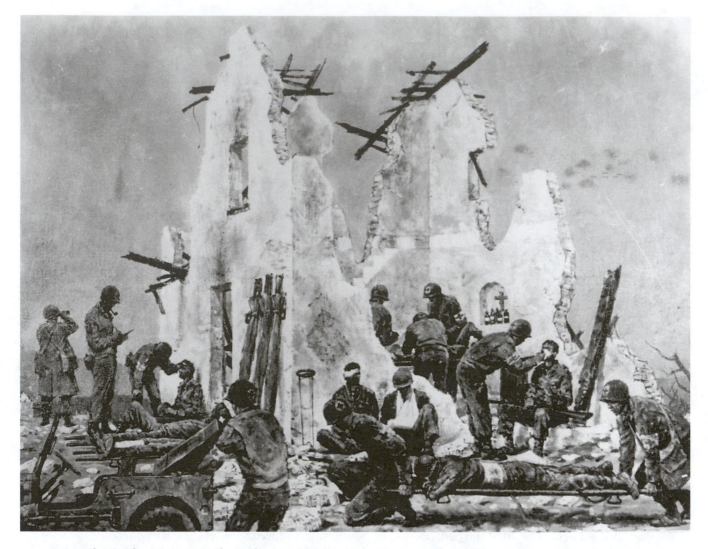

Joseph Hirsch. *Company in the Parlor* (1944). Oil on canvas. 32 × 42 in. Army Art Collection, U.S. Army Center of Military History.

forces railroad train also remains available. Again, visual perspective is sacrificed. Instead, Johnson applied the tactful theory of exaggerating or distorting those aspects of the human condition that psychologically, physically, and emotionally suffer from pain, anxiety, and despair. Details and textured qualities are totally ignored.

Johnson introduced a sequence of events so that a movement of activities is established while allowing for the anticipation of future incidents. Because of the lack of three-dimensionality, human emotions were seldom recorded. Strong horizontal planes are counteracted by the equally strong vertical stature of the figurative forms. Several rectangular shapes circulate throughout the painting, forming a pattern of activity aside from the major subject matter.

The author Richard Powell wrote about

Johnson's work: "In another Red Cross painting *Convalescents from Somewhere* (1944) Johnson's uncanny composition and abstract treatment of the figures again contribute to a mood of other worldliness and spirituality. Johnson's evocative image of a woman in white, flanked on both sides by altarlike, wooden ceiling supports, takes the painting's hospice narrative to another, more symbolic level, one that suggests spiritual as much a physical healing."[3] Johnson has been described as a foremost exponent of religious painting as well as the African-American cause for freedom. This spiritual ingredient has found its way into many of his war paintings. There is a stillness. The passive mood seems ever-present in his work. The passionate theme of the Crucifixion seems as aftermath even though symbolic reds are appropriately positioned. In *Convalescents from Some-*

where, there are no blood stains, perhaps because the healing process was current or subsided.[4] The composition is simple and direct. The blend of subject matter and environment is ideal. There is no outward rebellion, only a recording of events. A muted revolt occurs the moment brush meets canvas. Regardless of technical approaches, the fact that the expression was recorded is reason enough to believe in Johnson's message.

Hospital Ship Approaching San Francisco (1945; see color section) is a provocative painting by the noted American artist Franklin Boggs.[5] The Golden Gate Bridge becomes the focal point as the wounded soldiers gaze intently on the famous symbolic image of freedom. The viewer is forced to acknowledge the famed bridge as well, although the artist has appropriately positioned the wounded survivors on the picture plane. The dawn of a new day is symbolic of a return to freedom. The illuminating horizon becomes a welcomed sight, and the anticipation of fulfillment increases as the hospital ship nears its goal. One can only predict the inner stress that accompanies the wounded veterans, whose identities are left unknown. Bodily gestures express the excitement and joy of home. The introduction of strong

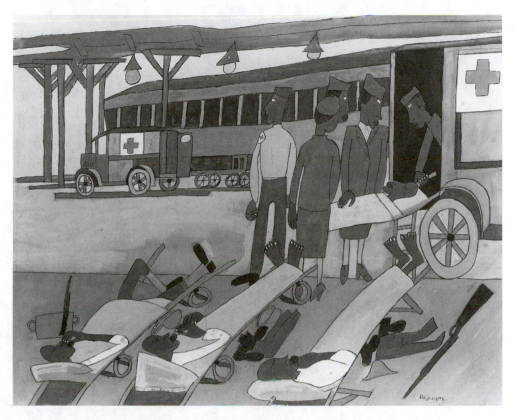

William Johnson. *Station Stop, Red Cross Ambulance* (1945). 1967.59.1040. National Museum of American Art, Smithsonian Institution, Gift of the Harmon Foundation.

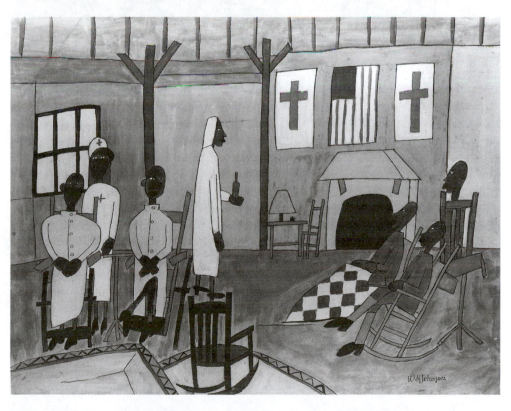

William Johnson. *Convalescents from Somewhere* (1944). 1967.59.1040. National Museum of American Art, Smithsonian Institution, Gift of the Harmon Foundation.

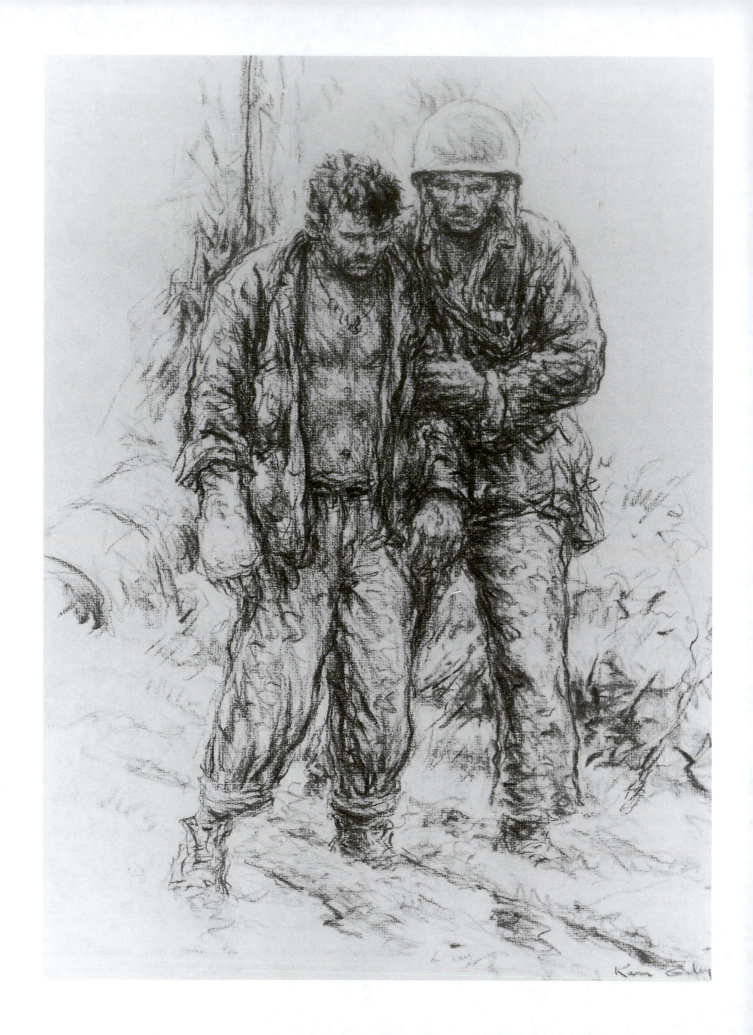

diagonal segments assists in the attention granted the wounded soldiers. Although seemingly insignificant, the circle of seagulls approaching the ship equalizes the lightness of the horizon in an obvious attempt to encircle the light segments of the painting.

Kerr Eby, one of America's foremost printmakers, shows his accomplishments in the typical work *He Walks Who Can* (1944).[6] Eby's provocative drawings and lithographs are direct and deeply personal and reflect a humble and compassionate concern for the human condition. In *He Walks Who Can*, an American GI aids a comrade to safety. The gesture drawing illustrates Eby's intuitive response to the physical characteristics of the human person.

The scribbles become dense as they define three-dimensional traits of the participants. The muted background aids in amplifying the message. Because of the simplicity of portrayal and the lack of objective disruption, *He Walks Who Can* is a direct depiction of a tender side of aggression and conflict. The intuitive background forms a sense of completeness to an otherwise sketchy performance.

The Price (1944; see color section), an image of gutsy valor under fire, marks the artist Tom Lea's emotional reaction to a war seemingly endless in its struggle for freedom.[7] The bloody victim, whose face is partially shot away, trudges forward, seemingly unaware of his own misfortune. Lea purposely cemented his victim solidly within the picture plane, disallowing any objective disruptions. The environmental background is mute and unknown. It matters little, since Lea's strong human figure lunges at the viewer.

The bleeding victim's image is terrifying. To witness such horror and then contain oneself—to express it under a controlled manner—is indeed a remarkable achievement. The victim is shocked that his own death is inevitable and yet subconsciously moves forward as if under military command. The tense, outstretched arm unaffected by the severe injury reaches out for support that does not exist. The drama that Lea has accentuated is appropriate to the theme. Subsequently, the message is communicated that war is a grueling, suffering, and deadly experience. Lea's painting is more than a recording; it is a provocative awareness of life put on hold.

Protection for the Wounded (1943), a Kerr Eby drawing, exhibits the guts and thunder of his direct hits.[8] Eby was noted for his realism, and doubtlessly he isolated his thoughts and emotions before recording. Thus, his expressions suggest a compassionate reflection on the loss of human lives and the aftereffects for those loved ones left behind.

Eby's drawings are forever direct, and yet they reflect the correspondent recording of timely events. Eby was not one to record a scene or event for the sake of an article commission. He allowed himself the need to reflect, to console oneself, and perhaps an element of prayer also becomes a part of the creative process. *Protection for the Wounded* reveals the bravery of the American soldiers, indeed a teamwork that creates a oneness of purpose. Because of the physical idleness between the actual event and the artistic expression of it, there exists an image of a truly provocative nature. Eby's drawing becomes an artistic product because the artistic pauses were allowed to generate a profound message rather than an accurate report of the news.

An eerie mood is created by Robert Benney's night scene titled *Flashlight Surgery in Saipan* (1943; see color section).[9] The source of light in a totally dark environment is reflected and highlighted on medics and doctors as they relentlessly and feverishly attempt to operate on a wounded soldier. To concentrate the viewer's focus on the timely event of the surgery itself, Benny has posted two vertical structures to psychologically and compositionally sideline other occupants and medical paraphernalia. Yet, by creating shadows and highlights in contrasting fashion, the artist establishes a unity of light and dark. Flickers of light are distributed throughout the composition. Benney's work is realistic, as was much of the art production during the World War II years.

The angle from which an event is recorded is the difference between an illustration and a work of art. Kerr Eby is noted for his arrangements of the human form in order to express the fullest impact of the situation. In his series of drawings of wounded veterans, Eby chose angles from which emotional responses readily occur. In *Wounded Man* (1944), two veteran American GIs assist in the comforting of a comrade. The environment within which Eby's recordings

Opposite: Kerr Eby. *He Walks Who Can* (1944). Charcoal drawing. 22 × 17 in. U.S. Navy Art Collection, Naval Historical Center.

occur is usually mute, nondisruptive, or non-existent.

Since deliberate distortion was never a part of Eby's approach, in order to provoke a dramatic appeal, a rearrangement of the original incident became essential. A similar approach was utilized in such noted works as *Litter-Borne GI* (1944), *Plasma, A Wounded Marine* (1944), and *Waiting for the Wounded* (1943). Eby recorded the action of each work, allowing the viewer to react to the hidden effects on the wounded humans. Eby focused on an upper view, looking down on the wounded being lowered to a waiting LST for transfer.

Hospital Scene (1972), by Joseph Hirsch, is a paradox of beliefs.[10] The scene in Italy reveals a bizarre contrast. The American hospital is the site of a former Fascist locale. American soldiers, on recovering, are treated to enemy propaganda. The huge Italian mural dwarfs the human bodies in hospital beds. The artist depicted several individual personalities, united them into a common bond of similarities. Each single human form, if enlarged, could compose an individual painting. In a sense, a panoramic site is established because of possibilities of endless cots of wounded American soldiers.

Hirsch established an unusual composition because the environmental background serves only a segment of the subject matter while the lower segment's background remains outside the picture plane. To avoid the picture's dominance by the propaganda mural, the artist tore segments to represent age and to correspond to areas of white pigment. One is treated to an objective view of several American soldiers recovering from their wounds.

Wounded Crewmen (1943), a drawing by Lawrence Beale Smith, records an actual scene of wounded crewmen taken off a crippled bomber that managed to limp home.[11] Focus is on the attention given to the wounded by the medics; in the background are gesture drawings of spectators and onlookers. The positioning of figures creates an overlapping that promotes a unified composition.

The gesture drawings vary in density of line, thus suggesting an informality that makes for a moving and compassionate portrayal. Smith's lines are energetic and anxiously applied to create a form of humility and meditation. There is a stillness in spite of the exciting linear suggestion of movement and action. The total unity consists of a triple combination of episodes, each of which contains the ingredients of a full-fledged composition.

Noted for his fantastic paintings such as *The Eternal City* (1934–37) and *The Rock* (1936), Peter Blume's unusual theme expressed in *Fracture Ward* (1945; see color section) lacks the imaginative power that is evidenced in works in which plans precede the final production.[12] In *Fracture Ward*, only the title hints at the unusual. It depicts wounded soldiers whose arms and legs are strapped and bound in weights. Architectural structures of bedposts compete with human torsos in a hospital ward. The painting is meticulously rendered in photographic imagery. In spite of the seemingly free space surrounding the wounded, the soldiers are trapped not within cages or enclosures of any sort but within the confines of their own individual physical boundaries.

Mitchell Jamieson's painting *First Aid Station* (1945) reveals a makeshift hospital ward amid enemy fire.[13] A Red Cross banner is hoisted upward to identify with the presence of the wounded soldiers. A typical front view of war casualties is a composite of a horizontal bunker and bayonets in vertical positions, forcing a unity of the foreground and the background. Focus is on the five wounded veterans.

Marion Greenwood's *Night in Spain*, painted in 1940 during Hitler's reign of terror in Europe, is an eerie exposé of anguish endured by a single victim of the war.[14] The overwhelming fear exhibited in the gaping eyes and tensed body of the prostrated woman is amplified by the desolation surrounding her. The naked structures flanking the shrieking victim add to the isolation and the inevitable lack of mercy.

Greenwood's terrifying imagery was painted from memory and recordings of earlier visions of war. The shriek is echoed through the stillness of the night and acts as a symbol of aggression. *Night in Spain* is not a typical recording of war. In a deeply reflective reaction, Greenwood displayed a profound concern for the victims of German aggression. The naked landscape suggests a total erasure of human life.

The artist Harriet Berger, in her aquatint etching *Wounded Soldiers* (1944), portrays the question of available assistance in a deeply dramatic fashion. The two wounded soldiers are isolated within a desolate landscape of despair. The horror of war is etched into the facial expressions of the hopeless victims. Berger has thrust the terrifying effects of war onto the viewer. The

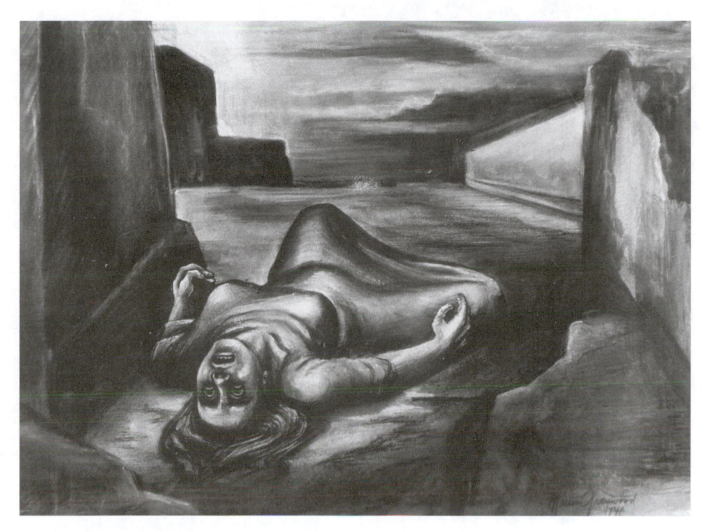

Marion Greenwood. *Night in Spain* (1940). Gouache. 14⅛ × 19 in. Collection of Madison Art Center, Madison, Wisconsin. Purchase, through Rudolph and Louise Langer Fund.

subjective expression enhanced by the muted environment recalls the futility of war, the execution of human beings. The kneeling figure touches the emaciated, naked body of his comrade, knowing that death has already arrived.

Berger's mild title only hints at the gross bodily condition of the victims of war. *Wounded Soldiers* implies recovery. Berger's wounded soldiers exhibit death and the fear of death. The etching is an exquisite example of the futility of war. Berger's rendition of terror and of the devastation to the human condition makes *Wounded Soldiers* a masterful portrayal of the evils of violence and combat.

CHAPTER 3

The Survivors

The word *survivor* means an escape to freedom or an escape from tyranny or terrorism to a realm of safety. Sol Wilson described his serigraph *The Twelfth Day* (1943) as follows: "This print was made during the war and the theme was suggested by a number of news reports of men having been seen at sea on a raft many days and nights after their ship had been destroyed. On the print the broken raft is suggested behind the men crawling up the rope."[1]

The five survivors, stunned by the isolated shoreline, doggedly prepare for the unknown future. The figurative anatomies sustain the ruggedness of the cliff-like terrain as each victim faces a fearful journey into nowhere.

Wilson has thrusted his victims of war onto the frontal plane, thus causing an audience reaction. Waves beating against the coral reef contrast with the solemn, exhausted, physical bodies of the escapees. The notion of prayer is without question reflected in the faces of the survivors. Survival does not necessitate freedom. A worse fate may lurk in the future.

A more grotesque display of physical torture and survival for death is Benton Spruance's unbelievably mind-shattering etching *Souvenir of Lidice* (1943).[2] It records the anguished physical remains of three survivors, who resemble the three crucified at Calvary. The dramatic physical distortions of elongation and foreshortening are witnessed in the grotesque and emaciated bodies of

the victims of war. Survivors in one sense but prisoners in another, the three tortured victims, each muscle strained beyond reality, exhibit a striking resemblance to Christ and the two thieves. The interlocking of muscular bodies not only reflects the artist's pronounced knowledge of anatomy but also reveals the strength, stamina, and determination of the victims, who finally fall prey to the aggressor's torturous tactics.

During World War II, surviving meant living from day to day. True survival was possible only when victims were safe on American soil, even though permanent residence is never guaranteed. An example is witnessed in Charles Baskerville's masterful painting *Shooting the Breeze* (1947; see color section). The detailed, circular composition is described as follows by the artist: "Convalescents in the Army Air Forces Hospital at Coral Gables, Florida, don't always believe one another's tall tales of combat, but they tolerate them for the return privilege of narrator. All three of these men went back to full duty. The armor-like aspect of the casts and the rich colors of the regulation hospital clothes presented them to the eyes of the artist as undated warriors of all wars."[3]

Although considered survivors of a battle, the three wounded returned to war. Baskerville presented a slice of life from a panoramic view of a hospital site. Aside from a realistic portrayal, the artist suggested bits of surrealism with the

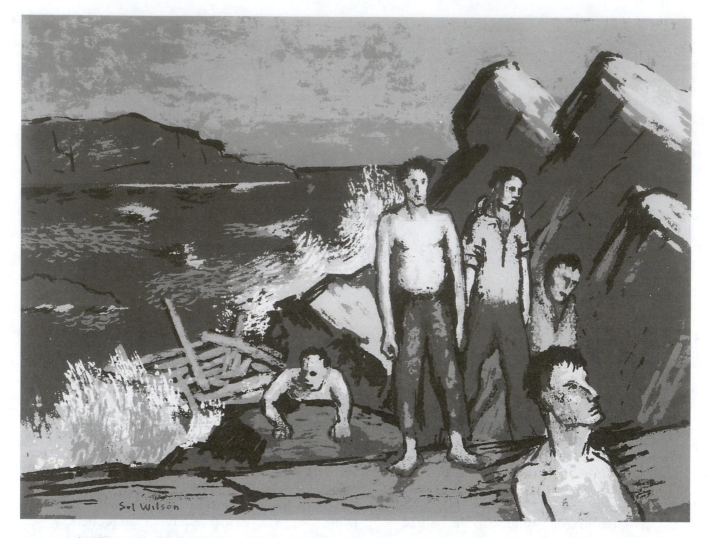

Sol Wilson. *The Twelfth Day* (1943). Serigraph. 30.5 × 40.8 cm. Gift, Artists for Victory. Collection of the Library of Congress, Washington, D.C.

structural designs of cure. Neck and arm braces, abnormally structured, cover the scars of war but remain symbols of unreality. A certain eerieness prevails as victims seem caged within their own bodies. There is a mood not of joy or sorrow, contentment or anxiety, but of curiosity and uncertainty.

Survivors of the war faced unusual circumstances. Amid the war-torn shreds of a Tuscan city was a group of Italian survivors whose homes had been demolished by the Nazi forces before the American liberation. A group of seven bewildered Italian citizens emerged from the underground sewers to claim temporary security under the protection of American Army Service Forces. *Oil Supply Line through a Tuscan City* (1947), a masterful work by Edward Laning, shows the anxiety of these freedom-seekers. Hope seems to renew itself daily because, as Laning noted, "liberation is hard

to distinguish from occupation, or even from conquest."[4]

The overlap of debris with the human element in this work is eloquent and ideally suited to the conditions of the environment. A huge bronze statue lies among the ruins, beheaded, as if symbolizing the fall of the religious and cultural history of the ancient city. There is a sense of fulfillment, as if the artist had succeeded not only in transmitting the message of the armed forces but in cultivating a spiritual message as well. Although the structural ruins are reminiscent of the ruins of ancient Rome as depicted by the Northern Renaissance artists, one is also reminded of Peter Blume's *Eternal City*, a masterpiece that epitomizes eternity of life in spite of material and human destruction.

Laning detailed his painting throughout without disrupting the visual perspective of the

Karl Schrag. *Persecution* (1940). Etching and aquatint. 30.4 × 30.4 cm. Gift, Artists for Victory. Collection of the Library of Congress, Washington, D.C.

numerous objectives that constitute the painting. Yet, by developing its own residential environment (the underground sewer), Laning has made foremost the subordinate group of individuals (the freedom-seekers). The busted statue lies in repose as a symbol of life's spiritual interruptions. But Laning pictured a similar sculptural form in the distance, thus recording a continuance of faith.

Under certain circumstances the survivor may live to see another day, but the eventual outcome is seldom one worthy of the extension of life. A case in point is portrayed in Karl Schrag's ghoulish *Persecution* (1940). Reminiscent of Goya's war scenes, but more important, similar to the Ecco Homo paintings and etchings of contemporary artists, *Persecution* provokes the viewer into a sense of shame and anger at the governmental

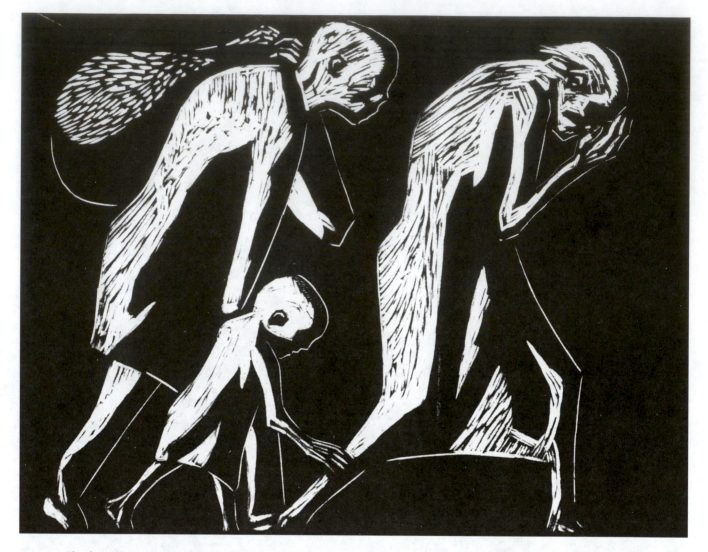

Charles Quest. *Nearing the End* (1943). Woodcut. 21.5 × 28 cm. Gift, Artists for Victory. Collection of the Library of Congress, Washington, D.C.

forces responsible for the persecution. The half-naked prisoner of war standing before a crowd of jeering antagonists is a survivor for the sole purpose of party satisfaction. Buffoonery had become a source of audience survival, not unlike the behavior of the crowds that mocked Christ during his torturous journey to Calvary. The artist admitted "that in the end the spiritual strength of the victim would prevail — that all these surrounding criminal and vulgar powers could not succeed."[5]

A terrifying experience of fear is equaled in Hugh Pearce Botts' version of survival titled *Refuge* (1943).[6] Huddled under a kitchen table is a family of five, as well as a dog, embracing each other while tensely awaiting an unknown fate. Each facial expression relates a glare of hesitant resignation. While the mother and her three children await the inevitable, the father grips a

candleholder as a weapon of defense. The members of this closely knit family, caged within four walls and anchored under a protective tabletop, fear the unknown and expect the worst. They are survivors for the moment, and it is this anticipation of future anxiety and perhaps even death that exhilarates the artist and his audience.

Crammed between vertical table legs, the frightened family presents an intimate view of desperation. The environmental background sustains a simplicity and muteness that aids in strengthening the focus of the survivors. Botts' rendition of a refuge is an enduring landscape of human anxiety.

Through the influences of Kathe Kollwitz, Honore Daumier, and Fransisco Goya, Charles Quest became an exponent of the abstract expressionist school of thought. His intimately con-

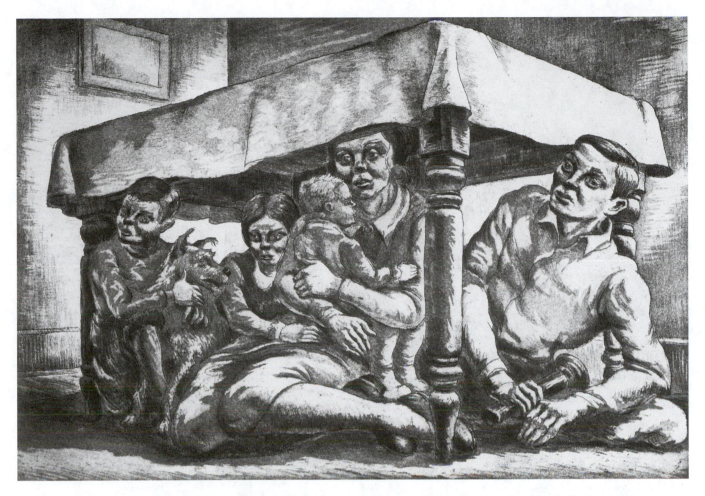

Hugh Pearce Botts. *Refuge* (1943). Soft ground etching. 18.8 × 27.1 cm. Gift, Artists for Victory. Collection of the Library of Congress, Washington, D.C.

ceived and executed woodcut *Nearing the End* (1943) pictures a family of three trudging fearfully toward an unknown end.[7] The black-and-white portrayal adds to the drama as sharp shadows create an eerie but compassionate image of a family in fear.

The blackness of the background unites with the white highlights to create a oneness, a singleness of purpose, a singularity of imagery. The three individuals become a unit, a team that performs as a trio. Facial expressions remain blank, but bodily gestures strongly affirm tragedy and despair. The journey ahead is unknown. Each agonizing step becomes a step further into uncertainty.

The title, *Nearing the End*, could be optimistic or pessimistic depending on the interpretation. It could mean the end of physical and spiritual domination, or it could relate to the end of life itself.

Harold Paris, born in 1925, was a young man

when he completed *They Suffer Too* (1944), a color woodcut focusing on an American GI's widow who is being comforted by an American soldier and a Catholic priest.[8] The widow occupies a central position, flanked by the two significant role-players. The linear drawing of the three figures is blended into a single unit by an overlapping abstract shape of color. The color itself aids as a blending technique of three figurative forms. The American soldier, draped in a helmet, machine gun, grenade, and rounds of ammunition, creates a contrast to the humbly attired peasant woman. There are looks of concern by both embracers while the irregular chips of abstractionism consume the background. Combined, they form a unique contrast of style resulting in a rather forceful view of the trio of role-players.

After long and deep reflection on the war, David Fredenthal painted *Requiem* (1946).[9] The subject was a peasant woman weeping over her dead husband, whose body was confined to a

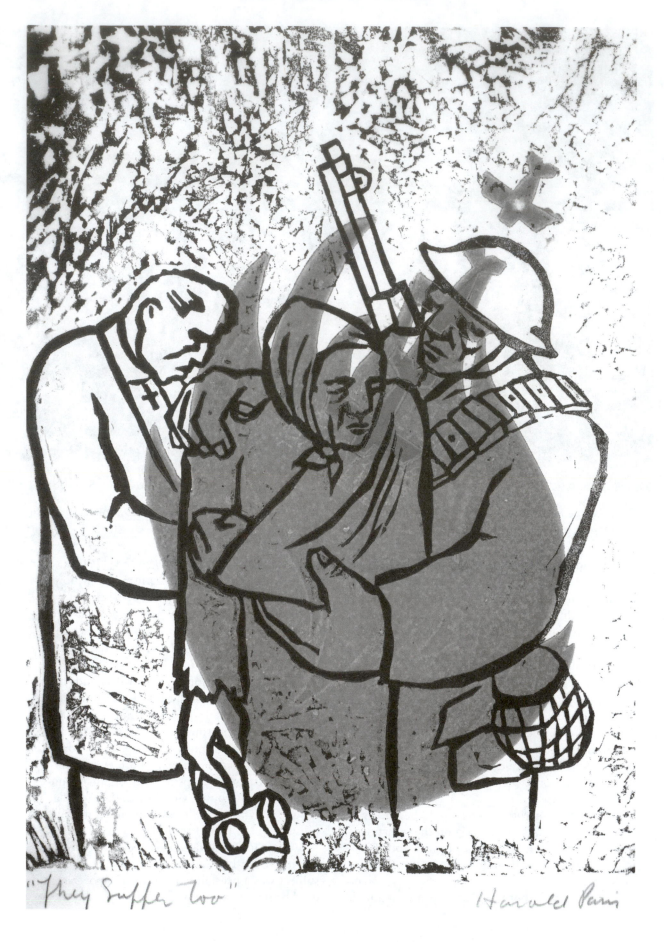

"They Suffer Too" Harold Paris

cheaply built coffin. *Requiem* is a composite of all the agony and misery of war. Fredenthal's work represents the grief of all families lost in battle. The skeletal forms underlying the rugged flesh tones are markedly pronounced as the emotional tears score the peasant woman's cheekbones.

A darkened hood covering the widow's head is shaped in an angular course of jagged lines. The grieving face and grasping hand collaborate to sustain a tumultuous moment. Although the grief may be momentary for special circumstances, it can also be eternally present. Fredenthal's portrayal is an everlasting reminder of the devastation of war and the effects that the war had on millions of humans.

Perhaps no other artist was as profoundly affected by World War II as was the German-American George Grosz. His biting satirical displays of life made him a prominent exponent of German expressionism, but his grueling and satirical exposé of the German regime led him eventually to American soil. An example of Hitlerism is witnessed in *A Piece of My World* (1935-36), his torrid, hellish portrayal of survivors wandering blindly through a forest of fiery remains of a demolished landscape.

Referring to this painting, he said: "In this world of mud ruins, shell holes and debris some men are trudging on like their own shadows, like ghosts. They are insane from fear, hopelessness, and hunger; shrunken, long before old age, by the power of fate and destiny. Trudging on, marching forever. They seem to follow a dark figure with a blank banner, a banner which represents nothing, is a symbol of nothingness. All the men carry memories of weapons. Full of fear that one day they may have to defend themselves, maybe against each other. There are hordes of rats. They are symbols too, symbols of the marcher's bleak thoughts tormenting them, remnants of a once sane conscience. The burning buildings and still smoldering ruins are dreams they can't forget in a world where actually nothing exists but fear and an idiotic marching behind a blank banner."[10]

Although seemingly chaotic in appearance, the painting demanded the highest degree of order to maintain its chaotic message. The exquisite details are reminiscent of the eloquent renderings of an Aaron Bohrod or an Ivan Albright. The patience essential to a highly explosive emotional rendering is truly a mark of distinction. Individual compositions overlap, run adjacent to each other, and interpenetrate to form a totally unique and complete arrangement of emotional segments of life.

The human figures enmeshed in an environment of ruins and destruction are survivors, but survivors with a blind and empty future. Grosz described his color approach: "My painting is dark reddish-brown, like dried blood; some greenish hues, like fungus; bluish-black, and vermilion, colors as in a cave not penetrated by the prismatic colors of the sun. For hell has a different light, a kind of phosphor glowing from within. This 'piece of my world' is related to the medieval backdrops of Bosch and Breughel. The darkness that was theirs has to be faced once more by us 'moderns.'"[11]

She Walks Among the Ruins (1947), a painting by Yasuo Kuniyoshi, depicts a lone woman, a survivor of World War II.[12] Highly subjective in its arrangement, the painting's symbolic notions emerge, suggesting self-determination. The artist did not identify the site or time of the event, but it was painted during the forties. Therefore, World War II is the obvious motivation for Kuniyoshi. Whether intended or not, religious overtones seem to emerge, and since several artists of the forties, affected by the terrorism and death created by the war, turned to the spirituality of life, it is conceivable that a cruciform was established through semi-abstractionism. The environmental landscape remained desolate from the war's destructive forces and in so doing diminished the hope of salvation.

In *The New Order* (1942), by the artist William Sharp, five condemned humans, although awaiting death, are survivors of the old order.[13] Pictured in the dramatically rendered lithograph the five convicted of nonconformity to the new form of government called German Nazism await execution. Sharp portrayed the five German citizens, whose only crime was to live according to personal consciences, awaiting execution like convicted murderers. However, they are actually victims and heroes, the martyrs of a lost generation. Sharp has resurrected the theme of Nazi propaganda and murder that prevailed during the war years of the forties. They were survivors for the moment and yet prisoners of their own country.

Opposite: **Harold Persico Paris. *They Suffer Too* (1944). Woodcut. 28 × 20.5 cm. Gift, Artists for Victory. Collection of the Library of Congress, Washington, D.C.**

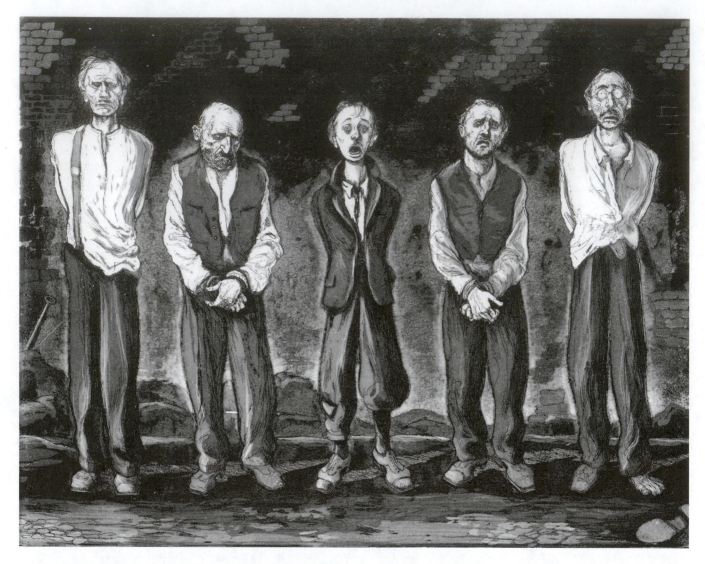

William Sharp. *The New Order* (1942). Etching and aquatint. Collection of the Library of Congress, Washington, D.C.

The new order had forsaken humanity as man had known it. Under Hitler, the new order became the demolition of the Jewish race and of those who were unable to qualify for the "master race."

Compositionally, Sharp skillfully alternated his victims of the German Reich, distinguishing one from the other and avoiding monotony by cuffing some of the victims' hands with rope in front of their bodies, others in back. Facial expressions of fear, agony, and despair accompany the weakened bodies. Each figure is attired slightly differently, to avoid repetition. Yet, there is a communion of thought, a oneness that supersedes any individual plea for mercy. The victims of the new German order are thrust at the viewer much like a police line-up. Only in Sharp's portrayal, the viewer is forced to react compassionately.

Praying Mothers (1945), an eerie but compas-sionate portrayal of mothers whose sons were killed in action, were missing in action, or were in danger of being killed, depicts the anguish of war.[14] The intuitive response is electrifying in its merging of finite and infinite figurative forms. Suggesting mummified angels, the artist Edna Reindel approached her theme of the devastation of the war in the abstract expressionist school. The mothers, with hands folded devoutly in agonized despair, remain unidentified. Reindel preferred to defer recognizable features and create a universal awareness of the shattering tragedy of death.

Wings seem to sprout from the figurative forms, symbolizing the eternity of life, the contin-uance of lost souls whose earthly existence will one day resurrect. However, Reindel's portrayal is a mere suggestion. *Praying Mothers* remains a cur-rent event that applies to the widowed survivors

of catastrophic proportions. Her approach is intimate and personal and subjectively thrust upon the viewer. There is no escape, either for the occupants of the painting or the participating viewers.

Praying Mothers is a drastic shift from Reindel's earlier work *Drilling Holes* (1943), which is discussed in Chapter 7. This is a personal and direct attack on the war and its overwhelming loss of human lives. Although Reindel served as a war illustrator for *Life* magazine during the war, it was her noncommissioned work that truly identified with the inhumanity to man, the total futility of mass murder.

Praying Mothers reflects the complete frustration and human drama of the war's effects on the human condition. Although the widows were not actual war combatants, they were nonetheless survivors. They lived through the sleepless nights and long days of fear and uncertainty, and even after the death of their loved ones, the tragic news continued to burn within their hearts.

Reindel sustained a vertical composition while swishing her brushstrokes in a circular fashion. Each individual female form is singularly fashioned, enveloped in gestures, not to offer suggestion but to identify with the anxious moments of individual mothers. Reindel's title, *Praying Mothers*, suggests a mood of solitude, an emotional state of meditative quietude, but instead one views a mood of anxiety, movement, and uncertainty.

The artist Joseph Hirsch used the effects of war to record the human suffering of a sole survivor in his painting *Air Raid* (1943). The expressionistic technique reveals a bandaged head wound, a mouth partially opened, and eyes gazing heavenward as they reflect the horrors of war. Hirsch's subjective portrayal is made more intense by the muted background. Aside from its thera-

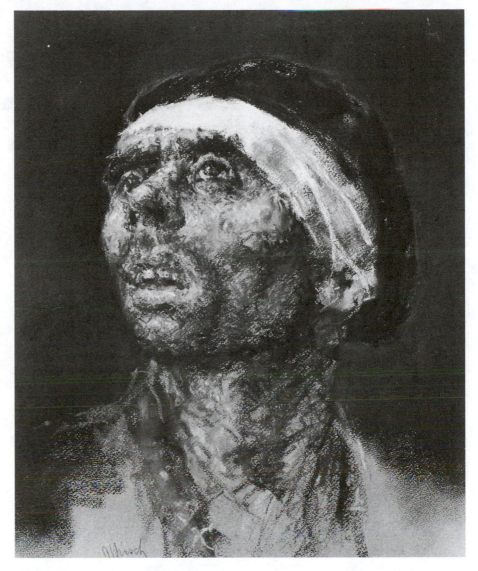

Joseph Hirsch. *Air Raid* (1943). Pastel on paper. 20 × 16¼ in. (50.8 × 41.c cm.) The Metropolitan Museum of Art, Gift of Pennsylvania W.P.A., 1943. (43.46.9)

peutic and physical benefits, the head bandage serves as a compositional device in corralling the viewer's attention to the significant eye glance of the victim. The rugged facial surface reveals the scars of war, leaving an indelible mark on the survivor. *Air Raid* is highly subjective and yet instinctive, as nervous brushstrokes identify flesh wounds and the muscular tone of a well-disciplined soldier of war.

Hirsch portrayed the typical American soldier under the most devastating circumstances. The portrayal may well be the result of personal observation or of recall, since the war was a significant stimulus for most artists of the early forties.

Ben Shahn painted a series of works picturing

Ben Shahn. *Italian Landscape I* (1944). Tempera on paper. Collection of Walker Art Center, Gift of the T. B. Walker Foundation, Gilbert M. Walker Fund, 1944.

the destruction and reconstruction of the European landscape after World War II. Several titles reveal the agony of lost loved ones. *Italian Landscape I* (1944) reveals female figurative forms contemplating the loneliness and despair amid the rubble of war destruction. A young mother with a child observes a coffin being carried from the ruins. Shahn's appropriate use of vast areas of emptiness adds agonizing drama.

A similar scene transpires in his painting *Italian Landscape II* (1944), in which a young mother searches the ruins of the rock piles. *Cherubs and Children* (1944) displays the homeless and helpless children orphaned because of the war. They slept wherever and whenever their tired bodies found a resting place.

Shahn's *The Red Stairway* (1944) reveals the aggressive nature of the war's destructive forces. *Reconstruction* (1945) exhibits a crew of workmen contemplating a structural plan while children use the blocks of granite as toys to be enjoyed as long as workmen allow their freedom. And finally, Shahn's master painting *Liberation* (1945) shows three children swinging freely on a rejuvenated maypole amid a war-torn village of ruins and destruction. Shahn's paintings are dramatic recordings of European scenes, but his deliberate distortions enable the viewer to

Opposite, top: Ben Shahn. *Cherubs and Children* (1944). Tempera on composition board. 15 × 22⅞ in. (38.1 × 58.1 cm.) Collection of the Whitney Museum of American Art. *Opposite, bottom:* Ben Shahn. *Liberation* (1945). Tempera on cardboard mounted on composition board. 29¾ × 40 in. (75.6 × 101.4 cm.) The Museum of Modern Art, New York. James Thrall Soby bequest. Photograph ©2000 Museum of Modern Art, New York.

Hans Kleiber. *In the South Pacific* (1942). Etching and drypoint. Collection of the Library of Congress, Washington, D.C.

envision the great depths of agony and despair that prevailed.

Mitchell Siporin, known for his sad farewells and moments of loneliness, executes a masterpiece of despair in his foreboding depiction of war refugees. In *Night Piece* (1946), Siporin exploits the inner emotions of the human condition under the most dramatic and agonizing circumstances. In a profoundly subjective revelation, three survivors are pictured staring aimlessly and dejectedly into the unknown. The displaced or dispossessed person is the subject matter. The three overlapping figures possess a fear of the future, ever-present and hauntingly real. *Night Piece* is a dramatic appeal to society for compassion as the refugees look to the viewer outside the picture plane. The clouds serve a dual purpose as they accomplish their usual service as a sky breaker but also act as a structural barrier sheltering the refugees from further attack.

Peppino Mangravite's *Celebration* (1939) is a reflection not of victory but of negative nostalgia.[15] Memories of war linger, but life continues. According to Mangravite, the loss of a loved one to the service of one's country is a personal loss and should not affect the whole of society. In *Celebration*, a table is laden with food and drink while

music is furnished by a clarinetist. People make love, others eat and drink, and one member of the group stands atop a cliff overlooking the ocean shore.

A peace dove nestles atop a pillar partially destroyed by the ravages of war. The entire affair is set amid the ruins of destruction. Remotely positioned, but nonetheless significant, are the endless rows of white crosses symbolizing the American soldiers killed in the perilous war. A naked tree anchored to the left of the celebrant symbolizes a remission of life, a temporary death, a hope that will one day bloom again into existence.

Atop the distant mountains are linear structures resembling huge crosses, remote but symbolic of the most humble and unselfish death of all. Mangravite's *Celebration* is a joyous picture, a painting of thanksgiving by those who remain to live life because of those who have not died in vain.

Maxim Kopf used the Madonna-and-child theme as subject matter in a war-torn European environment. Titled *The Star* (1945), the painting pictures a mother and child as victims of the German invasion of Czechoslovakia.[16] The war in Europe was a call for religion. The mother-and-child theme became a symbol of eternal life in the

midst of war's desolation. Inhumanity has been an ever-present motivation for the American artist, and when coupled with religious fervor, it forms a legitimate and often ideal artistic expression.

Requiem (1946), by David Fredenthal, is a distillation of all the tortuous agony and despair of war.[17] The artist used a single portrait of a grieving mother as the illustrator of war's anguish. His personal experience of witnessing a peasant woman in a crude cart became the stimulus for a religious experience. The woman became a universal symbol for total suffering from the experiences of war.

Hans Kleiber's dramatic etching *In the South Pacific* (1943) portrays a pair of survivors whose fate remains uncertain.[18] The artist depicted two American pilots forced to crash-land into the ocean. Their fighter plane, momentarily afloat, is surrounded by dangerous sharks as the fighter pilots fearlessly await discovery and eventual safety. Kleiber established a spatial visual connection between the survivors and a potential rescue. Aside from the dramatic composition surrounding the shark-infested waters, the artist proposed a seemingly insignificant gesture by focusing on a single survivor who visually scans the horizon in search of an approaching plane.

The simple inclusion in the sky of a dot resembling a distant plane presents the dramatic anticipation of survival. The situation is a drama without end. Uncertainty remains. The stirring drama is expressed in permanent artistic form for decades of humanity to observe, thus appreciating America's quest for freedom.

Far less dramatic, but poignant nonetheless, is Raphael Soyer's lithograph *Farewell* (1942). The artist stated his motivation as follows: "During World War II I spent many hours at the Pennsylvania Railroad Station in New York watching American soldiers going to war in Europe. I witnessed many moving scenes of soldiers bidding their mothers, wives, and sweethearts farewell."[19] A woman has bid farewell to a loved one enrolled in the armed forces. At the moment of departure, the woman becomes a future survivor of months of silent prayers that may stretch into years of agonizing fears of uncertainty.

Farewell is a portrayal of gentleness and endearment. Soyer presented a dual composition: the one that transpires in the background between two lovers, and the one that shows a mother whose son has already departed. The latter situation transports the viewer from the scene to an unknown destination outside the picture plane.

Endless Journey is an appropriate title for Mitchell Siporin's dramatic version of the Jewish flight to freedom from Nazi persecution and execution.[20] Painted in 1946, the work is typical of the social-protest paintings the artist created during the war. The drastically distorted facial and bodily features of the boatload of Jewish refugees highlight the anguished fate of the Jewish race.

Not only is the voyage forever in progress, but the number of refugees seems endless. Resembling the proverbial can of sardines, the war refugees are physically stuffed into an oversized, canoe-shaped boat. The surrounding environment is a murky darkness and mountainous waves of water resembling crests of stony hedges. It is a stagnant journey. Endless? Yes, with destination unknown.

Siporin greets the viewer with a compassionate plea for mercy and simultaneously presents a message of hopelessness. *Endless Journey* is a study of personalities, a horde of hapless creatures destined for an unknown world.

The artist George Biddle was noted during the Great Depression as a social realist. His murals depicting the disadvantaged became American memorials to the tradition of democracy, which claimed victims in spite of its freedom of expression and opportunity for success. This same concern furnished Biddle with subject matter during World War II.

His provocative work *War Orphans* (1944; see color section) records the profound anguish suffered by the survivors of the war. Left homeless in a world of turmoil, fear, uncertainty, and despair, are three barefoot orphans whose fearful future is registered in their faces. The stark images of the poverty-stricken subjects are lodged on a huge rock that is entrenched in a desolate environment of useless brush. The mountainous terrain adds to the terrifying circumstances that enmesh the trio of orphans.

Biddle included a muted background that forces the viewer to immediately acknowledge the orphans' plight. In addition, the traditional placement of figures gives strength to the humility of the trio and enhances the hope of mercy. Another form of survivors is pictured in Hans Mangelsdorf's *Tokyo Station* (1945; see color section). Had the war not ended, the survivors would have been prisoners. Soldiers, mothers, and children jam the railroad depot as the overlapped figures lead the viewer from the foreground to the background. No one figure is significant as the viewer weaves

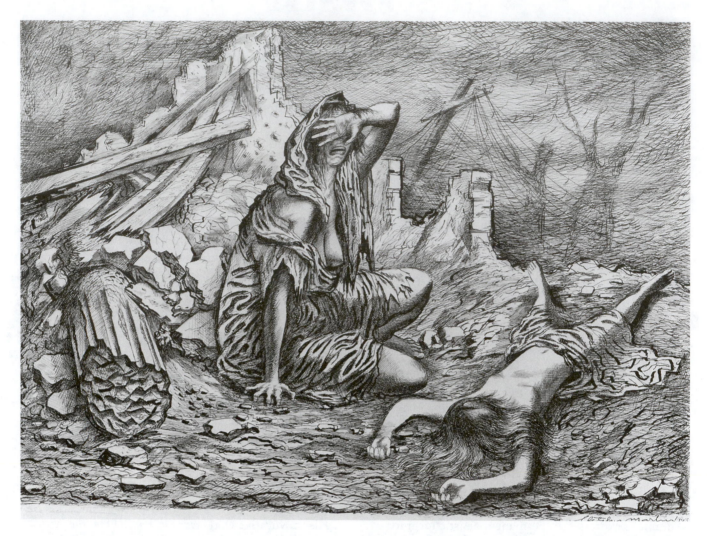

Fletcher Martin. *The Scream* (1943). Pen and ink on paper. 22 × 30 in. The Metropolitan Museum of Art, Purchase, Anonymous Gift, 1945. (45.33.5)

through the crowd of hapless Japanese soldiers. The crowd is a unit of individual personalities, each with secret desires but each a part of a humiliating defeat.

The locale or site of activity prevails but is displaced by the waves of Japanese soldiers and citizens returning to their homeland. Participants remain unidentified. Emotions have been drained from their bodies and physical movements radically curtailed because of the unexpected and insulting defeat.

A painter of the dramatic and the tragic was the American realist Fletcher Martin. His renowned works of the Depression decade were actually superseded by his passionate and provocative paintings of the war years. An example is his poignant painting of a lone survivor in pain because of the loss of a loved one. Simply titled *Next of Kin* (1944), the painting confronts the

viewer, whose reaction becomes an immediate emotional intercourse with the weeping widow or mother.

Totally neglecting facial expressions, the artist presented an intensely volatile situation, a visual drama created by a pair of hands, each of which displays emotional circumstances. The tightly clinched fist gripping a wrinkled death notice and the open hand pressing hard against her brow relate a tale of tragedy. A superb visual dialogue occurs between the two hands of the sobbing woman. The viewer's attention moves emotionally in vertical fashion between the two gripping hand gestures.

The emotional charge of the human condition is intellectually bordered by a rectangular vertical doorway, which seems to act as a symbol of released tension and, perhaps, hope for a foreseeable future. *Next of Kin* is a theme of ever-present

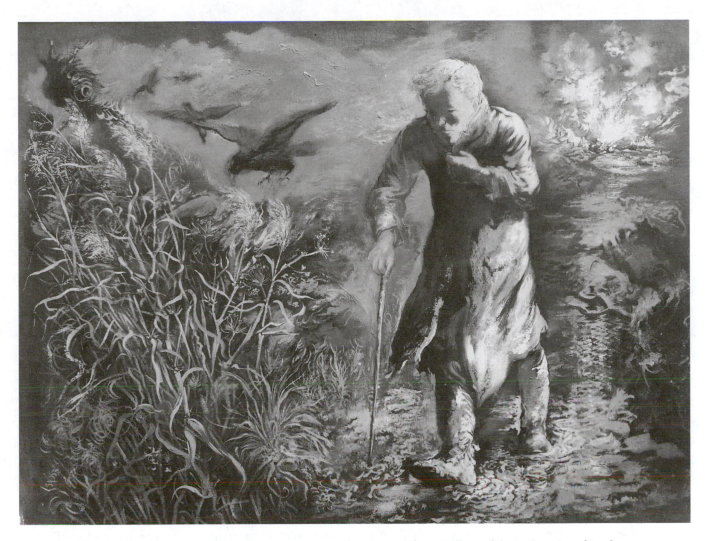

George Grosz. *The Wanderer* (1943). Oil on canvas. 30 × 40 in. Memorial Art Gallery of the University of Rochester, Marion Stratten Gould Fund.

universality. It is a suitable title for several situations and various circumstances. The vertical figure is dramatically reinforced by the strongly constructed entryway, which could also symbolize an open coffin. The circumstances surrounding the death notice strongly suggest the distressful mood of the victim. Martin's portrayal of grief also leads to speculation regarding possible suicidal tendencies.

A similar tragedy is evidenced in Martin's terrifying drawing *The Scream* (1943). A lone female figure mourns the death of her daughter, whose partially nude body lies motionless amid the ruins of war. There is a faint spiritual message in the image of a crucifix. Although it is a telephone pole, its fallen wires crisscross naked trees and evoke the image of Golgotha. The shrieking mother wails in agony as destructive forces continue to bombard the environment. The pen-and-

ink rendition allowed Martin to freely penetrate the depths of the human psyche. The lifeless body creates in the viewer a sense of finality. Yet, to enliven the expression, the artist granted the lone survivor life that may seem futile in any meaningful way. Martin has revealed the futility of war, the devastation and total destruction that reflects the end of time and the final day of judgment.

Martin's *Subway Sleepers, London* (1944) is a superb example of temporary survivors, for at any given moment bombs could disrupt their shelter and end their lives. The eerie atmosphere of bundles of human bodies forming a procession of restless images advances the drama of the Nazi aggression.

Reminiscent of Henry Moore's figurative approach to his sculpture and George Tooker's series of paintings titled *The Sleepers*, Martin's work portrayed a significant element of England's

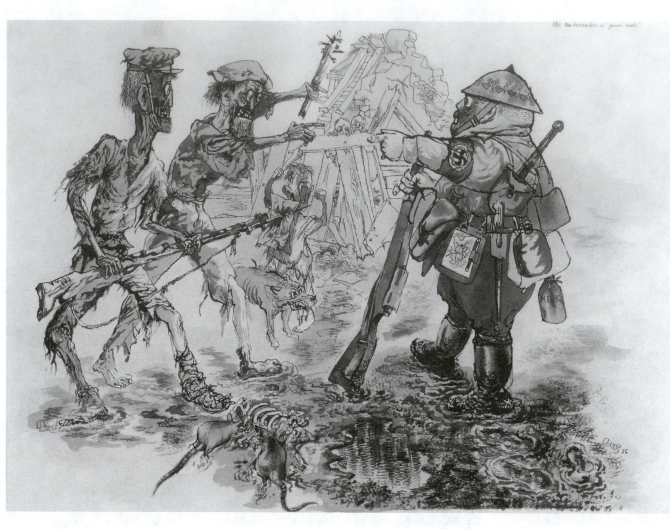

George Grosz. *The Ambassador of Good Will* (1943). Ink and watercolor on paper. 18 × 24 in. The Metropolitan Museum of Art, Gift of Mrs. Priscilla A. B. Henderson, 1950. (50.113.1)

stamina, determination, and courage against German's persistent bombardment of London. A single figure sits upright in Martin's painting, disrupting the sea of sprawling bodies. Martin thus created a point of departure from a strong diagonal composition and avoided the monotony of a single directional movement.

In another painting, the nonidentity of a human figure lying face down on a rocky shoreline illustrates the drama of Martin's style of approach. The compelling *Survivor* (1943) displays little evidence of its relationship to World War II, yet the date of completion strongly suggests that the survivor is dead after days spent on a raft floating the open seas. The lifeless body is an American soldier whose only identity is a tattooed symbol of a star etched into the body's hand.

In *Survivor*, Martin chose to amplify the figure and make it the subject matter. The sur-

rounding environment is the oceanside of reefs and threatening waters. The raft, which finally reached shore, floats partially under the water. Seagulls have begun to encircle the tragic event. The victim is physically distorted, enlarged to initiate a more powerful image. Although the title of the painting is *Survivor*, the viewer is left to speculate whether life or death is reality. It is the sense of uncertainty that provokes both the artist and his audience. Martin has set no solution. To exercise the right of decision would eliminate any speculation or interpretation. The excitement of determining one's own destiny in the personage of the subject matter is again left to the viewer.

George Grosz's painting *The Survivor* (1936) depicts an insane world, in which to survive would result only in the wish to die. His own comments reflect his personal attitude toward

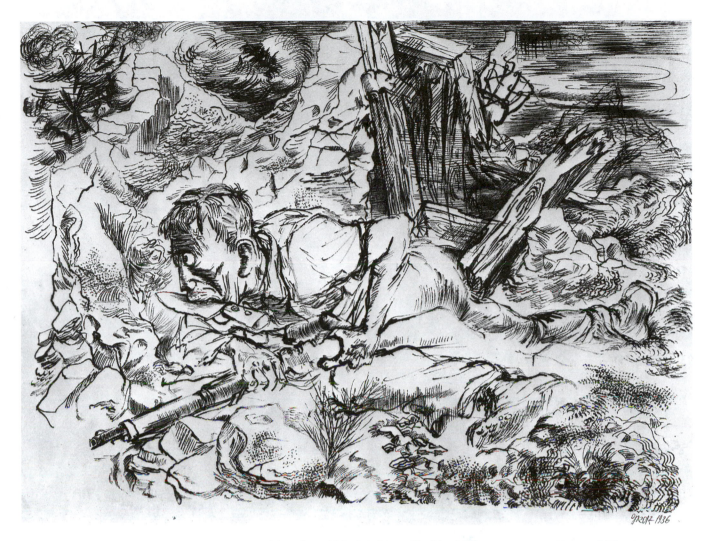

George Grosz. *The Survivor* (1936). Pen and brush and black ink on off-white laid paper. 48.5 × 63.4 cm.) **The Art Institute of Chicago, Gift of the Print and Drawing Club. 1939.311. Photograph courtesy of the Art Institute of Chicago.**

life but, more important, his artistic attitude toward potential subject matter. *The Survivor* has been called a "grotesque, horrible reflection of Europe."

Grosz's radical images have been considered at times to be self-portraits because of his search for the meaningful, the truth, and the spiritual enlightenment that seemingly eluded him. His German background and the Nazism reigning throughout Europe aided his perversive attitude and approach to life. He recorded the degradation and rotten atmosphere of social human activity. So in a sense, Grosz could be the survivor pictured in *The Survivor*. Trudging through the slime that surrounds the world, the lonely figure mushes through a debris of bombed leftovers. The human figure moves forward to a destination that doesn't exist. Grosz himself may well be considered a

survivor, since he described himself as pictured in *The Wanderer*: as a lost soul in a world without hope.

Even though Grosz was a survivor of Nazi Germany, he was also a prisoner of war in the sense that he was a prisoner of himself. It is difficult to distinguish between Grosz's survivors and prisoners. To survive the war meant freedom and to be a prisoner of war meant to be without freedom. However, from *The Ambassador of Good Will* (1943), *The Wanderer* (1943), *The Survivor* (1936), *Peace, II* (1946), *Waving the Flag* (1947-48), *The Battalion of the Hole* (1947), and *Homeward* (1947), the viewer is convinced that one is never free, or that Grosz has never been free of himself, that his own inner structure made him a prisoner not of the war but of himself. So, although he may have physically survived,

George Grosz. *Waving the Flag* (1948). Watercolor on paper. 25 × 18 in. (63.5 × 45.7 cm.) Collection of the Whitney Museum of American Art, purchase and exchange. Photograph copyright ©1996: Whitney Museum of American Art, New York.

emotionally and spiritually he was yet a prisoner. Death may have been a chosen alternative.

Of the previously mentioned paintings, *Homeward* relates the profound dilemma in which Grosz positioned himself. Although realistically portrayed, the autobiographical statement pertained to millions of Europeans who, had they survived, would have been ruptured mentally, physically, and spiritually. The crippled human figure heading homeward had become a shell of life — physically maimed, emotionally shattered, and spiritually empty. The environmental background of slashing brushstrokes reflects the ruins of bombed European nations. The faceless victim of what appears to be an intruder is typical of Grosz's subject matter. The universality of the victim, the deliberate omission of personality traits, becomes a personal autobiography in spite of the fact that the portrayal describes millions of other lost souls.

Even Adolf Hitler is portrayed as a survivor. In Grosz's provocative painting *Cain* (1944), the artist evokes an Old Testament character, and suddenly Hitler becomes absolved from his murderous ways.

Rationally, the two characters are utterly incompatible. The artist pictured Hitler wiping his brow in what appears to be a gesture of atonement while strewn about the fiery environment are heaps of human skeletons, flesh long integrated into the slimy earth's surface. The war aggressor is accompanied by his pile of sins. The hellish picture of Hitler is swamped by the skeletal remains of his countless victims. The fleshless creatures appear like ghastly insects clawing and fighting even in death.

Grosz's phenomenal painting *Waving the Flag* (1948) is a psychological recording of an image that doesn't exist and whose flag has no meaning in an environment that is nearing its end. There is doubt and uncertainty in the message given. It is a fragmented statement, a painting of endless meandering with little purpose. Yet the painting is a provocative image of the insanity of the German Fascist machine, of the total misdirection of the German people, and of the insurmountable confusion following the defeat of the Nazis. If the flag waver was a survivor, one must question the nature of the survival.

Survivors of World War II are surrounded by circumstances as varied as the personalities that they encase. Ben Shahn's various versions relate to orphans, widows, relatives, and friends. In *Cherubs and Children* (1944) he joined the real with the unreal, the human with the material. The sleeping orphaned children lie motionless against a dismantled environment. The viewer is led into the picture by the positioning of a strong marble rectangular wall, a favorite ingredient of Shahn's technical rendition of textural qualities.

This obsession is advanced in his compassionate portrayal of a surviving mother and child amid chunks of granite and marble of a dislodged and damaged hotel. Shahn's fascination with the treatment of architectural ruins is vividly exposed in his tragic yet poignant *Italian Landscape II* (1944). The war had devastating effects on the Italian landscape, but Shahn was challenged to record it artistically. Shahn abolished the grim features in favor of an optimistic future by fostering his personal style.

Shahn utilized two horizontal planes visually connected by the mother-and-child image. Yet, each horizontal habitat sustains its own textural nature. The segment of the European hotel contrasts with both environments in color and in texture. Shahn released the survivors, the tenants of the painting, from the immediate tragedies of the war and replaced them with hopeful signs of the future.

Another Shahn painting pictures survivors oblivious to the devastation upon which they seem to celebrate as if at a newly discovered playground. *Reconstruction* (1945) shows children playing among huge slabs of marble, the remains of a bombed city. Shahn utilized the scene to convert it into a challenging game of matching textures. Four children playfully balance themselves on the shiny surfaces as an American soldier in the background furnishes American goodies to another group of youngsters. According to the author James Thrall Soby: "The contrast between irreparable damage to ancient monuments and the gaudy self containment of the New World's packaged goods is quite possibly intended to have ironic overtones. If so, they are tender rather than bitter, and they confirm Shahn's faith in the inherent generosity of our people."[21]

Those artists who served during World War II were war correspondents commissioned either by the armed forces or by commercial agencies such as *Life* or *Fortune* magazine, or they were actively enlisted as fighters. Bernard Perlin was one of the latter. His painting *After the Ambush* (1944) is the result of an actual experience. The author Alexander Eliot described

Ben Shahn. *Reconstruction* (1945). Tempera on composition board. 26 × 39 in. (66 × 99.1 cm.) Collection of the Whitney Museum of American Art, New York. Purchase. 46.4.

Perlin's experience: "Bernard Perlin was twenty-six in the Spring of 1944, when he joined the 'Sacred Squadron,' a British-Greek commando unit, in a raid on the island of Samos. Falling into a German ambush which scattered the squadron, Perlin holed up with two other men in a mountain cave. For twenty-eight hours they huddled in the dark, listening to enemy search parties outside. Then by great good luck, they escaped back to their ship. *After an Ambush*, showing the painter himself tearing up official papers in the cave foreground, records his adventure in stark, nightmare fashion."[22]

The stark, domineering environment allows barely sufficient room for the survivors to hide. The surrounding mountainous terrain seems haven enough, even though the search parties are determined to discover their enemies. The richly endowed environmental structures helped to underscore the grim existence of the survivors. Perlin did more than express a personal experience. He relayed to thousands of viewers the fear of combat and the greater fear of losing individual freedom. The combination of cubism and realism became, in the hands of Perlin, a remarkable blend of styles that enhances rather than confuses the issue.

A compelling story is hidden behind the three figures in *The Garbage Collectors* (1946). The artist Edward Reep described his painting: "Whenever soldiers are in the field, children, old ladies, and nuns gathered about with empty containers, waiting to raid the garbage cans. There were times when eating before these hungry persons was next to impossible, and we would dump our plates of food directly into their pails. These three hungry *Ragazzi* stand in the recess of a doorway for food scraps. One wears an army helmet liner, a man's coat cut off short at the sleeves and sporting a Franklin D. Roosevelt Victory Medal, and a pair of outsize GI shoes. Two boys are smoking cigarettes found on the ground, while a third peers hopefully into a bucket."[23]

Edward Reep. *The Garbage Collectors* (1946). Oil on canvas. 24 × 36 in. Courtesy of the artist.

The children are arranged in a circular composition, with two appealing to the viewer; the youngest instead forces the viewer to acknowledge the bucket as well. The viewer is affectionately drawn to the three war children who have already shown evidence of resilience and independence. *The Garbage Collectors* is an unusual title for such a charming trio of youngsters.

The joy of liberation and the frustration of returning to a village ravaged by war are blended

Ben Shahn. *The Red Stairway* (1944). Oil on canvas. Courtesy of the Saint Louis Art Museum.

in William Gropper's lithograph *Liberated Village* (1945). Gropper displayed a bittersweet episode of a safe return to an unknown fate. Limited to the bare essentials, a husband-and-wife team and their young child peer in awe at their destroyed village. A second couple enters the scene from the distance, unaware of the forces of destruction that await them.

Gropper created a questionable communication between the victims of war and a posted communiqué; even though their lives have been spared, their futures remain bleak and seemingly hopeless. The artist muted the background in order for a meditative attitude to develop toward the unfortunate victims of war.

In a sense, *Liberated Village* presents a dual composition of anxiety in which anticipated action occurs within the spaces existing between the already arrived victims and the oncoming returnees and within the space joining the posted communiqué and the onlooking victims.

Liberated Village is an expression of pathos, a

sad commentary on the purpose of war. Victims seldom find reasons for such violent and vicious attacks on humanity. Gropper usually exaggerated his actions in his work in order to enforce his message. In *Liberated Village*, he merely recorded. There was no need to distort the savagery of war.

The viewer becomes a spectator rather than a participant. One looks at the scene and reacts emotionally to the symbolic imagery. In this sense, *Liberated Village* is an objective portrayal, since the viewer remains outside the action or, in this case, the reaction. Nonetheless, the viewer reacts emotionally to a scene of awesome destruction.

Ruth Leaf's etching *Tears*, a 1945 rendition of the grief of human loss, dramatically portrays the agony of war. Violence has been sidelined. It is the aftermath of violence that forces the astonishing view. The background is darkened, adding a psychologically terrifying fate. Leaf has systematically rendered a tactile reaction as each figure is faced in different directions.

The darkness of night, swallowing naked tree structures, deepens the unbelievable grief of the survivors. The enlarged hands of the grieving man cover the stream of tears. The adjacent woman, whose face is hidden from the viewer, is equally saddened by the loss of loved ones. The war has left the elderly couple hopelessly situated in a valley of tears. The grieving duo occupy the total working surface, so that disruption of the grief is impossible. The viewer is saddened by the victims' fates but rewarded by the compassion of the artist to her theme.

There is beauty in Leaf's masterpiece, beauty in an aesthetic sense, in the ability to shower profound sorrow onto a limited working surface of a copper plate with the medium of etching. The victims of war are not only the dead but also the living, who die slow deaths yearning for those lost in battle. Leaf greeted her audience with a compassionate version of an agonizing tragedy.

The Red Stairway (1944), by Ben Shahn, reveals the futility of war, the aftershock, and the tremendous waste of natural resources and the human spirit. A one-legged survivor of the war is shown at the base of an uphill stairway, steps that lead upward to nowhere and downward to an unknown destiny. The linear stairway is rendered in a flaming red, creating a central focus for the viewer. The fallen victim, surrounded by material destruction, remains to courageously continue life in a manner heretofore unfamiliar.

Shahn's portrayal is one of textural qualities and inventive composition. The viewer is forced to accept the ruins of war and the despair that ensues. Although enveloped by destruction, a lone figure is shown collecting the material remains of the ravaged village. The strong diagonals are counterbalanced by circular window frames and vertical concrete pillars, and although monumental in appearance, it is the human factor that communicates the message of the artist.

There is a sense of infinite despair as one views the distant horizon and the extent to which the desolation and destruction occurred. Visual perspective is enhanced by the unusual composition and the appropriate placement of the two human figures. Lumps of refuse and piles of shattered hunks of concrete are not logically positioned but are rather placed according to compositional needs.

Even though the captive performance occurs within a rather small, horizontal segment of the whole, it was essential that Shahn expand the environment in order to emphasize the significant aspects of the role-players. The window frames of dismantled structure shaped like cathedral windows are darkened, reflecting the loneliness of an empty church.

And it is conceivable that the ruins witnessed in *The Red Stairway* would not have been portrayed had Hitler believed in a divine being.

Shahn's work, particularly his war paintings, expressed hopelessness for the future. Never was hope or faith indicated, not that Shahn lacked in spiritual faith but that war held no hope for those intimately involved in the intensity of battle. Shahn recorded the past and the present. Eternity of life was of another dimension, and although spirituality and prayer became immediate referrals when death approached, life itself, not life hereafter, was more significant at the moment of the creation of the art. *The Red Stairway* reflects no spirituality. Human existence seems hopeless. Pity, rather than peace of soul, seems appropriate for Shahn's occupants of the war ravaged landscape.

Shahn was profoundly concerned with the effects of war on the human condition. It is difficult to portray spiritual hope within the presence of intense suffering and agony. But Shahn recorded the evils of war so vividly that acknowledgment of its devastation may, one hopes, lead to a future less dangerous to humanity.

A switch of scenery is evident in Agnes Tait's memorable lithograph of survivors in the South Pacific. *The Survivors* (1945) has a spiritual quality reminiscent of versions of Christ's flight into Egypt. It is an obvious circular composition aided by the mountainous terrain and watchful birds that act as alert bodyguards to the boat of survivors.

Tait focused on the safe arrival of grieving victims of war. A young child is helped out of the boat while others, including a mother and baby, patiently await their turns. On the shore is a young couple, hurriedly and anxiously awaiting the survivors' sure footage onto a haven of security. *The Survivors* is an expression of the unknown, a future of fear and hope. The artist cradled the survivors in what appears to be a safe island community. Nestled along the coastline and amid mountains, the villagers occupy time with routine chores.

The viewer becomes a participant in the rescue mission because of the close proximity of the action to the viewer. One is tempted to mentally

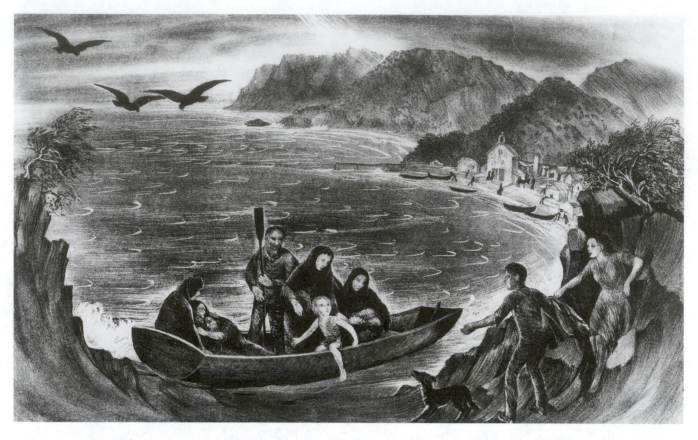

Agnes Tait. *The Survivors* (1945). Lithograph. 25 × 40.5 cm. Collection of the Library of Congress, Washington, D.C.

reach out to assist in the flight from the war. The swooping, arc-like foreground is moderated by the presence of the human survivors. *The Survivors* is an excitable expression because of the anticipation of action that seems inevitable. One does not sense permanent safety but rather a temporary departure for a locale unknown.

The lithographic process serves well the theme, and the composition is unique in portraying anticipation and anxiety. Highlights and shadows are technically employed, suiting compositional needs rather than utilizing natural sources of light. The contrast of dark and light is associated with the circular composition that forms the major pattern of excitement. The placement of the boatload of survivors is ideal in that immediate focus is placed on the prominent subject matter. There is a tenderness, a love of life, existing in space; that is, the visual distance between the boatload of survivors and those already on land is activated by the intense anxiety. The viewer waits patiently for the safe unloading and the final secure resting place.

But it is the artist's intent to emotionally sustain the uncertainty of an event in order to

control the intensity at hand and transfer that emotional tone onto a flat working surface. The emotional reaction experienced by this viewer is hope, although fear and anxiety are also present.

Quite different in both composition and medium is Misch Harris Kohn's color lithograph *Survivors* (1943). Ten survivors sit quietly in a boat, awaiting uncertain fates. The expression has a gesture-like application of color that tends to dictate a sense of action to an otherwise quiet and somber situation. Clouds rush across the background as segments of sunlight line the horizon. The composition lacks the sense of loneliness that usually accompanies lost boats at sea. Instead, the artist created a rough sea that avoids the image of infinity generally associated with the expanse of the ocean.

The artist has presented his survivors as victims of the unknown. *Survivors* is a simple composition, a direct statement with a positive intent to avoid extraneous objects that would disrupt the flow of attention. Brushstrokes are briskly applied, creating a sense of rough waters even though the survivors appear to be moored in stillness and facing inevitable death. Kohn did not extend hope

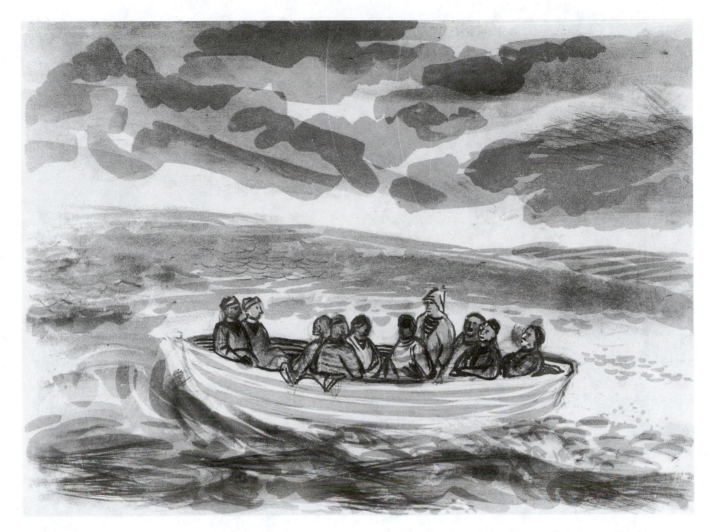

Misch Harris Kohn. *Survivors* (1943). Color lithograph. 21.6 × 34.8 cm. Collection of the Library of Congress, Washington, D.C.

for his victims, and so one waits; the viewer becomes a sympathetic spectator to a scene that has no answers.

Freedom from Want, a linocut by the artist Hilda Katz, was executed in 1942. It pictures a mother and her naked child struggling against the odds of Nazism. The dramatic scene of humans against the bold extension of the Nazi sword is characteristic of Hitler's crusade against mankind.

Freedom from Want is a strong statement of the evils of German aggression. The total disregard for the human body and soul is evidenced by the symbolic swastika and the piercing Fascist sword that splits the artistic expression into diagonal halves.

The darks and lights form a stark contrast between the human condition and the background environment. Included in the environmental habi-

tat are several grains of wheat, suggesting a glimmer of hope or a reminder of what used to be. There is an abstract quality to *Freedom from Want* because of the juxtaposition of both human and material objects. Visual perspective is totally ignored as objects are positioned on the frontal plane. Likewise, both recession and advancement of objects are forsaken because of the use of only black and white.

There is a loss of hope exhibited by the human beings due partly to the division of space created by the Nazi sword and also to the lack of tonal nuances that would symbolically represent options and degrees of freedom.

My Brother's Keeper (1940), by Merritt Mauzey, is a threefold rectangular composition in which each segment of subject matter is carefully considered in terms of a protective enclosure. The title itself indicates a sense of dependency. Amid

Merritt Mauzey. *My Brother's Keeper* (1940). Lithograph. 26 × 29 in. Collection of the Library of Congress, Washington, D.C.

the ruins of a war-torn village are two young survivors positioned before a razed structure serving as a doorway to the landscape beyond. A church, also hit by war's devastation but seemingly serviceable, seems to beckon the young, barefoot couple. Beyond the church, the environment appears endless, as if the world was destroyed and all that remained was the young couple.

Special care is attended to the detailed brick formation of structural remains. The artist has echoed the brick wall partitions throughout the expression. Wooden supports are appropriately placed to accent particular areas of the expression. The woman at first glance appears to be a young girl cradling a baby bundled in a thick, warm blanket. The viewer thus sees the trio as the trinity of Christianity. There is no escape for humanity, but Mauzey placed a haven of safety, at least temporarily, for the young family in the image of the distant church.

There are mundane objects strewn about the

Opposite: Hilda Katz. *Freedom from Want* (1942). Linocut. 26 × 18 cm. Collection of the Library of Congress, Washington, D.C.

foreground with little significance, except perhaps for the purpose of promoting interest within the total composition. Mauzey tempts the viewer to look beyond the frontal plane, to an event occurring outside the picture plane. As the viewer glances to the right of the lithographic expression, the vision is suddenly halted by a protruding piece of lumber purposely placed to beckon the spiritual atmosphere of the church in the distance. The barrenness of the scene is heightened by the appropriately placed naked trees that remind the viewer of the Crucifixion.

War as subject matter has fascinated the American painter for decades. Brutality appeals to the psychological nature of the artist, but more appealing are the moments of joy following the tragic events of combat, those ever-present glorious days of victory, and the romantic nostalgia that would remain with the American GI for years to come.

The purpose of this chapter was to record artists who related the war and its effects on the human society, especially on those survivors who had to relive the horrors of battle.

Survivors of World War II suffered emotional reactions in varying degrees and in varying intensities. The deaths of loved ones were forever etched in the memories of those mourners, whose only consolation was that those who sacrificed their lives would never be forgotten and would aid in the preservation of democracy in America and peace throughout the world.

CHAPTER 4

Prisoners of War

The prisoner of war was an ideal theme for the American artist during World War II. Jacob Lawrence was noted for his artistic expression of the downtrodden and the unfortunate. About his painting *Prisoners of War* (1947), the author Barbara Chapin said: "Ribbons of wire stretch from border to border across the face of the painting, enclosing a motley group of male figures — variously stoic, mad, lost — as in his previous works, cut off from the world and each other by intangible lines whose existence they do not even really recognize."[1]

Lawrence's prisoners have no escape. The barbed wire surrounding the anguished victims is systematically arranged to ensure an ironclad means of security. Yet its precise presentation enhances only the decorative pattern while diminishing the drama of the event. It is a case of symbolism overpowering the subject matter. Nonetheless, *Prisoners of War* projects a compelling rendition of World War II.[2]

Were the artist to rid the painting of barbed wire, the prisoners would be free to go, so to speak. And were Lawrence to disrupt the continuity of the fencing, an escape hatch would appear, allowing hope to exist within the hearts of the war victims. Each sharp barb is a single link to a rhythmic pattern that coincides with the vertical postures of the prisoners. However, Lawrence appropriately painted the anguished faces in full view, thus avoiding interference from the stylized barbs of the wire fence. Because the barbed-wire fence spans the multitude of prisoners, a second environment was established. The fence separates the prisoners from the outside world. This second environment relates to a life that remains unattainable. This second environment is abolished only after the wire fence is dismantled. The barbed-wire fence clearly blocks the road to freedom.

The artist George Biddle has recorded the reaction of a German soldier captured by American troops. The surprised and quizzical facial expression of the German prisoner in Biddle's painting *German Prisoner on Monte Cesima* (1943) overshadows the dead soldiers lying nearby.[3] The environment reflects the destructive forces of battle. Naked trees are scattered throughout the landscape. Biddle was noted for his portrayal of elongated figures, but in *German Prisoner on Monte Cesima*, his subject is presented as a plump, idiotic image whose clothes are larger than his physique. He is pictured as a buffoon with big feet and with clothes fit for a clown. The painting became a source of joy for the artist while using the freedom of expression to satisfy personal instincts.

Robert Benney's portrayal *The Residue of Defeat on Saipan* (1947) illustrates the profound agony of war. Amid the intensity of battle, grieving mothers bear the death of their children. Some are led blindly to dens of temporary safety. Graves

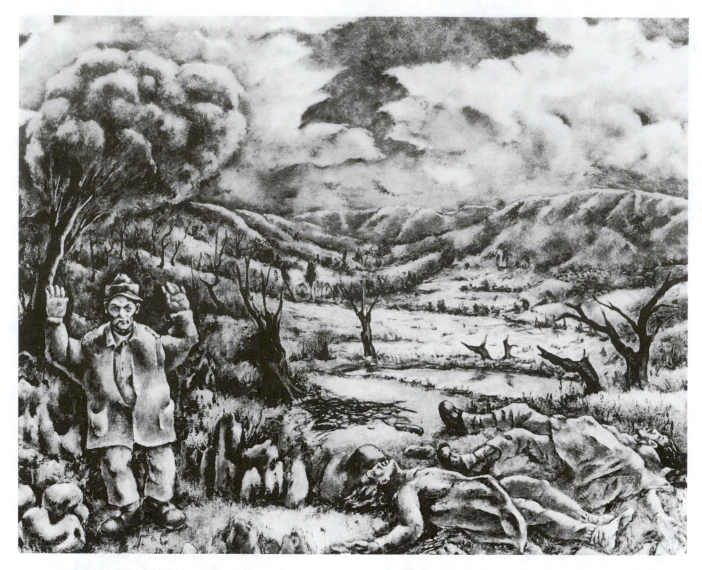

George Biddle. *German Prisoner on Monte Cesima* (1943). Oil on canvas. 40 × 50 in. Army Art Collection, U.S. Army Center of Military History.

are prepared for the dead while stretchers are readied for the wounded. These victims are civilians caught in the midst of bombings of their villages and cities.

Benney has made a dramatic statement — the blind male grasping at the air for aid and others barefoot and half-naked, stumbling across the rocky terrain for shelter, food, and medical assistance. The artist has depicted an emotional scene, a compassionate reaction of American troops to Japanese civilians. The viewer perceives the futility of aggression, the human weakness of greed and power, and the inevitable result of countless deaths and loss of loved ones. Benney's account of the scene is as follows: "During the battle, there was a constant flow of prisoners toward the rear areas. Our planes had dropped leaflets asking

them to surrender and specifying certain landmarks where they were to be picked up and conducted to places of safety. There, the disabled were placed on trucks and other vehicles and taken to the compounds that had been prepared for them on the southern end of the island.

Almost every one of the prisoners required medical care; many had been living in holes and caves and were starving. Others had terrible wounds inflicted by their own soldiers who had tried to keep them from giving themselves up, and many were wounded by our own fire, which preceded our landings."[4]

Jungle Surrender on Guam (1947) is a painting of American tank troops capturing Japanese soldiers in the hot, humid jungle climate of the South Pacific. Dense jungle foliage surrounds the

American tank soldiers and the captured Japanese prisoners. George Harding's painting is as densely populated as the jungle itself. The artist has crammed activity onto an already crowded environment. One seeks an entrance to safety, an opening of the jungle atmosphere, or a road to freedom. Psychologically or compositionally, no such escape is introduced.

Harding focuses on the actual capture by placing the enemy well within the picture plane and surrounding the captured victims with American troops. The densely populated jungle, with its overlapping trees and shrubs, does not allow the viewer a rest area, and yet, the artist has portrayed the reality of the scene. He explained: "The M-4 Series tank was used in the Pacific island campaigns to attack strong concrete defense positions and to wipe out machine gun emplacements on the edge of air fields where the Japs fell back into concealment of the jungle. Many improvisions and modifications were made by tank battalions during combat operations. Hatch screens were adapted after Tarawa, where the Japs threw hand grenades into open hatches, and were first used by marines at Saipan. Another innovation first used at Saipan was ventilator and exhaust screens to permit tanks to operate in deeper water in crossing reefs when landing from the tank lighters. Wood planks were secured to the tank sides, safeguarding against magnetic charges. Nails were welded on the top surfaces of hatches for the same reason."[5]

In *The Last Walk* (1943), grotesque German soldiers with fixed bayonets encircle a group of Czech prisoners while forcing them to inevitable deaths. The wood engraving by Hans Jelinek pictures distorted physical bodies of the German aggressors, who show little mercy toward the captured Czechs. Jelinek described this work and his purpose behind it: "When in the beginning of the war the Czech village Lidice was brutally annihilated by the Nazis, I was horrified as well as desperate, feeling my own inability to do something about it. Then one night it came to me that an artist could also contribute to the bitter fight if only with a piece of wood and a graver. The same night I made all the sketches for a series of engravings illustrating the sad story of Lidice. I believe that a work of art can still be art and also carry a message to the people."[6]

In *Recent Guests of Japan* (1945), the gaunt, emaciated bodies of American soldiers held as prisoners by Japanese forces are vivid examples of the cruelty inflicted on the human condition. In the background is an American Red Cross logo, identifying the presence of American medics and nurses; these soldiers have come home.

Standish Backus' painting reflects the torture and cruelty inflicted on American prisoners of war. The full front view of one American POW is a daring procedure offered by the artist to show the horror of war and, equally important, to reveal the inhumanity of the Japanese armed forces. The starved, elongated features of the human pictured in Backus' painting border on surrealism. Reality beyond the boundaries of its own definition verges on surreality.

Recent Guests of Japan is a subjective painting with enough secondary figurative forms to amplify the significance of the scene. Backus has confined the circular forms of the human body with architectural structures of the indoor environment. Yet, in spite of the several potential disruptions of distant figurative forms, the pathetic human creature occupying the foreground demands immediate and consistent attention. Backus successfully alerted the American public to the aggressor's inhuman tactics during wartime. In a sense, *Recent Guests of Japan* is a disgusting revelation. The painting succeeds in recording wartime concerns for the human condition. The rights of a government overshadowed the rights of human life. Backus' portrayal places the medium of art at a high priority by recording and displaying the rigors of war.

The artist William Gropper was a social realist. His biting satirical cartoons gained him worldwide fame. His lithographs and paintings were equally provocative and gave rise to antiwar demonstrations and protests against the German invasion of European nations. His painting *The Invaders* (1942) captures the fear of imprisonment and possible death.[7] Backed up against a rocky blockade and facing threatening bayonets are four innocent war victims whose only crimes were attempts to flee their native country.

Gropper has created a tension between the aggressor and the victimized. The four tremble with fear as the mother shields her child from the German aggressors. The human forms are anchored into the ground as if mired in a tired landscape. The enemy soldiers themselves appear weary and subsequently suggest the safety of the invaders. Gropper's ability to establish the anticipation of an event yet to occur marked him as an artist of intense control. A tragic event is foretold.

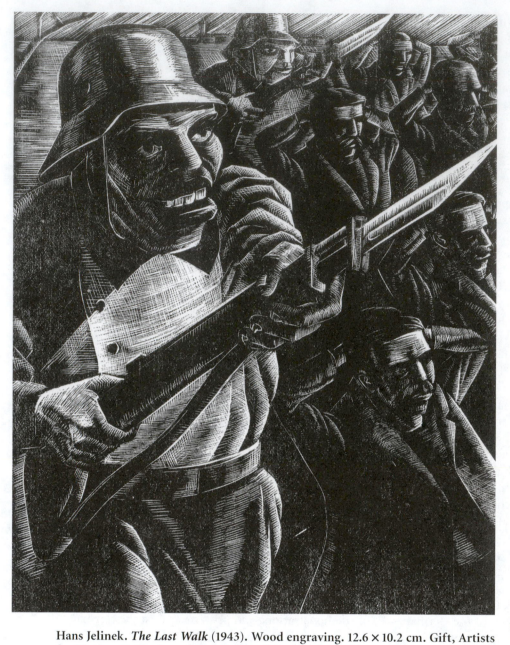

Hans Jelinek. *The Last Walk* (1943). Wood engraving. 12.6 × 10.2 cm. Gift, Artists for Victory. Collection of the Library of Congress, Washington, D.C.

capped. Simon has varied the physical positions of each of the six POWs embraced in the painting and in so doing has accentuated the human deformities suffered from enemy fire or Japanese torture.

The overlap of figurative forms creates a unit of suffering and anguish. The viewer shifts from one tragic figure to another, each displaying mental and physical ailments of major proportions. *P.O.W.'s* is one of Simon's most powerful and terrifying images, one long to be remembered.

Joseph Hirsch, with his lithograph *Watcher* (1950), made World War II a personal adventure.[9] After serving as a war correspondent, he surveyed the past and introduced his audience to ambiguous situations. *Watcher* is such an expression. The eerie, foreboding presentation invites speculation as to the purpose behind the work. Hirsch purposely avoided definition, but the figure could be a victim of war, a prisoner, an American soldier, or the enemy. The segmentized figurative form creates a haunting atmosphere, and one is forced to speculate and to adapt the figure to an outsider's reaction. By presenting a mystery, Hirsch has established opportunities for subjective reactions by his audience. Thus, the message to be communicated is interpreted by the receiver rather than the sender. The receiver might accept the partially hidden human form as a prisoner of war.

Marie Wilner's *The Devourer* (1963) is a terrifying image of death reminiscent of the millions tortured during World War II by the German

It is the excitement of anticipation that makes *The Invaders* such a provocative painting.

A ghastly portrayal is witnessed in Sidney Simon's painting of American prisoners in a Japanese prison camp. In *P.O.W.'s* (1943), the gruesome display of human flesh reveals Americans whose bodies are physically tortured both by mental exercises and by starvation.[8] Gaunt, emaciated bodies seem helplessly immobile. Facial features reflect fear and uncertainty. The future seems bleak, and futility reigns for the prisoners. Those too weak to feed themselves are fed by comrades, and even they are physically handi-

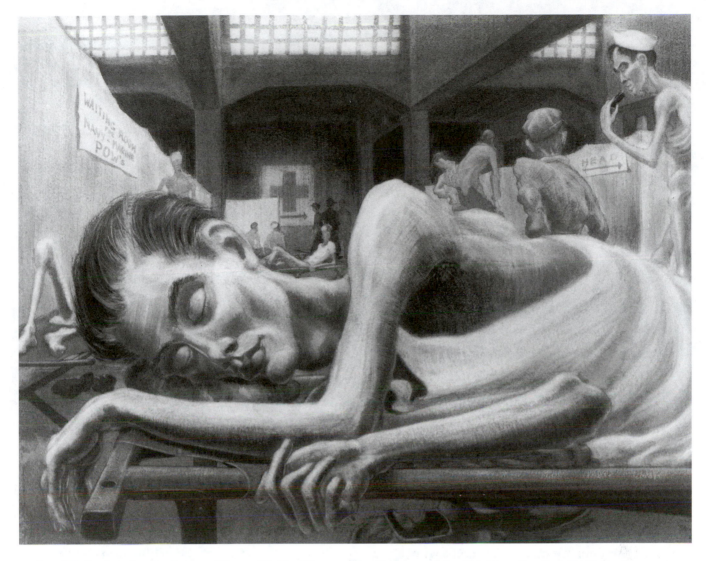

Standish Backus. *Recent Guests of Japan* (1945). Oil on canvas. Courtesy of the U.S. Navy Combat Art Collection, the U.S. Naval Historical Center.

Gestapo.[10] The holocaust was an unbelievable mass murder, and Marie Wilner's painting emphasizes the lurid imagery of consuming death. Naked figures enmeshed in the bowels of the earth reach frantically for physical support but reach in vain as the mass of indescribable matter swallows up all signs of life.

Wilner's devastating imagery is executed in an abstract expressionist manner, in a sense resembling a child's finger-painting. But a close scrutiny reveals the grotesque figures manipulated upward in a seemingly chaotic movement, in a frenzied sense of losing one's sanity while attempting to survive. The emotional impact alone is an emotional shock to the viewer. The gruesome aftermath has made prisoners of innocent victims, but Wilner's painting is a protest not only of World War II but of all violence stemming from man's search for power.

Segments of nude bodies are scattered throughout the environmental background. However, there seems to be no distinction between the foreground and background. The naked bodies and bits of flesh have blended into the habitat to render a stunning image of frenzy and tragedy. Although life persists, death is near. There is no escape. Prisoners grapple for life, but the stretch for freedom seems endless.

Edward Reep's painting *An Italian Town Surrenders* (1945) is an exquisite rendering of the human figure. German soldiers surrender to American troops rather than face the partisans. Buildings are still intact but are shifted at different angles to dramatize the environment. Even the

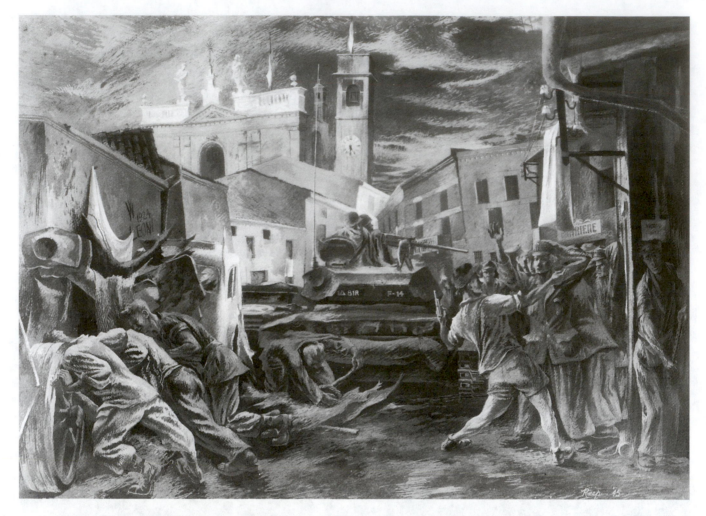

Edward Reep. *An Italian Town Surrenders* **(1945). Goache. 20½ × 28½ in. Courtesy of the artist.**

sky, seemingly remote in its occupancy of space and distant placement, is dramatically rendered. Several compositions converge onto the foreground. Minute aspects of the physical world are incorporated to ensure continual excitement throughout the painting. The artist described the painting as follows: "This painting was created from dozens of careful sketches made during the hectic moments of entering the town of Leno. It depicts our men aided by partisans, rounding up German soldiers and clearing the streets. Our tanks, draped with large, fluorescent orange banners to identify them to our aircraft, lend a spectacular note of contrast to the omnipresent olive greens, somber earth colors, and stark white flags of surrender."[11] *An Italian Town Surrenders* is a remarkable composition of detailed aspects of a World War II event. No area is left inactivated.

John Ward McClelland's reactions to the atrocities of World War II are witnessed in his tragic scene of victims imprisoned. *Imprisoned*

Outcasts (1943) is a rendition of human dignity lost and forsaken and the probability of insanity soon to embellish the prison walls. A single ray of light renders no hope for the captives, who no longer belong to their native country. Each human figure tells its own tale of woe. Some hang their heads in despair while others pray for divine guidance and spiritual wisdom. There is no compromise in McClelland's display of human degradation. Yet in spite of the hopeless circumstances, one senses a divine revelation soon to occur.

McClelland's prisoners face the viewer except for the lone figure clinging to the iron barred window that prevents their freedom. The composition is a consistent overlap of human emotions. Frustration, despair, fear, anxiety, and the agony of the unknown are evident in the faces of the captives.

McClelland has carefully arranged his human figures in an orderly fashion as if each were assigned to a unique space that became their entire world. The basic horizontal design of

human beings is counteracted with a few vertical tactics—the wooden ladder that leads nowhere, the vertical pillar that tends to divide the prisoners, and the iron bars that define the prison environment.

McClelland's dramatic display of human suffering beckons the viewer to enter the scene. The viewer is indeed a spectator of the occupants, who hope, pray, and wonder. Facial expressions reveal the despair and agony of the war. The victims appear numb and hopelessly caught in a web of inevitable death. The artist has focused on hands and faces to express his message of grief and sorrow. Newly born babies and young children have not been spared. It is a tragic scene, and the artist has made it an endless congregation of war victims even though the viewer is treated to a mere segment of the total group of imprisoned outcasts.

Although each tragic figure is carefully and individually portrayed, the common bond existing among the victims creates a subjective imagery. The prisoners are no longer a lineup of forgotten and neglected human beings but form a team of innocent subjects whose joy will reign in the eternal life. For one cannot expect freedom for McClelland's victims of war. His victims seem resigned to sentences of death. The viewer may only speculate, but it is this uncertainty that has created the anxiety that cannot free the viewer from the despair of *The Imprisoned Outcasts*.

CHAPTER 5

The Ruins of War

No other American artist has portrayed the ruins of war more devastatingly than the German transplant George Grosz. His astonishingly dramatic painting *The Juggernaut* compels the viewer to witness and then rebel. Perhaps the artist explained it best: "My painting is the subconscious realization of the futility of all war rather than a specific picture of any one event in any one war. I have tried to paint the unending mud in all its horror, full of the diseased debris of war. The foreground is like a draining abscess, as though the earth were trying to rid itself of the contamination of war. The tank is the juggernaut of the god of war rising out of the filth to crush beneath its treads what life may still remain in the broken bodies caught in the mire. The fire in the background might be a blaring ammunition dump or a flaming village, symbolizing the flames of destruction. In the shattered building at the left, the remnants of a bedstead and a mirror on the wall show that the innocent suffer as the combatants."[1]

Grosz was a realist who recorded life in its most blatant and graphic fashion. The result of war is usually nothingness. Innocent victims are swallowed up by the power and greed, as witnessed in *The Juggernaut*.

Although less dramatically, the ruins of war are also revealed in Ogden Pleissner's painting *Tank Breakthrough at St. Lo.* (1947). American troops are pictured surveying the destruction of the city. Pleissner described the painting as fol-

lows: "St. Lo., a strategic rail center fiercely defended by German paratroopers, corked up the Normandy bottleneck for almost two months. On July 25, 1944, the combined strength of the Eighth and Ninth Air Forces, numbering 3,000 planes, was hurled against this town. After one of the most terrific bombing operations of the war, our ground forces pushed through the German lines and swept across France. I went into St. Lo. immediately after it was taken, and this painting depicts the Sherman tanks of the First Army moving through the dust and rubble of the once prosperous Norman city. In the distance, on the citadel, stands the one remaining spire of the cathedral. St. Lo. goes down in history as a great battlefield."[2]

Havoc in Hawaii (1945), a lithograph by Alexander MacLeod, depicts a scrap heap of demolished airplanes caused by the bombing of Pearl Harbor.[3] The focal point is the remains of the surprise attack. There is no deliberate distortion, only a rearrangement of subject matter in order to suit the artist's attempt at a total and complete composition. Iron scraps are strewn about the environment. A slight glimpse of sky is witnessed in order to identify locale to be established.

Havoc in Hawaii differs considerably from Grosz's *Juggernaut* in technique, composition, color, and emotional interpretation. Grosz's human concerns were directly influenced by his

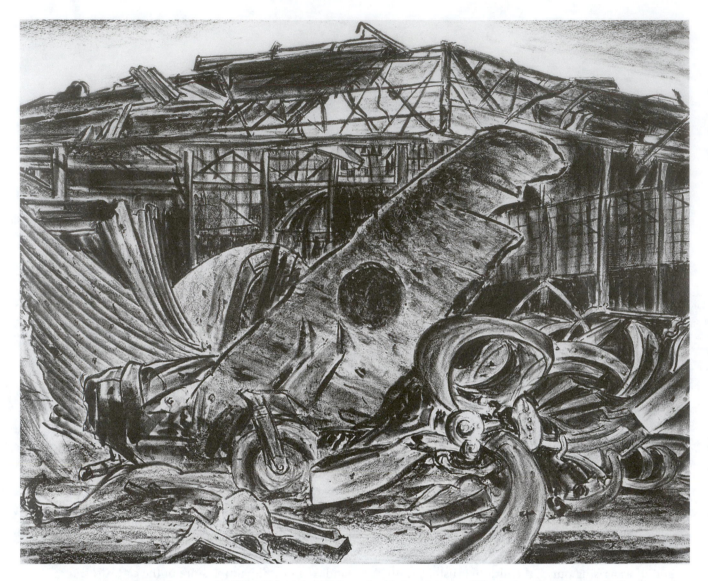

Alexander MacLeod. *Havoc in Hawaii* (1945). Lithograph. 43.6 × 35.4 cm. Gift, Artists for Victory. Collection of the Library of Congress, Washington, D.C.

German rearing under the dictatorship of Adolf Hitler. MacLeod's lithograph is a factual and visual recording rather than a psychological study or emotional reaction to the scene. It is a true statement, a direct response to a visual happening.

In *Cleanup on the Road to Tokyo: Philippines, Spring 1945*, smoke continued to spiral heavenward from the fires ablaze in the distance as an American crew ventured onto Clark Field.[4] The airfield had taken its first bombs when the Japanese attacked in December 1941. This exquisite rendering of death and destruction is detailed in bits of scrap metal scattered about the terrain. Broken human bodies also constitute the foreground's subject matter. The artist, Frede Vidar, was noted for his elegant and appropriate coloring. Although

dramatic episodes are evident in the minute particles of burnt fuselages, the horror is fully dramatized in human bodies lying on the earth's surface.

Flying-Bomb Damage, Hyde Park, is a pen-and-ink drawing by Fletcher Martin. Executed in 1944, it depicts the results of a single bomb. The uprooting and splitting of trees represents a small segment of the total destruction.

A lone army officer examines the bomb's remains as onlookers stand in awe. The five figurative forms are enclosed by charred, naked trees severed by destructive forces. Objective in arrangement, the scene of destroyed trees and the remaining occupants is also objectively executed. Yet, the finality is viewed subjectively partly because of the medium of expression. The war

destroyed not only human life but also the environment.

Hiroshima — 1945, a drawing by Standish Backus, shows the horrors of destruction, the devastation caused by the atomic bomb.[5] Human lives were sacrificed in order to bring the war with Japan to a sudden end and, by so doing, save more lives. The panoramic view of unreality is an eerie picture of nothingness, a science fiction portrayal of total destruction.

A few distant human figures are positioned along the byways, not as survivors of the holocaust but rather as a comparison of the human figure to the destruction of an entire community. *Hiroshima — 1945* is a segment of a larger picture of destruction. The artist's drawing of a few lonely human figures indicates the futility of war and, more particularly, the suicidal efforts that eventually destroy human life around the globe.

President Harry Truman's decision to drop the atomic bomb became a warning to the world as to the extremes to which man may go in the maintenance of freedom. Civilization would no longer exist. Backus' portrayal is of a nightmare and yet of reality.

In spite of its objectivity, the focus on a single aspect of the catastrophe would totally erase the scale of the tragedy. In other words, to enlarge a single aspect in order to project a detailed subjective response would automatically dislodge any notion of a major disaster. Even Backus' portrayal does not suggest the vast scope of the reality of destruction.

Peter Blume's famous painting *The Rock* (1948) represents birth, death and rebirth.[6] Symbolically, the rock image is the earth shattered into a shell of mountainous terrain as if blown apart by the atom bomb. Atomic explosions had become an artistic motif. Yet, one had to realize its appropriate use to avoid misinterpretation. *The Rock* represents the destruction of the world amid reconstruction — the effects of the war and the aftermath.

The fear of an atomic explosion amid a reconstruction period is witnessed in Blume's masterpiece. The interior of a Victorian room surrounded by clouds of atomic ash is a symbol of time. The charred ruins of buildings pierce the atmosphere as indelible reminders of the war. The balloons of smoke, which seem to have no origin, rise into the atmosphere like miniature atomic clouds, as if descendants of the Hiroshima bomb.

Fear from World War II continued long after the victory by American troops. Ben Shahn's morbid scene of a man cowering in fear of the possibility of total destruction is such an example. Executed in typical Shahn style, *Man* (1961) symbolizes the dread horror of the atomic menace. The highly personal image is elongated and seemingly floating in space as foreground and background are similar in textural application of pigmented color. Mirages or hallucinations appear in the background environment, creating fear of the unknown because of the atomic experience.

Engaged in a somewhat different motive from those already discussed is the portrayal by Stefan Hirsch. *Nuremberg* relates his elation over the city's destruction by the American air force during World War II.[7] His childhood memories of hatred for his birthplace were diminished by the bombing of this Nazi stronghold. Compositionally, *Nuremberg* (1946) represents a bombing in action, but it reflects intensity in remission. It is a dynamic tug-of-war between action and anticipation. The destruction is overwhelming. Yet, the artist has stabilized the church structure in order to grant spiritual hope to the survivors. In fact, the spiraling steeples are amplified, suggesting divine intervention. The strong explosive diagonals of the skies are counterbalanced by the angled cathedral structures that lean slightly toward the right.

Ogden Pleissner, noted for his quiet landscapes, continued the stillness with his painting *Action in Italy* (1947). Although the title suggests an activated scene, it seems that the action had already occurred. The subject matter is the remains of fierce bombings, the shells of buildings lining the open sea. Italian fishermen tend their boats moored along the water docks. Peace once again prevails, although the destruction will long be remembered.

Strong diagonals lead the viewer undeniably to the right as fishing boats tend to diminish the surge in a single direction. The movement is blocked by the human element that lends an inquiring mind to the scene. Furthermore, the upright masts of the boats disrupt slightly the angle from which the scene is recorded.

Garden at Hiroshima (1945) is a sardonic expression of a tumultuous graveyard. The artist, Standish Backus, here presented the devastation of the atomic bomb. The few naked trees gracing the barren landscape are gnarled, distorted, and dead but reveal a dynamic potential of life with all its fulfillment once again in the offing.

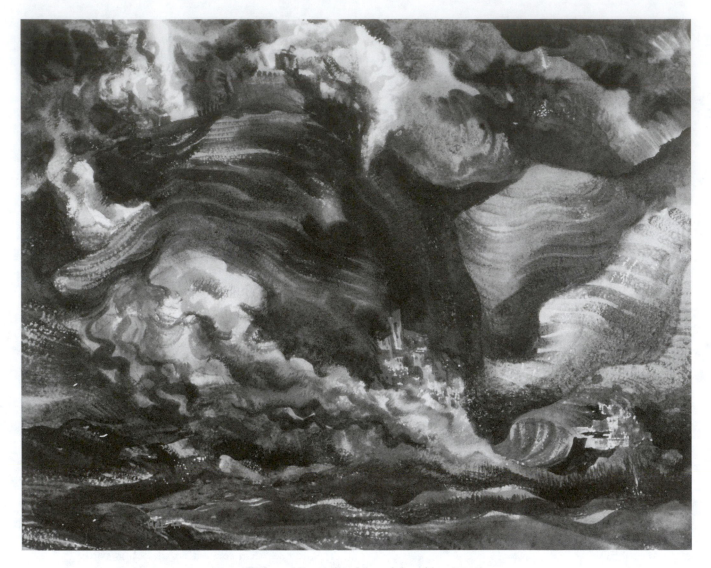

Edward Reep. *Bombing of the Abbey* (1944).

Distorted buildings once piercing the heavens in dramatic grandeur now resemble miniature tombstones whittled into a desert-like environment. Particles of Japanese rickshaws dot the foreground as do human bones, a grim reminder of the atomic age. A mother and her two children are the focal point, provoking a surreal effect when one considers the trio of humans as the sole survivors. In spite of the total physical destruction, the heavens are resplendent with the light of future hope.

Vire (1945) by Harrison Standley portrays the ruins of war in the total destruction of municipal buildings and cathedrals. Among the physical ruins are human beings, whose lives may be considered ruins, since survival often results in permanent disability. The mountains of rubble recorded by Standley present an eerie environment of shadows. Charred structural surfaces symbolize the end of a civilization, although the presence of survivors creates hope for the future.

The visual perspective of Standley's painting suggests a far-reaching destruction, as if the city Vire were a mere segment of the total picture. One does sense a panoramic vista, even though a select portion is recorded. The viewer is ushered onto the scene by the artist's placement of a cyclist who remains motionless as he determines his next move. Assessing the destruction seems essential to his future destiny.

The abbey at Monte Cassino in Cassino, Italy, was a German stronghold in World War II, and it was heavily bombed by Allied forces. *Bombing of the Abbey* (1944) by Edward Reep, which portrays this destruction, resembles a work from the

Abstract Expressionist movement. Although Reep is a Realist, the destruction of the earth here has forced him to paint the action rather than the aftermath.

Segments of the city of Monte Cassino are viewed as bits of buildings surrounded by fire and smoke. The dense cloud formation created by the bombing all but buries the abbey, and yet Reep has used those segments as a compositional technique. The dramatic background of smoke creates difficulty in discovering the abbey itself. *Bombing of the Abbey* reveals the horror of war, the destruction of cities and their occupants. It can also be considered as an abstract painting or design of swirling colors. Reep's brushwork reflects an alertness and a need to record the event swiftly. He has captured the terror and the drama of the scene. One becomes engrossed by the destructive force of the bombing, and the abbey itself appears lost in the excitement.

Bombing of the Abbey is not a traditional Reep portrayal, yet it is rendered realistically, in keeping with his manner of expression during the war. His is a summation of the futility of war and the suffering and death of human beings.

The mountainous city of Cassino was also painted by Tom Craig. The rugged terrain surrounding the city allowed the artist to utilize an expressionist approach to a realistic theme. The remains of a cathedral in the foreground testify to the destruction of the area. The huge structure perched atop the mountains and hillsides, target for fire in the war, is an exciting example of portrayal in the painting.

Craig was chosen by the U.S. government armed forces as one of several outstanding American artists to record, in artistic terms, the daily encounters of the American troops' battles with enemy forces. He has, in *The Abbey of Monte Cassino* (1946), projected a factual recording yet also an intuitive and emotional reaction to the destructive forces against a single site.[8]

An ink drawing by Albert Gold, *The St. Giles Strong Point* (1945), reveals a total disaster area.[9] The naked landscape of charred trees and destroyed buildings is rendered in appropriate media. The black and white drawing is dramatic in its contrasting darks and lights. In its panoramic vista, one realizes the tremendous distance of destruction that the war has created.

Havoc was created by the 137th American infantry. The Germans used the cathedral as the stronghold and shield as they fired through the wall openings of the church. Several encounters occurred before the American troops could eventually capture the site. Gold's recordings are drastically different from his provocative figurative paintings of the 1930s. *St. Giles Strong Point* was instantaneous in its execution, thus eluding any provocative assertions. It is a visual depiction of a factual scene recorded as seen and without the luxury of meditation.

One is placed as a witness to the scene, arriving after the destruction has occurred. The display of ruins was typical of the daily route of the war correspondent, who was either hired by commercial agencies such as *Life*, *Time*, *Fortune*, Abbott and Upjohn or was an enlisted member of the armed forces.

A familiar pattern of reconstructing the war is witnessed in Hughie Lee-Smith's rendition of the ruins of war, suspiciously titled *Untitled* (1948). This is a recall of the destruction caused by World War II. The rubble, seemingly chaotic, seems to suggest the amassing of skeletal forms of the Holocaust. In a central location, a human form seems to emerge from the devastation; whether it is symbolic of survival or hope for eventual freedom is questionable. Remnants of buildings remain intact as if spared momentarily before an ensuing bombardment.

The painting relies on three horizontal planes, each lessening in chaotic appearance as it recedes. The middle ground appears undisturbed by the bombing, and the most recessive area appears quiet while settling into a peaceful harmony with a hopeful future.

Lee-Smith is noted for his isolationist paintings, recordings of lone figures residing in vast deserted landscapes, loners in a world of apparent opportunity. But his black heritage serves him well as an artist of pride and final acceptance into the mainstream of American art. This acceptance was not easily attained. Since his painting was left untitled, so to speak, it not only identifies with the ruins of bombed European cities but also could relate to the burning of Detroit in the race riots of the 1940s.

The ruins of war involve the human condition as well as the physical landscape. In the case of Umberto Romano's dramatic reaction to war, *Greed* (1945), motivation was stirred by World War II.[10] Abstract forms of anatomical segments move rhythmically over the canvas surface, highlighting clawed tentacles, sharply defined teeth resembling thorns, and deeply rooted crevices of

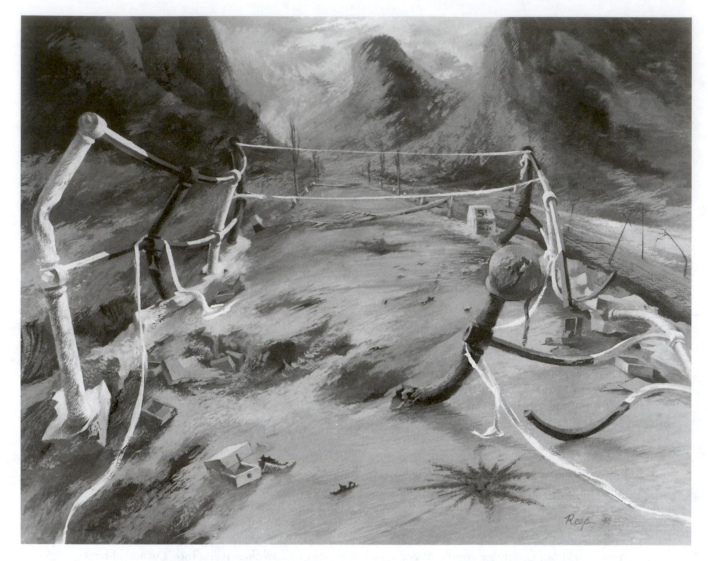

Edward Reep. *No Man's Road to Bologna* (1945). Gouache. 19 × 24 in. Courtesy of the artist.

the digestive system. Man is transformed into a gluttony figure of humanity. The violent rages of war are seen in the sharply honed, saber-like claws.

The intermingling of positive and negative space forms a single oscillating plane. The recessive environment weaves throughout the advancing habitat, creating a oneness. Human elements sustain a mysterious nature because the obvious is sidelined and partially hidden. There are only deformed structures of flesh resembling animalistic figures. Because of the greed and the conditions of war, the human race has been transformed into an animalistic world.

The ruins of war often bring images of sureality. In Edward Reep's portrayal of the aftermath of battle, *No Man's Road to Bologna* (1945), images were erased by the effectiveness of buried mines.

Bridge rails were damaged beyond repair. A bullet-riddled helmet hangs over an uprooted rail support that oddly resembles a human skeleton. Deep holes mark the once popular roadway, which leads the viewer onto the scene, but once there, the viewer is trapped within the structural deformities that recede in to seemingly endless turmoil. The mountain ranges surrounding the destructive aftermath add to the distortion of reality.

Reep described *No Man's Road to Bologna*: "It depicts several white ribbons, or tapes that were tied to iron railings guarding both sides of a small bridge that spanned a culvert and drainage canal. The rails, little more than oversized pipes, were now grotesquely distorted, mutely attesting to the fierce struggle that had been waged over this tiny but strategic landmark. At this juncture both armies had recognized that they were both dead-

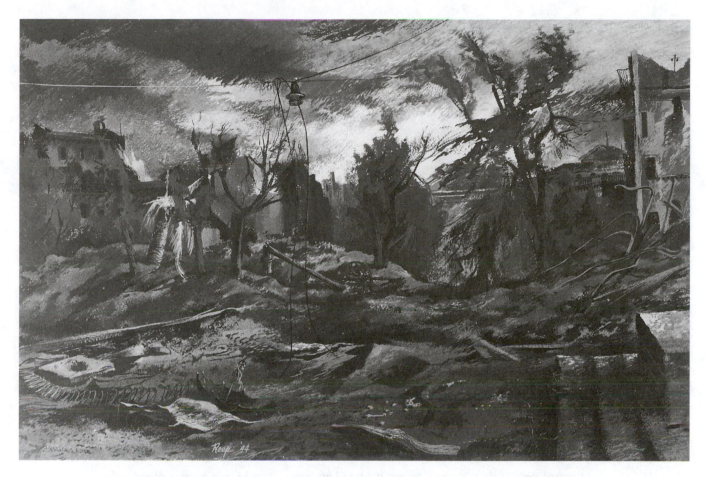

Edward Reep. *Piazza in Leghorn* **(1944). Gouache. 15¼ × 22½ in. Courtesy of the artist.**

locked, prompting our forces to string the ribbons as a warning not to proceed beyond that point.

There were personnel mines everywhere, buried, half exposed, or just strewn on the road; they were little wooden boxes cleverly hinged so that when a person stepped on one, the lid would sever the pin and detonate the mine. The minute craters clearly visible demonstrated their effectiveness."[11]

Reality is the distortion of nature and becomes surreality when the natural order of things is disrupted and altered beyond its original appearance and constitution. *No Man's Road to Bologna* is such an expression.

There is a certain beauty in ugliness. Reep admits this in his statement regarding *Piazza in Leghorn* (1944): "The old saw that the artist sees beauty in ruin held true: twisted steely shattered glass, broken concrete, macabre tree forms, and dangling wires all suggest strange patterns and movement."[12] The ruins are exquisitely rendered: Reep has taken pride in focusing on the inner life of the commonplace and torture-laden items. In

spite of the evils of war and the ruins resulting from war, there prevails the artistic ingredient that so frequently remains unidentified. Reep's focus on details that normally escape the viewer's eye is fervently portrayed as if a sacred vow needed fulfillment. The total devastation witnessed in *Piazza in Leghorn* is simultaneously regarded as details of exquisite value.

Ruins of war depict a peculiar beauty. A stillness resulting from dynamic and explosive events seems evident in Reep's unusual display *Ack-Ack over Cervaro* (1944). The uniformity of design and the union of seemingly opposing geometric forces create an ethereal sense of eternity. In spite of massive destruction, the crucifix atop the partially destroyed cathedral evokes a spiritual overtone.

In spite of the artist's attempt to capture the ambiance of a fleeting moment between night and day, there nonetheless prevails a sense of the stillness of a committed event, a moving yet cautiously stable occurrence. *Ack-Ack over Cervaro* is solidly anchored in the earth's surface. It is the result of heavy bombardment, but in the skillful

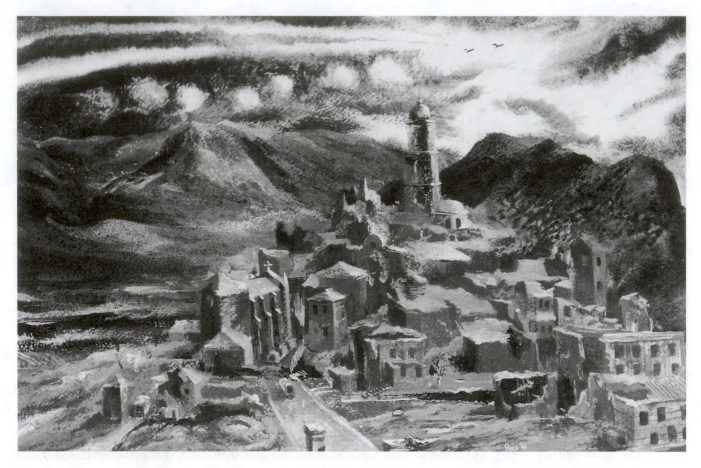

Edward Reep. *Ack-Ack over Cervaro* (1944) Oil on canvas. 15 × 23 in. Courtesy of the artist.

hands of the artist, the substantial remains not only identify locale but also emerge into a satisfying display of geometric structures. The mountainous terrain surrounding the bombarded village lost its fight to protect the city and its residents.

The cross, which seems everpresent amid ruin and destruction, symbolizes life and death and frequently the notion of resurrection. Reep described *Ack-Ack over Cervaro*: "I had painted abandoned enemy positions but hadn't confronted the Germans in action until I saw two reconnaissance planes blazing by the mountain village of Cervaro. Their vapor trails and the puffs of our pursuing antiaircraft fire were so striking couched against a darkening cool blue sky that I determined to build a painting around the event. Amid the rubble of Cervaro are several Red Cross vehicles, a church, and the dominating building."[13]

Although the painting was executed on the scene in watercolor, it was repainted in Reep's studio, where reflective moments controlled and directed his energies. Details were merely noted in the watercolor painting but were refined and enhanced in the final gouache painting, a more permanent medium.

River of Blood (1943) is a terrifying display of the lunacy of war. The artist, Beatrice Levy, illustrated the ghoulish route of one man's greed and warped sense of humanity. Hitler becomes witness to his own gory and insane attacks on the human race. His victims cry out from the dead, taunting and haunting him until he himself becomes a victim of his own insanity.

Bodies drowning in the blood of defeat reach out in vain to the self-proclaimed supreme being of the world. His failure to destroy the American troops and their allies created for the artist an unbelievable yet true picture of the power of a single human being. Hitler wades through a river of blood whose drowning victims float in countless numbers like a "log jam" of human bodies converging on the fallen emperor.

Compositionally, Levy has projected the major force of the action, the cause of the action, forefront with unmistakable identity. The environmental background swirls in devastation as once famous landmarks disintegrate into clouds of

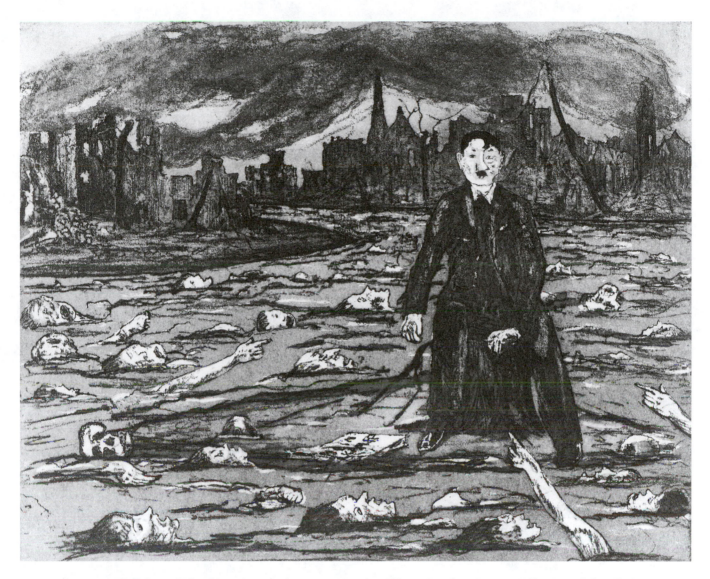

Beatrice Levy. *The River of Blood* (1943). Aquatint. 20.2 × 24.9 in. Gift, Artists for Victory. Collection of the Library of Congress, Washington, D.C.

fiery bomb blasts. *River of Blood* is an accurate account in a surreal sense in that the gory display of human flesh speaks from a bloody grave to condemn the horrible evils.

What appears to be grossly exaggerated is not at all overstated when one considers the millions of deaths committed by the Hitler regime. The artist has forced Hitler to recognize his gruesome acts of murder, but more important, Levy has awakened the world to the unbelievable horror that can be created when a single person is given the freedom to express and execute a free will that counteracts all freedom of decency, tolerance, and love. *River of Blood* is a depiction of the worst in man. We must never allow such insanity to occur again.

CHAPTER 6

The Dead

"If our sons are burdened with war and death, the blame will be ours, who would not build peace. The work of the burial squads is the tragic evidence that our fathers failed."[1]

This quotation applies to Joseph Hirsch's painting *The Burden* (1947), in which an American soldier totes white crosses to be spiked into the earth's surface to represent more of the war dead. Hirsch had deliberately forsaken the morbid scene of actual burial and the lineup of hundreds of crosses identified with the dead. Instead, the focal point is the icy stare of the American GI whose burden is the heavy white crosses. Yet, the real burden lay in the hearts of those American soldiers who still lived amid the rubble of a destroyed landscape.

The artist purposely envisioned the actual death scene outside the picture plane and subsequently activated the white crosses as symbols of death. A second American GI unloads a jeep filled with white crosses and thus extends the rows of American war dead.

Gritty attire and bodily features of blood and sweat match the sordid ordeal of burial. The torrential spread of smoke colors the horizon. Posted upward is a sharply defined tree, naked in its thorn-like branches, in close alliance with the crown of thorns endured by Christ at Gethsemane. The thorn tree sustains a prominent position in Hirsch's painting, not unlike works by other Americans: Rattner, Lebrun, Moller, Nagler,

Jankowski, Aronson, and Romano. Such relationships are discussed in Chapter 9, "The War and Religion."

An unusual death notice appears in *Uprooted Stalk* (1945), an extraordinary approach to war and religious overtones.[2] A contemporary rendition of the Christian theme *Pieta* is seen in Prentiss Taylor's etching. Instead of grasping a segment of the cross as in the early Byzantine and Renaissance paintings and sculpture, in Taylor's version the deceased grips a corn stalk. The dead soldier lies unclothed across the grieving mother's lap. *Uprooted Stalk* is a religious painting but with World War II associations. As the mother holds her beloved son, planes circle overhead and a flyer parachutes safely to earth. The image of the mother is faceless, thus identifying with the universal. The artist has purposely introduced the religious connection, allowing the spiritual to overpower the expression.

The strong female form resting in a field of corn clings relentlessly to the nude body of the deceased soldier. The strong diagonals of cornstalks crisscross the dead body and widow to form a unified composition. The environmental background displays the continuous battle with enemy planes. The interchange of visual dialogue between the dead and the living is disrupted only by the single corn stalk that splits the visual communication. The stalk is strong in appearance and placement and serves as a symbolic gesture of

peace. Yet, it is ironic that life should end in a cornfield. One may argue coincidence, but the placement and the strength of the stalk dispel any possibility of haphazard event. Taylor's composition is intellectually conceived and executed, but in the final analysis the work is emotionally charged with compassion and tenderness.

Hiroshima was death. In a sense, it was the salvation of thousands of souls. In spite of the thousands killed as a result of the atomic bomb, the unprecedented surrender of Japan saved Japanese lives as well as those of American GIs. In *Hiroshima* (1946), Edna Reindel's horrifying imagery of death and ruin, one sees scraps of bone and flesh, the remnants of a once human civilization.[3] The devastating remains were the result of the atomic explosion that shocked the universe. The bombing stunned Reindel to exhibit a new approach to painting. Her vividly peaceful landscapes and poetic still lifes were forsaken in favor of the explosive ingredients of a war-torn world.

Hiroshima is void of human suffering. Images of the dead were replaced with what appears to be a huge insect clawing and gnawing at the effects of the atomic explosion. The abstract expressionist approach is an intuitive response to an event of abominable nature. Although her approach is a delayed reaction, it is nonetheless instinctive and spontaneous. It was a controlled emotion and intellect that pondered, conceived, and executed a seemingly chaotic work. Yet, it was precisely this image that created the surge of emotional drama that confronts the viewer.

Hiroshima is an essential expression for the artist and her audience. Life was destroyed not by human combat but by the press of a button, making the event that much more terrifying. Reindel recognized the human destruction created at a moment's decision and insisted that the world be warned.

Death camps were prevalent during World War II. American prisoners of war were left to die as were thousands of German citizens who were activists against the Nazi government. Such a camp was recorded in Loren Fisher's painting *Death Camp at Buchenwald* (1946).[4] Nude bodies lie partially covered with white sheets. Gaunt and emaciated bodies rot in outdoor graves. Fisher painted a ghastly scene of diminishing flesh. The death camp at Buchenwald was one of many camps in which the Nazis methodically tortured, starved, and murdered millions of people.

An equally terrifying recording of the same scene and site is *Buchenwald Atrocities*. According to the historian Kim Levin, the artist Jonah Kinigstein utilized intensified realism in painting *Buchenwald Atrocities* because he felt it essential "to convey the psychological shock that he felt toward his subject matter. His use of colors was also quite subdued for the same reason."[5] Skeletal forms pile on one another, a typical Nazi tradition of treating the human being as inhuman cargo ready for disposal. The shocking display of God's creations murdered to suit an egomaniac's desire for power attests to the horror of the event.

The composition is direct and confronts the viewer with bony structures of innocent victims of the German Gestapo. As grotesque as the scene appears, Kinigstein managed to create a circular arrangement of skulls with bodily segments acting as supporting facets to a total and complete union. The provocative painting makes known the evils of aggression and the profound need to recognize such evils in order to combat them in a democratic fashion.

Levin further stated: "He has done a series of meat slaughterhouse paintings in bright violent colors reminiscent of Soutine; another series was of dead fish. The paintings of both meat and fish have as their theme the sacrifice of life. Another related subject that absorbed his attention was people who are incapacitated mentally or physically. These figures in wheelchairs retain only the shell of life; they exist at the edges of this world and the next, images of sacrifice. Developing out of these somber wheelchair paintings, Kinigstein proceeded to a series dealing with Buchenwald; skeletal figures in tortured positions appear to cram the canvases. There is the feeling that these figures of Kinigstein's, with their gaping hollow mouths and eyes, are trying to scream as they undergo the transition from flesh to bone. Kinigstein states that he is concerned with the universal and indeed these Buchenwald paintings seem to be fragments of some terrifying medieval conception of the Last Judgment."[6]

The theme seldom dictates the medium or the style. World War II was successfully expressed in the medium most suitable to the artist. Likewise, the style seldom changes to suit the theme or subject matter. The art of William Johnson changed dramatically, from abstract expressionism to a sort of primitivism, not because of theme but because of the learning process. His presence in Germany also influenced his approach to painting.

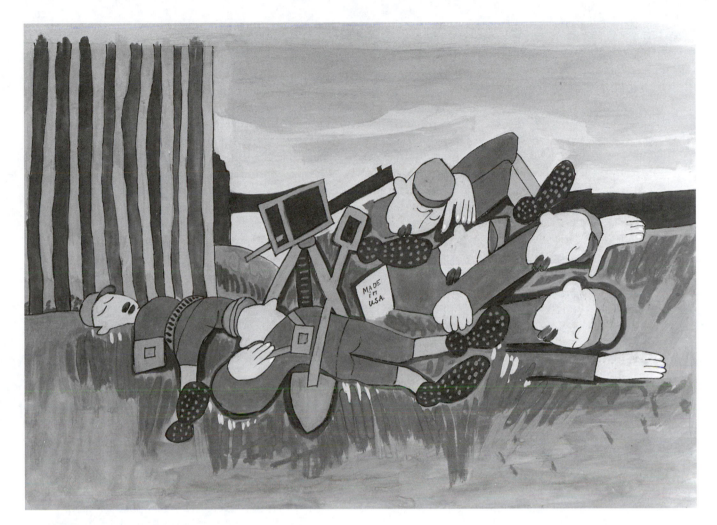

William Johnson. *Killed in Action* (1944). 1967.59.175. National Museum of American Art, Smithsonian Institution, Washington, D.C.

His works executed during World War II were primitive in style.

About his painting *Killed in Action* (1944), the author Richard Powell stated: "The violent and deadly side of war appears in this body of work. In this single painting of six dead Japanese soldiers, piled one on top of the other and alongside an American-made machine gun, the dual message — war's ultimate human toll along with its relationship to marketing and business — again shows an ironic aspect to Johnson's visual commentaries on World War II."[7]

Killed in Action seems more a symbolic vision than an actual scene of the dead. Death is final. There is no suggestion of prior suffering, only the remains of what were once brave, courageous soldiers. Visual perspective is ignored. Bodily gestures are forsaken. Emotional reactions are absent. In fact, the entire painting seems more a recording of an event neatly packaged than a gruesome body of blood-stained uniforms. Tall blades of grass surround the victims, as if a symbolic message were being transmitted.

Johnson has made it clear and definite that it was the American made machine gun that caused the deaths of the Japanese soldiers: the gun is the central focus of the painting. *Killed in Action* is more decorative than realistic. The equal distribution of color forms a circular composition. Although the bodies overlap, Johnson painstakingly avoided overlapping the bodies with the surrounding environment. This same theme would have greatly profited from his earlier abstract expressionist approach to painting.

Italian Landscape I (1944) by Ben Shahn is unusual in the compositional aspect of death. While widows await the arrival of caskets from under a partially destroyed, meticulously textured brick archway, the tension arising between the two human elements intensifies as the viewer

anticipates an increase of emotions among the two factions. The dark, flatly painted attire of the widows creates a sharp contrast with the delicately textured brick walls of the environmental background.

Although remains of the war prevail, Shahn's carefully conceived composition and intricate display of eloquently rendered details help to create an optimistic view of the future. A young tree was placed to the far right of the painting as a symbol of future growth and prosperity. It also represents a glimmer of hope amid foreboding circumstances.

In *Faid Pass* (1943) by Fletcher Martin, a single cross marking the grave of a slain American soldier is scarcely noticed on a desolate mountainous terrain. In fact, the diminutive size of the cross creates its own significance. The irony of the scene is the seemingly peaceful nature of the dead contrasted with the dynamic, fiery environment. One may question whether the subject matter of the painting is the small cross, the mountainous terrain, the fiery sky, or the landscape itself.

Whether the destroyed army vehicle entrenched near the marked grave is related to the dead American also remains a mystery. The roughly textured plains and mountains are monuments that are carefully conceived and arranged to form a subjective and personal expression. The gravesite cross adds a psychological twist to an already total and complete landscape.

A gruesome sight is the dead washed ashore in *Ebb Tide* (1943). The artist, Kerr Eby, has been discussed in other chapters of this book. He painted compassionate and provocative images of war victims. His approach of realism is appropriately suited to the black-and-white medium of lithography. In describing *Ebb Tide*, Eby has said, "This is the most frightful thing I have seen."[8]

The bodies, watersoaked beyond recognition, hang on a slimy, roped barricade. Eby spared us the view of decaying flesh and instead revealed torsos of unrecognizable nature. The simple and direct approach to this horror of war is made even more dramatic by its medium of expression. Were color added to the working surface, perhaps the drama would have lessened in intensity. One is reminded of George Grosz's terrifying death scenes of German atrocities.

Direct Hit (1943), another work by Eby, reveals a truly realistic picture of the tragedy of war.[9] Compiled into a seemingly haphazard design, the fallen victims of an amphibious tractor had no chance of survival. The sudden attack was rearranged in artistic unification in order to appropriately consume the boundaries of the working surface that the artist had chosen to use. *Direct Hit* is a circular composition of human bodies designed to present the true message of the war dead. Shadows and highlights were distributed to foster drama and amplify it beyond reality. There is a finality to *Direct Hit*, a sense of eternity and a reason for death. Eby recorded, rearranged, and expressed not only the reality of life but also the reality of death. The scene is peaceful in spite of its message. The viewer hopes that the message of death is the freedom of democracy. One needs to know the horrors of war in order to respect and eventually abolish war. This, Eby has done.

George Biddle, as a war correspondent, traveled the European theater making numerous sketches of the ruins of war, survivors, innocent victims pleading for aid, and prisoners of war. His drawings resulted in nightmarish paintings such as *Civilians* (1944), which shows several human corpses as innocent victims of war.[10] The distorted bodies reflect the pain and suffering encountered before death, and the thinly clad figures reveal the physicality of the distortion. The partially transparent clothing worn by the victims enabled Biddle to reveal the gnarled bodies and torn flesh.

The four victims huddled together strongly suggest that Biddle created a composition from the several physical scenes made available to him. There is a delicacy of linear contours that seems alien to the circumstances but that translates into a greater degree of suffering.

Orderly Retreat (1943), Philip Evergood's sardonic expression of the Nazi defeat at the hands of the allied Russians, is grotesque.[11] Evergood's purpose in this ugly satire was to express in pictorial form the futility of selfish and greedy aggression. Evergood believed in making known the evils of man so that purposeful remedies would be employed to eradicate such injustices.

In his now famous painting, the artist revealed endless rows of German soldiers, already dead, marching into infinity. Evergood's satirical climate is heightened by the tuba player setting a musical cadence for the marching dead. A family of survivors witness the parade of "deadbeats" as the dead direct the dead. The futility of war has never been more directly and strongly communicated.

Evergood continued his attack on the warmongers whose greedy appetites accounted for

innumerable deaths of American servicemen. Because of his work portraying the evils of war, Evergood was accused of an un-American recording of war events. In his painting *The Quarantined Citadel* (1945), Evergood took issue with the warmongers by depositing them on a single island and engaging them in a make-believe conquest with toy soldiers.

Paul Cadmus' irony is as fascinating as it is controversial. Society may object to his critical analysis of certain issues but frequently must agree with his message. *War Memorial* (1945) is a case in point. It is a remarkable satire of the war effort. The dead veteran sustains the posture of a Michelangelo *Pieta*, with a wound in his chest resembling that of the pierced side of Christ. Partially shielded in the background is the quote: "They Shall Have Died in Vain." What a devastating satire on the purpose of war!

The victim's lower torso is wrapped in the American flag while anguished women mourn his departure. However, the greed, jocularity, and total disconcern of the remaining audience consumes the right segment of the canvas. Split the painting in half, and two separate paintings emerge, totally opposite each other in both composition and subject matter. War furnishes a fertile ground for artistic expression. Aside from the action itself, its ever-present effects on the human condition are endless and present varying degrees of emotional responses to the memory of the tragedies that never seem to end. Wars are limited in time, but memories live forever.

The discovery of dead bodies washed ashore was a common scene in both theaters of war. Mitchell Jamieson's version, *Normandy, Low Tide* (1943), compares favorably with Kerr Eby's adaptation, *Ebb Tide* (1943).[12] Jamieson has drawn a cruciform over which an unidentified body hangs between the crossbars. At the base and adjacent to the cross of decayed timber are other human remains watersoaked beyond recognition.

The horror of war is indelibly etched in the viewer's mind in Jamieson's gruesome recording of the incidental crucifixion of American soldiers. At the right is an upright crucifix stemming from the watery grave too distant to acknowledge any human flesh clinging to its rotted moorings. The seemingly instinctive response was recorded in objective fashion without diminishing the terrifying visual sightings. *Normandy, Low Tide* is unquestionably one of Jamieson's most emotional pieces of work.

In Philip Evergood's painting *Epitaph* (1953), the subject matter is the extermination of the Jews during World War II. The painting depicts Nazi soldiers routinely and without forethought machine gunning men, women, and children. After the slaughter, the bodies were transferred to incinerators so that no evidence of murder remained.

Evergood explained his reason for painting *Epitaph*: "It was painted in solemn and humble tribute to the unbreakable will of the oppressed peoples of the world. It was painted with revulsion and hatred against all aggressors, all tyrants, all cruel little executioners and torturers who do their masters bidding of whip-lashing, slander, evil propaganda and murder."[13]

The demonic facial expressions of the German soldiers and the vultures swooping down on the slain bodies make for a terrifying vision of inhumanity. Some critics claim that Evergood's portrayal was overstated, overdistorted. Yet, it is the artist's incentive to move his audience beyond reality, and, in the case of *Epitaph*, to warn society of German atrocities.

Firing Squad (1940) is a dynamic portrayal of Germany's atrocities against those who dared to oppose Adolf Hitler. Five Nazi soldiers fire on the helpless victims. Gropper's portrayal focuses on the cause and effect of a German atrocity. The visual distance between the German soldiers and the victims of the German firing squad is one of anticipation. The viewer scans the distance between the two factions much like one watching a tennis match, but Gropper's display is one of finality.

The murderous event is simplified by its directness and by the muted background. In addition, the vastness of the environment acts to solemnize the event and lift the German race to a loftier plane. Dehumanization became the credo of Fascism, although Hitler's cause — to create a master race — was never questioned by the German hierarchy. Paradoxically, his goal of ridding the human race of imperfection was itself the insanity of an insanely imperfect man.

In Gropper's painting *Firing Squad*, the victims become the martyrs and the slayers face eternal damnation. Gropper accentuated the event by inserting a strong, light diagonal shape encasing the victims in contrast to an intense dark shadow around the firing squad. In addition, the simple attire of the firing squad helped to sustain the drama of the event.

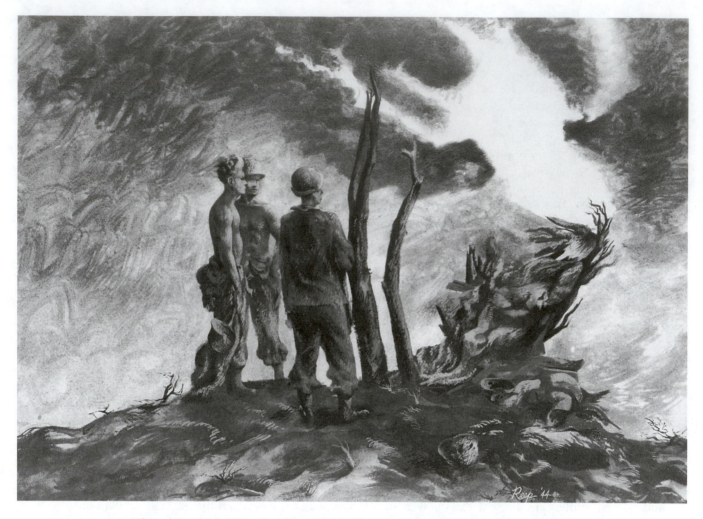

Edward Reep. ***The Morning After*** **(1944). Gouache. 15⅜ × 21¼ in. Courtesy of the artist.**

In Edward Reep's surrealistic *The Morning After* (1944), three GIs suggest the infinity of life. The dead will one day awake and continue the battle. A tempestuous sky encircles the spot on which the deceased lie.

There is a sense of serenity amid a stormy anticipation. There is peace and yet fear of the unknown. *The Morning After* is a memorable scene. The three American soldiers meditate in unorthodox fashion alongside two naked tree stumps clawing the heavens for mercy. There are religious overtones in the restless sky and in the tree stripped of its bark and foliage as if the coming of a divine power were to intercede.

Two totally different plans of action unite to welcome the three American soldiers who mourn the eternal departure of their comrades. Anchored to the battlefield but surrounded by anticipated warfare, the human condition prevails momentarily in saddened gestures. One is reminded of George Grosz's scandalous renditions of Nazi

atrocities, not so much in the theme as in the technical application of color. Small remnants of branches pierce the horizon as if one were envisioning the crown of thorns jabbing the brow of Christ.

It has been stated that no painting or work of art is without its degree of spirituality, that the very nature of creation is spiritually fundamental. The creative process, therefore, sustains a lofty plane regardless of one's attempt to do otherwise. Moments of reflection after the fact have resulted in spiritual meanderings and a contemplative process. *The Morning After* is indeed a work of art over which one would meditate to advantage. The inner peace resulting from a sustained viewing is the result of Reep's compassion toward humanity and his belief in man's purpose in regard to divinity.

Reep has applied an appropriate textural quality throughout the environment, into which his role-players are planted as if they too will

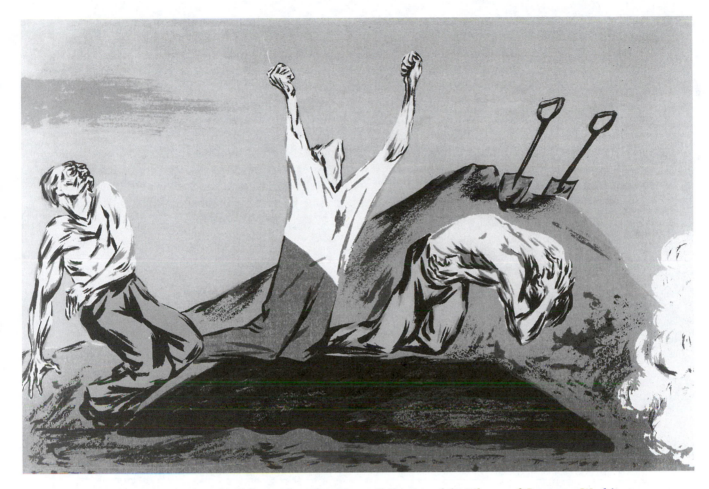

Marvin Jules. *Hostages* (1943). Color lithograph. 35.5 × 52 cm. Collection of the Library of Congress, Washington, D.C.

eventually be engulfed by the eternal theme of life and death. Reep described *The Morning After*: "The work, in watercolor and casein, depicted dazed soldiers stripped to the waist and emotionless, gathering up the remnants of clothing and equipment of the fallen men and stacking it in neat piles. A small tree, now brutally stripped of its bark and foliage, reached upward into a bleak sky, heavy and colorless. The clouds formed a vague monster-like image with gaping jaws and elongated clawed hands. I fought against being melodramatic or too pictorial, and as a result the painting remains, in my judgment, as one of my most potent statements of the war."[14]

Seymour Nydorf's eerie portrayal of the future of tomorrow is witnessed in *Today, Europe; Tomorrow, the World* (1943). The lithograph depicts a ghostly embrace of two skeletal forms. Even in death the communication continues, and the viewer is repelled by the gas-masked appearance. The bony imagery is the result of the Nazi invasion of Europe and the insanity that would

continue if Hitler and his Fascist regime were not halted.

The title and date of Nydorf's expression define the theme. The ghoulish images are appropriate for several contemporary themes, and the eerie bony creatures symbolize a mere segment of the fierce atrocities committed by the German dictator. Nydorf has not allowed nonessentials to interfere with his message. The background environment is darkened, adding to the shadowy effects of the ghostly creatures.

Nydorf's *Today, Europe; Tomorrow, the World* is a prediction, a premonition of the death not only of Europe but of the entire human race. Hitler would become the supreme being and thus control life and death. Nydorf's message is dramatic but subtle, and yet, it is a warning. His composition is simple and direct. It appears as a preliminary to a greater work, a mural in fact in which the image of Hitler is identified as the ruler of the world surrounded by the world's devastation — except for Hitler's select throng of

survivors, who would propagate the "new world." Similar to Bosch's version of Hell, Nydorf's rendition would be Hell on earth.

Hostages (1943) shows a trio of war prisoners pleading for mercy while being shot and buried in a grave likely dug by the victims themselves. An initial glance suggests atonement by the victims, but a second glance reveals an execution in progress. The lithograph by Marvin Jules is a simple, direct statement limited to a positive foreground and a negative background.

Although the action occurs within the confines of the forefront, the negative environment is activated by the three hostages, whose bodies extend into the background. Each hostage is pictured in differing degrees of suffering. Each is in the process of dying and of falling into his grave. Although there are three hostages, the artist has revealed only two shovels that unearthed the fatal hole. The inclusion of a third shovel may well have disrupted the final composition.

The artist made a special effort to focus on the hands, distorted and elongated, of each victim as he grasped for the final moment of freedom.

CHAPTER 7

The Workers of War

Will Barnet's *Swing Shift* (1940) portrays a commonplace theme that seems innocent but that gains significance because of its extended purpose: serving the cause of war and the fight for freedom.

The subjectivity of the image is diminished somewhat by the inclusion of functional apparatus. The singularity of person and purpose initiates an obsession with ethnic groups that, during World War II, were seldom favored. But it was precisely this unity of class and commonality of purpose that placed the homefront in complete harmony with the front lines.

Because of the war effort, workers adhered to irregular hours. According to Barnet, "This was a time when there were no eight hour work days, and more often than not workers had to work a day well beyond ten or twelve hours."[1]

Labor in a Diesel Plant (1940), by the noted wood engraver Letterio Calapai, expressed in multiple unison a series of technical processes of diesel engineering.[2] The organization is the result of several on-the-scene sketches arranged on a vertical panel of boxwood. Each composition is dynamically positioned in a sequence of events and in a reinforcing attitude of reliance. Each episode is enhanced by the physical endurance of workers who are patriotically destined to total and complete obsession with American democracy. The muscular depiction of the war workers indicates and symbolizes the strength and power of a democratic society. The artist has included himself

as a participant in the engineering process by painting himself into the lower corner as a team worker. The striking forces of black and white are dramatically expressed in *Labor in a Diesel Plant*, which is the result of the ideal medium of expression for the dynamic, muscular, figurative forms of the war effort.

The theme of the swing shift was popular for artists during World War II, and compositional approaches to it were varied. Unlike Barnet's version, Donald Vogel's *Swing Shift* (1943) incorporates both the incoming and the outgoing shifts of war workers. Vogel's etching of architectural design is totally objective in arrangement and yet includes the parade of human images as a unit or team rather than as individual personalities. The universality of the daily work schedule is witnessed in an unidentifiable workforce lacking in emotions but dedicated to the cause of freedom. There is a oneness, a truly unselfish devotion to a single purpose.

Swing Shift depicts coal miners, its only identity being an obscure sign in the uppermost corner of the etching: "Peerless Coal." Because of the total objectivity, one would suspect a lack of emotional reactions as well; and yet, the quiet and somber mood created by the atmospheric conditions of the nighttime incident does not erase the individual intensity of purpose.

Structural buildings do not compete with the human factor, since Vogel was careful to structure

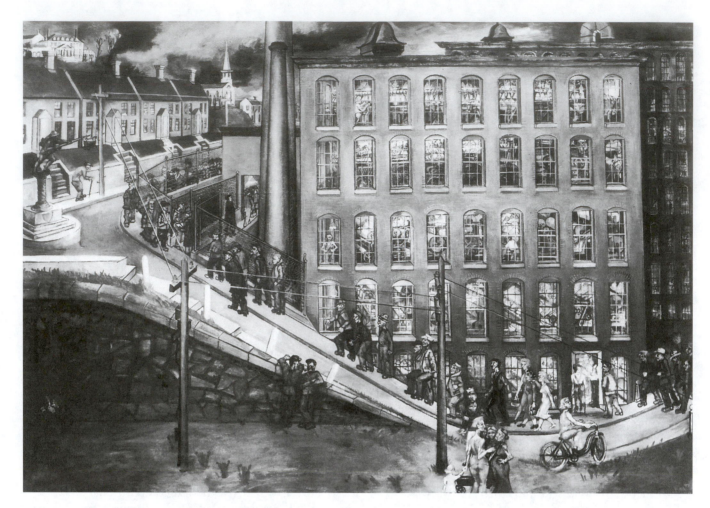

Philip Evergood. *Through the Mill* (1940). Oil on canvas. 35 × 52 in. Collection of the Whitney Museum of American Art, New York. Purchase (aq. #41.24).

individual stretches of walk space for the coal miners. Vogel's *Swing Shift* is a companion piece to Philip Evergood's *Through the Mill*, which also features shift changes.[3] Although Evergood's painting is dated 1940, it was nonetheless attributable to the ever-increasing tension of war fears. Hitler's invasion of European nations had already devastated world peace. And the war effort had already affected war material production in the United States, aiding Great Britain and France.

The swing shift had become automatic. Industry was at full force. The defense worker became an important part of the total scheme of winning the war against aggression. In spite of its multifacet objectivity, *Through the Mill* reflects a profoundly subjective progression of individual purposes, and yet each purpose is singularly directed to the war effort.

The dynamic lithograph *War Worker* (1943) depicts a black man as a machine operator for the war effort. The work, by Ira Moskowitz, is a pow-

erful rendering of dark images with appropriate highlights. Light reflections are scattered throughout the composition and reside on particular body parts of the war worker. The physical structure of the black operator controls the powerful machinery while both are superseded by the drama of the event, established by the source and distribution of light. The foreground and background are darkened so that the focus of attention is on the central portion of the painting.

A similar view is presented in Jay McVicker's etching *Arc Welder* (1943), in which a worker is silhouetted against a brilliant light emanating from a blast furnace. As in *War Worker*, light is distributed appropriately throughout the composition as a unifying technique. According to the artist, "*Arc Welder* represents one of many episodes that occurred on a night shift of the construction project."[4]

The darkness of the environment and the circumstances surrounding the event create an

eerieness that sets the tone and emotional reaction. Aside from its dramatic appeal, the challenge of reversing darks and lights to accommodate an unusual scene became an artistic stimulus. The simplicity of design adds to the drama of the activity.

Arc Welder is a remarkable work. It is a subjective portrayal in spite of its intellectual concept and its eloquent rendering. It is objectively executed and yet conveys a personal and intimate message. *Arc Welder* is a contemplative piece, a meditative, peaceful scene of a person devoted to a singular purpose.

Although the act is commonplace for the worker, sparks of light created by the act of welding, generate a mood of solitude and isolation. One is indeed placed within a realm of contemplation and prayer. Whether intended or not, spiritual overtones are present.

Edna Reindel portrays women at war work in her provocative painting *Drilling Holes* (1943).[5] Even though her series of paintings *Women at War* served to advance the feminine cause in the war effort, they also served a highly artistic purpose. Strangely, her style of painting was interpreted differently by two factions. To the layperson and to the U.S. Defense Department, Reindel's paintings of the war effort were considered true to life and answered the calling. However, to the art critic and the historian, her work seemed to verge on the surreal.

The literally exact recording of helmeted defense workers drilling holes into essential war materials is indeed realistic, and yet, Reindel's style of painting translates the real into the unreal. The women war-workers were seemingly caged in their own cerebral helmets. Although the helmets worn by the defense workers were objects that were required to be worn, the women resembled caged robots whose jobs were regulated by machines rather than humans.

One is reminded of George Tooker's *Sleepers*, in which humans are void of personalities. In Reindel's *Drilling Holes*, the monotonous, repetitious job resembles the brainless heads of Tooker's *Sleepers*.[6] In a sense, that is the essence of war. Logic and sanity never seem to motivate an outbreak, even though such human qualities are essential to winning.

Home Front (1943), a lithograph by Jolan Gross-Bettleheim, portrays mass production at a munitions plant. Again, Tooker's *Sleepers* comes to mind as Gross-Bettleheim's unidentified,

impersonal female images work the machines in robot-like fashion. The philosophy during the war on all fronts, including the defense plants, was the singularity of purpose — to win the war. That singleness of purpose is witnessed in *Home Front* as all participating war-workers become glued to their respective assignments. The lithograph differs from Tooker's work in terms of artistic purpose. Whereas Tooker's subject matter relied on images of hopelessness and despair, Gross-Bettleheim's role-players were optimistic and victorious in their quests.

Visual perspective is totally and completely ignored as foreground and background merge into a single frontal plane. Yet, on closer scrutiny, certain aspects of factory units recede and advance to form optical illusions. It is this play with sharp contrasts that dazzles the visual senses even though the monotony of workmanship remains. Gross-Bettleheim took a monotonous theme and transformed it into an exciting display of semi-geometric shapes with perfect harmony. The simple contours of the workers' faces indicate the singleness of purpose and the intense concentration to the task at hand. Conveyor lines motivate the composition, but because of the complexity of design, visual perspective is difficult to ascertain. *Home Front* is the power of mass production in the dedication of oneself to a cause to serve all of humanity.

The artist Edna Reindel made the song "Rosie the Riveter" popular during World War II with her painting of an identical title. Another artist, Howard Baer, did a series of paintings also acknowledging, and in some cases glorifying, women's part in World War II. On the homefront, defense workers were highly significant members of the World War II effort. In Baer's painting *Waves Take Over* (1944), sailors and Waves work harmoniously to repair seaplanes.[8] Although recorded realistically, Baer's painting expressed a sense of singleness and individual dedication. And yet, a team has emerged in working for a common cause. There is no emotion because of the routine fashion of the work, the monotony and commonplace, and the total and complete necessity of performance. The Navy Waves were a prominent force abroad and at home. Although objective in its figurative forms and details, this painting, in its compact unity, does lean toward the personal and subjective expression.

Edna Reindel painted the popular *Rosie the Riveter* (1943).[9] Artistic freedom is witnessed in

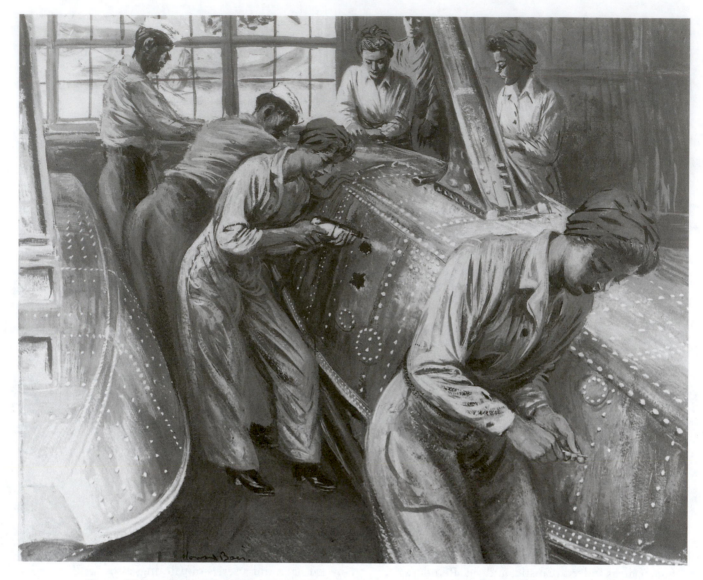

Howard Baer. *Waves Take Over* (1944). Oil on canvas. U.S. Navy Art Collection, Naval Historical Center.

Reindel's version of Rosie. The eye shield, which was required by safety law, was omitted in favor of the attractive facial features of the essential role-player. Two factions dominate *Rosie the Riveter*: the figurative form of Rosie and the spray of ignited sparks from the welding apparatus.

In spite of intersecting planes of background machinery, visual anticipation occurs when viewing the distance between the eyes of the riveter and the spot being riveted. A second activated space occurs between the spot being riveted and the spark settlement at the floor base. The compositional movement of the figurative form adds to the rhythmic pattern. The downward movement of the ignited sparks is softened and redirected in the bodily form of the riveter. *Rosie the Riveter*, although painted in the 1940s, resembles the work

of a photorealist practicing during the 1980s. Reindel's painting is a compositional delight.

Similar to Reindel's *Women at War* series is Minna Citron's *Welder* (1941).[10] The painting reflects an eerie image of a defense worker whose personality is totally hidden by protective paraphernalia. Steel helmet, eyeglasses, leather gloves, and heavy coveralls shield the worker from sparks of fire, presenting a surreal image within a realistic environment. Related tools and machinery form a circular composition surrounding the subject. In spite of the focal point of the welding spot and the attention tended to the visual distance between the eye-hand coordination of the subject, appropriate positioning of the several items of a mechanical nature unites to form a total expression. The undefinable portrayal of the subject

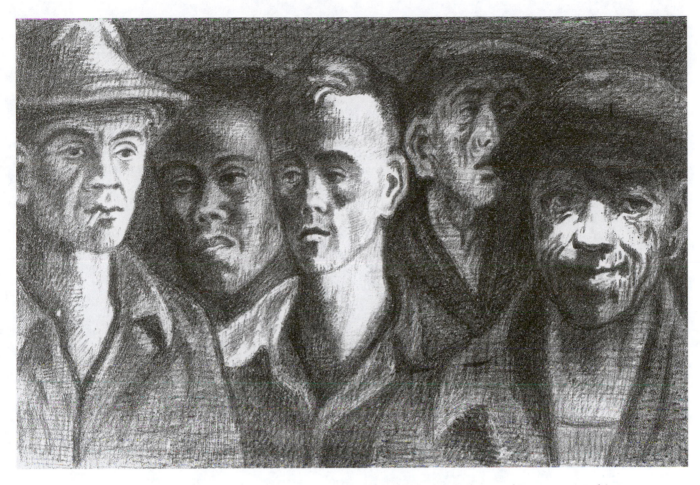

Moses Soyer. *War Workers* (1936). Lithograph. 25.5 × 38.3 in. Collection of the Library of Congress, Washington, D.C.

suggests a universality of theme that contributes to the national war effort.

Making mess kits for the army may seem commonplace, but in *Making Mess Kits* (1943), George Beyer has created a truly American attitude toward the war effort. The lithograph portrays defense workers during World War II. With his expression, Beyer transformed a routine product into one of significance.

In *Making Mess Kits*, visual perspective is evident in the recession of the defense workers. The human condition is balanced by the mechanical environment. The complex arrangement of subject matter serves to amplify the intense dedication of defense workers to the war effort.

During the war, the production of war materials allowed the American worker overtime employment that better served the needs of the armed forces. *Making Mess Kits* is a composition of the human and the mechanical. In spite of the compact and complex arrangement of humans and machines, there existed a respect for the machine

because of its purpose in producing goods and materials that served and saved the lives of American troops. Social activity on the job was seldom encountered because each worker had a set goal to be maintained according to government schedules. *Making Mess Kits* became a challenge for Beyer, as well as a recording of an essential event of the war effort.

War Workers (1936), by Moses Soyer, is an expression of sorrow. The theme has no bearing on the emotional facial gestures of the five men. Although bonded together by a single cause, each role-player sustains personal concerns.

Because of the subjective view attended each participant, each becomes a study of emotions. Soyer's models resemble a police lineup instead of war workers engaged in the crucial task of the manufacture of war materials.

Remove one figure, and the composition collapses because of the appropriate overlap. Full facial expressions are in evidence even though a consistent overlap of figurative heads prevails.

Natural lighting is forsaken in order to create a more haunting composition. The focus is on the three figures in the forefront, with sharp contrasting facial features. The viewer becomes a member of the quintet of workers. They are dedicated to the preservation of democracy and world peace. *War Workers* reflects several interpretive titles, and the role-players are the same figurative forms that are witnessed in other Soyer works. His two brothers, Raphael and Isaac, differed little in their choice of subject matter and technical skills. In fact, it is indeed difficult to differentiate one brother's work from another. However, *War Workers* is a traditional theme and compositionally in tune with the times and the artistic climate of the early 1940s.

War Workers possesses a sense of compassion for the people that Soyer portrays. They appear sad. The figures seem posed yet photographed as if caught off-guard. The painting reflects a toilsome day's work that extended beyond a single eight-hour hitch. There is an element of burnout, a silent plea for the war's end. And Soyer has forced the viewer to acknowledge each individual plea by avoiding an environmental background. Since the workers' images absorb the entire working surface, the viewer can focus totally on the image of the war workers.

Personalities change slightly from one character to another by a single gesture — a glance, a twinge, a smirk, a smile, a frown. But all sustain a common bond to work toward an American victory.

CHAPTER 8

The Homefront

The homefront has been illustrated in diverse situations but always in a positive manner. A woodcut by William Soles, *The Freedoms Conquer* (1943), dramatically defends democratic rights.[1] The title itself illustrates an American victory over greed, power, and insanity. The artist utilized an environmental background of democratic principles and practices better known as freedoms—opportunity for success and advancement, freedom to worship in one's own religion, the family unit, agricultural participation, freedom of speech, freedom to assemble, and freedom from aggression.

Soles focused on the major aggressors, Hitler and Hirohito, whose portraits are positioned in aggressive and defiant action in attempts to overtake the American dream. However, in defense is the strength of American war power. *The Freedoms Conquer* is a compelling expression of belief in one's national principles and the determination to save the nation from opposing forces. The artist has acknowledged defeat for America's enemies.

Hitler and Hirohito both tightly grip the swastika image while Hitler simultaneously waves a dagger in defiance. Their chances of success as aggressors are dramatically thwarted by the American bayonet splitting the swastika and entering the throat of the surprised Japanese emperor. *The Freedoms Conquer* is a compact and complex composition. The artist detailed his approach as follows: "Like everyone during the war, I was much concerned about its outcome, and our aims in it. Consequently, my prints of that period reflected that concern, and *The Freedoms Conquer* was one of that group. I do not believe that one print can do very much, but it adds to the force of a belief if many artists battle away at an idea.

My feeling about the war as conflict I tried to translate into graphic terms, opposing black against white, form against form, diagonals piercing the dignity of verticals, destroying the peace of horizontals."[2]

A totally different approach to the homefront theme is witnessed in Robert Gwathmey's serigraph *Rural Home Front* (1943). A quietly subdued expression but of an eerie atmosphere provokes a sense of nostalgic calm for those with wartime memories. Those of later generations feel an envy of those slow-paced events of the rural landscape. It is best described by the artist himself: "I've simply taken various rural images and combined them in a composite picture, showing the total effort of farm people, including the children. I've used two flat colors and have been particularly aware of the two dimensional space."[3]

Rural Home Front is a semi-abstract pattern of realistic images held together by a color design. The environmental habitat is darkness, into which are positioned several images of farmland. The Gwathmey style prevails—flatly painted shapes defined with contours of varying degrees. The brass bed, the primitively designed quilt, the

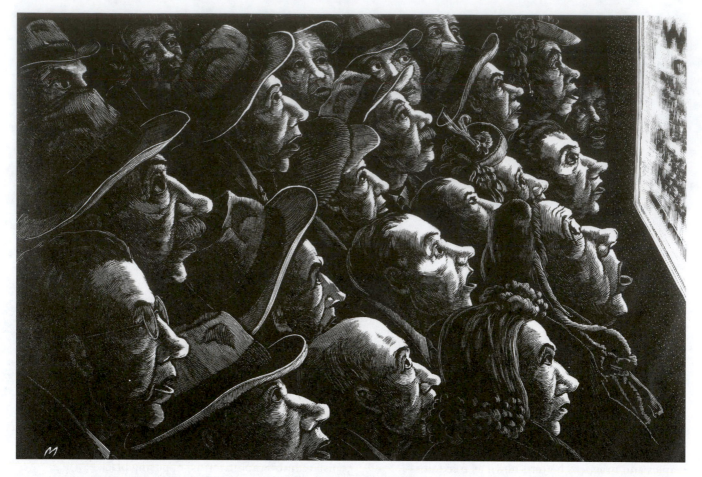

Leo John Meissner. *War Bulletins* (1942). Wood engraving. Collection of the Library of Congress, Washington, D.C.

outhouse, the mother toting wood for the fireplace, the father tilling the soil, the children picking crops, and the newborn propped nakedly in bed symbolize the rural scene. The single clue to the war is the star attached to the distant background.

War bulletins kept the homefront alert to the latest developments. Newspaper extras, radio broadcasts, and posted billboard messages were common. A unique example is Leo John Meissner's wood engraving *War Bulletins* (1942).[4] It pictures a crowd of people whose facial expressions reflect the fear of uncertainty. Each witness to the news is awed by the latest events of the war.

The use of highlights on the faces of the crowd creates an eerie sense of the unknown. The news reflected on the posted screen is astonishing and undoubtedly tragic for the American people. The imagery is amplified by the similarity of action and the repetition of human reaction. The intensity and anxiety of wonder is multiplied by the number of role-players.

Meissner focused on the effects of the war

news on those viewing the message. The message itself is less important than the human reactions, the emotional changes evolving from the war news. The artist's deliberate focus on human reactions and his intentional evasiveness and purposeful neglect of a significant placement of the cause of effects permits him to give full view to the effects of the event rather than to the event itself.

The artist unloaded the burden of war from the viewer and cast it on the viewers in the painting. Meissner realized that the tragedy is measured in direct relationship to the extent that it emotionalizes those who may be directly affected by it. In other words, the truth is told through the results of motivation, and in *War Bulletins*, the motivation *is* the war bulletins.

This notion of avoiding nonessential aspects of an environment in order to fully focus on the subject matter is a major premise of subjectivity. Yet, several artists have preferred to include both cause and effect and, by so doing, sacrifice the potency of both. This may result in a psychologically and compositionally accurate recording of

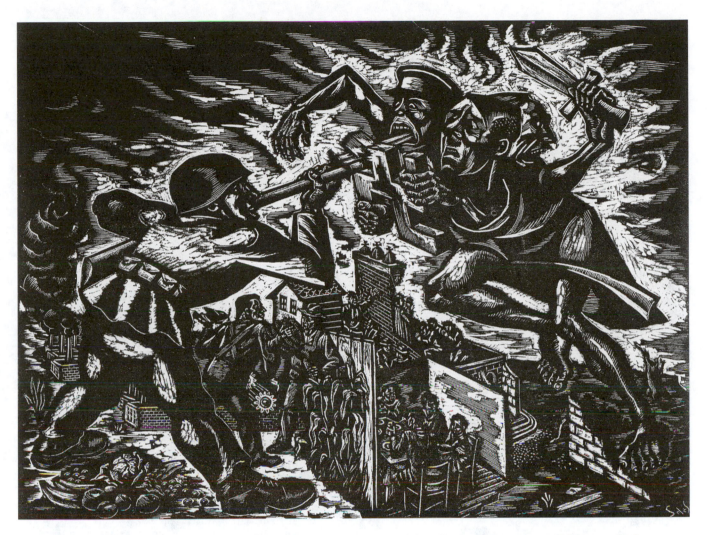

William Soles. *The Freedoms Conquer* (1943). Woodcut. Collection of the Library of Congress, Washington, D.C.

the event, with the emphasis on either relying on the discretion of the artist.

The cause is better served by its inclusion in the picture plane. To exclude the cause would intensify the effects on the human condition. In other words, the tragedy becomes more effective in its transfer from the cause to the effect.

Meissner's *War Bulletins* forces the viewer to merely acknowledge the news bulletin as the cause of the awesome reactions of the American citizens. The dramatic response was created initially by the war news, but also by the artist who has chosen the appropriate medium of expression. The extreme contrast of color (black and white) also adds to the drama of the event.

Although individually portrayed, human emotions amass to form a unique commonality, a subjective experience that has permitted the viewer to participate as a witness.

A popular lithographer during the Great Depression and later during the war years, Caroline Durieux produced the charming work *Bourbon Street, New Orleans* (1943), which captured the attention of a wide audience.[5] The lithograph depicts two singers entertaining a crew of sailors, who constitute the secondary subject matter. The viewer's attention shifts to and from the primary figurative forms of the entertainers and the appreciative audience.

Bourbon Street, New Orleans, is a reminder of the USO groups that entertained the troops worldwide. In this instance, however, the homefront was hosted.

The furnishing of food for the armed forces was a basic homefront activity. Frederick Detwiller expressed one event of wartime America in his serigraph *Sardines for the Army*.[6] The activities related to the preparation not only are expressed in art form but also are illustrated with the following statement: "The print was made from

Caroline Durieux. ***Bourbon Street, New Orleans*** **(1943). Lithograph. Collection of the Library of Congress, Washington, D.C.**

a series of watercolor studies made in the fish wharves in Maine. In sequence I want to express the various stages in the preparation of the sardines; the boats that bring them in from the sea and the fisher folk cleaning them on the cutting tables. To do this I used the diagonal relation of shapes and color and linear perspective."[7]

The activity itself relates the objectivity of Detwiller's recording of a common occurrence at oceanside cities. Individuals lack personalities because the teamwork is needed. Details become

William Johnson. *Red Cross Workers Handing Out Wool for Knitting* (1942). Oil on canvas. National Museum of American Art, Smithsonian Institution, Gift of the Harmon Foundation.

blotches of color strewn about in disorderly fashion. It is an event recorded at the scene during the moments of involvement.

The homefront activities not only served a common cause but also created a form of integration of events among people throughout the nation. While husbands and fathers were at war overseas, their families were attended to at home. An example is William Johnson's rendition *Red Cross Nurses Handing Out Wool for Knitting* (1942). This "shows one of the Red Cross's basic public services. Johnson places the Red Cross 'Gray Ladies' and their patrons in one of his typical rural-folk settings. *Red Cross Nurses Handing Out Wool for Knitting*— with its stark landscape and sculptural, transfixed women and children — could easily be interpreted as depicting some time-honored African ritual, involving an 'offering' by three cross-bearing priestesses."[8]

It may seem strange that an artist of Johnson's stature should resort to the childlike expression of elementary children. The flatly painted figures, whose three-dimensional qualities are totally neglected, the remnants of the baseline theory, the typical childlike facial features, and the lollipop trees all unite to form a primitive painting. However, the difference between Johnson and the primitive school of art is Johnson's return to primitivism from abstract expressionism and realism and the never-changing tactics of the self-taught artist.

Johnson's painting seems a matter-of-fact portrayal of a not-so-important event. Yet, with his unique style, he has alerted the American people of the needs of the homefolk as well as of the services rendered by the Red Cross.

Johnson's childlike images are continued in his painting *The Home Front* (1942). Skinny necks protruding from broad shoulders, huge hands anchoring slim, elongated arms, skinny legs

Jack Levine. *Welcome Home* (1946). Oil on canvas. 101.5 × 152.3 cm (39 $^{15}/_{16}$ × 59 $^{15}/_{16}$ in.) Brooklyn Museum of Art, John B. Woodward Memorial Fun. 46.124.

hooked onto dress hems, and curved lines representing noses are incorporated into a composition of vertical panels of color. The simplicity of both foreground and background forces the viewer to focus on the subject matter. Johnson purposely omitted extraneous matters that would interfere with a full appreciation of the family unit.

In *The Home Front*, according to the author Richard Powell, "the uncompromising frontality, rough, textured surfaces, and big questioning eyes and groping hands of the figures work in concert to fuel a vague, but persistent, thematic sense of anxiety."[9]

Emily Genauer, a New York critic, wrote: "Johnson is a Negro, and his subjects are always Negroes. And yet, as depicted by him, they're devoid of any consciousness of race. They're not particularly emphasized as people, but rather as elements in his design. He distorts and stylizes them and then organizes them into flat, shadowless compositions built on a linear pattern. They're almost like cartoons, but they are put together with an extremely original flair for design, with a pervading sense of movement and rhythm."[10]

As mentioned earlier, a war offers a diversification of subject matter. A case in point is Jack Levine's satirical *Welcome Home* (1946). The painting is a revengeful attack on his commanding officer and the U.S. Army snob system. The entire group of bigwigs was effortlessly and convincingly portrayed by individual figurative images. Although personally situated, they constitute a singular unit and thus initiate a subjective experience. Each character plays a significant role in the scheme of things. Each personality enhances the appearance of another. Levine has engaged in a sardonic exploitation of the wartime army caste system.

Opposite: William Johnson. *The Home Front* (1942). Oil on canvas. National Museum of American Art, Smithsonian Institution, Gift of the Harmon Foundation.

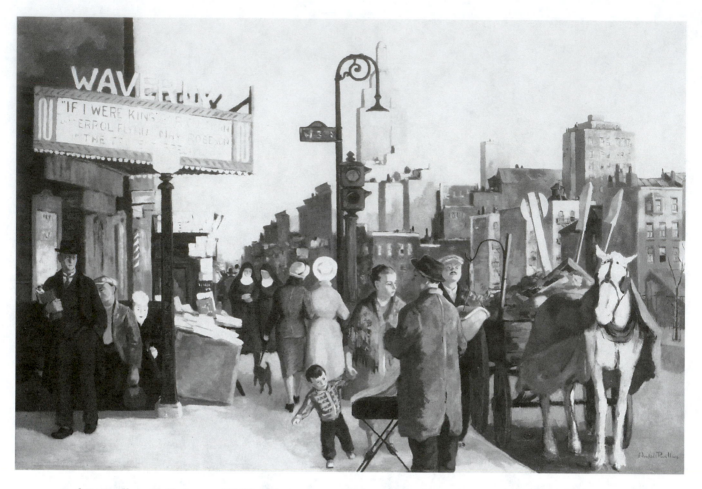

Andrée Ruellen. *Sixth Avenue* (1945). Oil on canvas. 28½ × 42½ in. The James Philip Gray Collection, Museum of Fine Arts, Springfield, Massachusetts.

Levine's attack is personal, which may elude the viewer. To some the painting may appear to be a portrayal of greed as an individual trait unrelated to any wartime experience. But to the initiated, it is a harmless revenge, a satisfying reproach to a timeless discriminatory practice. *Welcome Home* is a compact picture, an endless portrayal of an endless grouping of pseudo-socialites whose claim to fame is pomposity and greed accumulated at the expense of the commonplace enlisted man.

The sin of greed is replaced with the evils of gluttony and the deliberate exaggeration of the physical beings. The refilling of champagne glasses also releases a note of grandioseness that fits this gala affair.

Although the homefront assisted the war effort in terms of recycling, rationing, and entertainment features such as USO clubs and veteran organizations, employment was at an all-time high, which made Andrée Ruellen's painting *Sixth Avenue* (1945) seem commonplace. Yet, the 1940s

were a unified decade of cooperation and understanding."

America learned to pray in silence and dedicated itself to a seemingly normal way of life. Executed during the peak of the war, *Sixth Avenue* portrays the American citizen tending to daily chores, but beneath the quiet movements and body gestures are elements of anxiety. The street vendor with his faithful horse and wagon loaded with fresh fruits weighs food for potential buyers. Nuns wearing the traditional habits walk pensively along the crowded thoroughfare. The corner newsstand exhibits the latest news about the homefront and overseas. The theater marquee advertises a double-feature program as sheer entertainment instead of a war reminder.

Ruellan was a master at incorporating several compositions within a large picture. Spatial distances are featured as people recede and advance on the picture plane. There is a stillness to the scene, a resignation to accept the unpredictable future.

The homefront effort involved the rural areas as well as the urban communities. The farmer produced wheat and grains for overseas consumption by the American GI in all parts of the world. The artist Leo Rosco Weeks illustrated the farmer's cooperation in the war effort in his painting *Stacking the Straw* (1944). It is a realistic recording of an autumn agricultural chore. Surplus crops were destined for European and South Pacific armed forces, and the farmer was compensated for his efforts.

Weeks' portrayal of picking and stacking wheat sustains an expressionistic flavor. Brushstrokes are brisk and sure but reflect a movement. A cloudy, tempestuous firmament is matched by the rugged roadway in the foreground. The farmers are eagerly at work as the figures and objects blend into a single experience. The diminutive size of the painting suggests a carefully designed composition, indicating an intuitive application of pigment. There is a sureness of touch: a few brushstrokes are enough to identify familiar farm animals. The human form emerges, although indistinctly, in a frankness that suggests tenants of the soil who seem anchored to the farmland as if emerging from the earth's surface.

Although the homefront assisted the war effort by recycling and rationing products and tooling essential war machines, the homefront was also the scene of weeping widows and mothers. *Weeping Girl* (1941), a dramatic painting by Fletcher Martin, represents the thousands of women left at home to mourn the loss of loved ones.[12] Martin's dramatic exposure of the female form, tearless and faceless, reflects beauty under duress. The unrelenting pose of total anguish is unusual for Martin, whose female forms are generally nude or partially clothed. The viewer is drawn to the total collapse of physical stamina.

It is a scene that prevailed throughout the decade of the 1940s. In fact, long after World War II, the sorrow remained. Thousands of homes throughout America displayed the emblem of the war dead. The horizontal composition has heightened the agony of the victim, as the simple environment is muted to accentuate the lone occupant of a terrifying experience. The gritty textural quality of the canvas adds to the drama and sustains the agony of the victim for as long as the painting remains in existence.

The horizontal approach is further dramatized by the elongation of the figure, not by deliberate distortion or exaggeration, which is often the case in emotional reactions, but by the angle from which the artist portrayed his role-player. The upper body is fully stretched, as if expelling the final anguish, and although the scene is realistically portrayed, one is plagued by the intuitive nature of the painting. *Weeping Girl* would seem to incorporate tears and facial anguish, but Martin communicated his message more dramatically by eluding such obvious features and assumes the viewer onto the scene.

Welders (1943) by Ben Shahn is a superb example of the artist's subjective reaction to a theme. Welders were primary sources of home defense and were awarded special recognition in war defense plants throughout America. Ben Shahn's version captures the intensity of the theme as each welder is totally committed to the war effort. Helmets and protective eyeglasses create a warlike atmosphere. The gaze of each welder fulfills a spatial obligation in which the viewer is beckoned to focus on an invisible focal point as well as a point beyond the picture plane.

Total unity is also performed with the inclusion of racial harmony in the persons of the welders, and to amplify this union of races, Shahn has muted the background, thus forcing total attention to the subject matter. The extension of the welder's arm across the canvas fulfills a compositional need as well as the need to identify with the activity. The welder's hand illustrates the hardship of defense work and is a reminder of America's total war effort.

The severe separation of the two welders from each other is diminished by the visual glances of the role-players and by the head slant of each participant. Shahn was noted for his approach to viewers. His forceful posters during the war were a great aid in the conditioning of social awareness to the war and the freedom for which it was being fought.

Shahn's *Full Employment after the War Register Vote* (1944) is a lithographic poster of the same image. The welders remain undisturbed by the lettering layout that is a direct statement. The work was a plea for peace and a hope for total employment following an American victory. The transition from war defense contracts to domestic production generally results in pink slipping. Shahn's plea was for a satisfactory transition.

A painting by Clarence Carter, *Outside the City Limits* (1938–46), strongly suggests a patriotic celebration of Independence Day.[13] The rural setting and the title indicate a ban on the sale of

Ben Shahn. *Welders* (1943). Tempera on cardboard. 22 × 39¾ in. (55.9 × 100.9 cm.) The Museum of Modern Art, New York. Purchase. Photograph ©2000 The Museum of Modern Art, New York.

fireworks within city limits. Carter has made ample use of the American flag, forming a parallelogramic composition that encircles four human characters located within the midst of a frequently used fruit-and-vegetable stand.

The intricate arrangement of vertical and diagonal planes complement each other but overshadow the human element. The compact and colorful display of fireworks is a factual recording of the scene but supersedes the human dialogue between seller and buyer. The rural environment, already accommodated by textural details of grasslands and tree foliage, is intensified by shadows and highlights of a brilliantly sunny sky.

On the homefront, the corner newsstand was crucial to the passerby, whose views of the war were substantiated by the latest news. Paul Haller Jones' painting *St. Anthony* (1945) recalls the universal newsstand that was particularly popular during the war and that could be witnessed in cities and villages throughout the nation.[13] The title was derived from the familiar personality of Tony, affectionately called "the paperman," whose "sainthood" stemmed from his devotion to his career through the roughest atmospheric conditions.

St. Anthony is an image of a typically crowded newsstand of magazines and newspapers that record and report the latest views and news of the war. "Tony" is pictured in appropriate attire for the onslaught of winter. Newspapers hang at varied angles as Tony looks outside the picture plane to satisfy the buyers' wishes. The chaotic appearance of the newsstand matches the shabby attire of the "saint."

What appears as an expressionistic version of a commonplace theme is in actually a diligently organized construction. Although the layout was carefully conceived and executed, Jones intuitively applied pigment to create an active and moving replica of the corner newsstand. Apparent disorder is really a profound and decisive deliberation of subject matter. Jones succeeded in recording a segment of the homefront war efforts, a single person's concern for the freedom of democracy. His approach, although more realistic than most others, is a resemblance to the abstract expressionist movement of the 1950s.

A lithograph by Albert Abramovitz, *Letter from Overseas* (1944), illustrates the intense anxiety created among family members. The artist has gathered together a father and his family in an

effort to relate tragic or otherwise news of the son in service, whose portrait hangs appropriately on the wall as a constant reminder of the sacrifice. The portrait serves both the compositional needs of the artist and the psychological needs of the depicted family.

Letters from overseas were commonplace and, although rigidly censored by the government, gave hope to those families who daily prayed for the war's end and the safe return of their loved ones. Daily chores were suddenly interrupted when such letters arrived. The apprehension and anxiety are reflected in the facial expressions of family members. Abramovitz's portrayal is an example of thousands of similar events that occurred daily in homes throughout the nation. Although incidental, three generations coexist in Abramovitz's portrayal, it was a common relationship of compatibility during the war years.

The USO group of entertainers was a major morale booster for the American armed forces. USO centers were located in major cities throughout the nation and were usually hosted by Hollywood screen stars. The artist Alicia Legg, in her lithograph *Hopeful*, has identified her group with the USO banner stretched across the background of the expression. Partially hidden behind the lineup of role-players, who are all beautiful women, is the USO sign, shrouded in semi-darkness. The figurative forms dominating the forefront seem to beckon the figure onto the scene. The viewer becomes a spectator.

The identification symbol as a compositional element performs as an activated force uniting the mechanical with the human; facial expressions play an essential role, since variety creates visual movement. Each personality, although singularly rendered, constitutes a team of players, a unit that presents a sense of subjectivity.

Works of the forties were usually naturalistic or realistically portrayed. Aside from the few abstract artists, such as Stuart Davis, John Marin, and Lyonel Feininger, the easily recognizable subject matter was typical of the war years.

An unusual homefront illustration is Mara Malliczky Schroether's wood engraving *Worker and Soldier* (1944), a rendition of warfront and homefront unity. An adjacently positioned soldier with fixed bayonet and a shielded defense worker are bonded together in the common cause for peace and freedom. Protective headgear guard both, as each faces an imaginary foe.

The balance of highlights and shadows adds dramatic effects to a powerful composition. Sharp angular shapes sustain the viewer's interest as one visually encircles the subject matter. A third element, which resembles an explosion as well as a blast furnace, acts as a target of attack; it also halts the viewer's visual exit from the picture plank. Schroether leaves little room for objective observation. The closeup view absorbs the litho stone and forces the viewer to engage in the artist's intent. *Worker and Soldier* is a fine rendition of total commitment to the cause of freedom.

T. C. Galloway. *Operation Soapsuds* (1943). Oil on canvas. 35 × 36 in. Courtesy of the U.S. Air Force Art Collection.

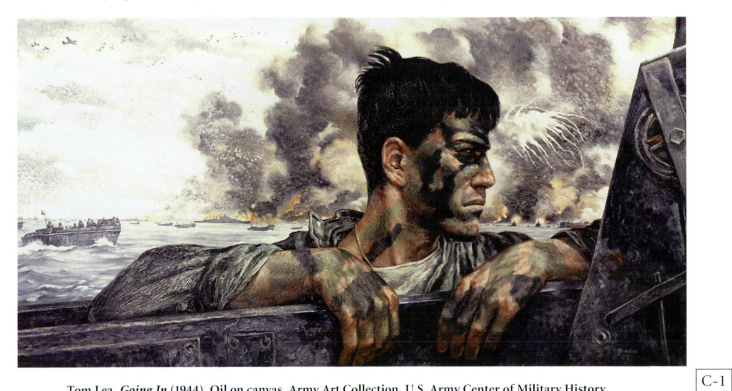

Tom Lea. *Going In* (1944). Oil on canvas. Army Art Collection, U.S. Army Center of Military History.

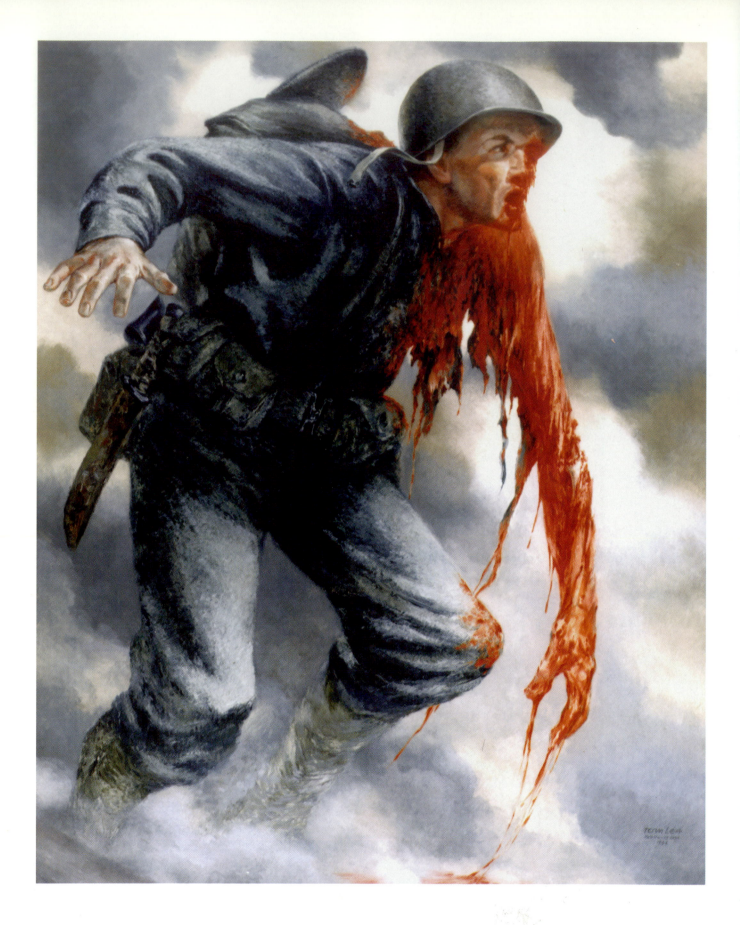

Tom Lea. *The Price* (1944). Oil on canvas. Army Art Collection, U.S. Army Center of Military History.

George Biddle. *War Orphans* (1944). Oil on canvas. 25 × 30 in. Army Art Collection, U.S. Army Center of Military History.

Peter Blume. *Fracture Ward* (1945). Oil on canvas. Army Art Collection, U.S. Army Center of Military History.

C-4

Right: Franklin Boggs. *Hospital Ship Approaching San Francisco* (1945). Oil on canvas. Army Art Collection, U.S. Army Center of Military History.

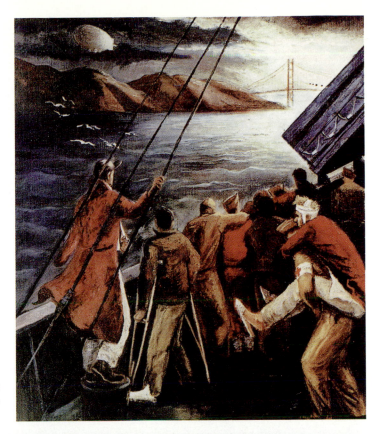

Below: Robert Benney. *Flashlight Surgery in Saipan* (1943). Oil on canvas. Army Art Collection, U.S. Army Center of Military History.

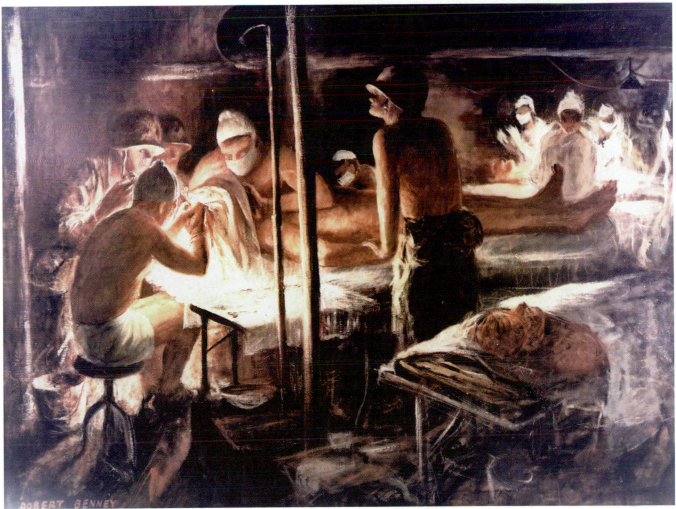

C-6

Left: Charles Baskerville. *Shooting the Breeze* (1947). Courtesy of the U.S. Air Force Art Collection. *Right:* Hans Mangelsdorf. *Tokyo Station, April 1945* (1945). 42 × 30 in. Army Art Collection, U.S. Army Center of Military History.

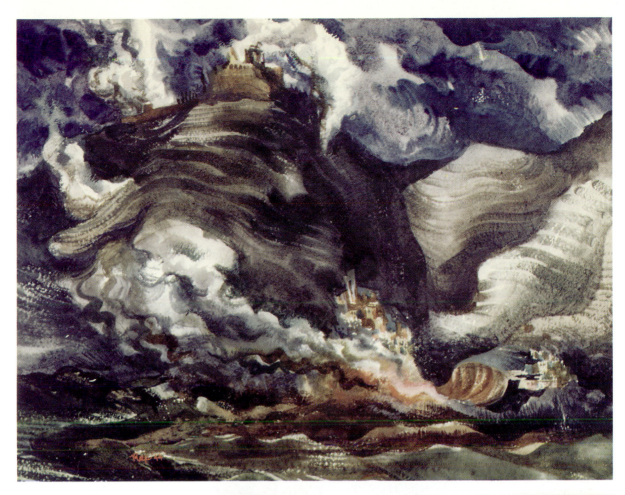

Above: Edward Reep. ***Bombing of the Abbey*** (1944, Cassino, Italy). Watercolor, 17½" × 22¼". U.S. Army Art Collection. W.6.177.45.

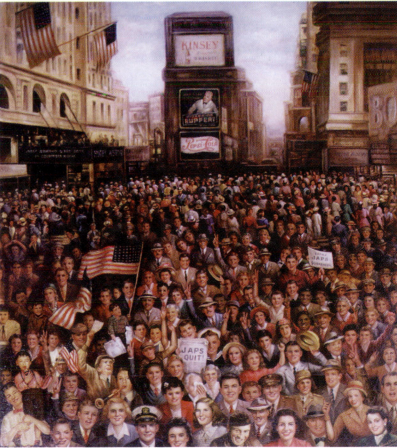

Right: Edward Dancig. ***V-J Day: Crowds Cheering at Times Square*** (1947). Oil on canvas. Private collection, courtesy of D. Wigmore Fine Art, Inc., New York.

Abraham Rattner. *The Last Judgment* (1953–56). Oil on panel, triptych. 96 × 144 in. Leepa-Rattner Museum of Art, St. Petersburg Junior College.

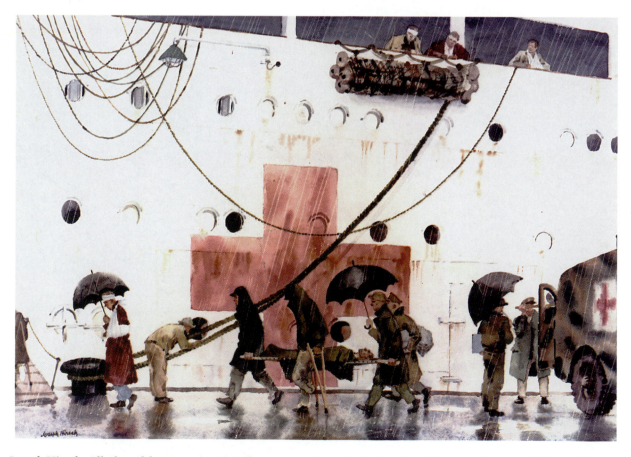

Joseph Hirsch. *All Aboard for Home* (1946). Oil on canvas. Army Art Collection, U.S. Army Center of Military History.

CHAPTER 9

The War and Religion

Since World War II, many artists have submitted their mental, emotional, and spiritual talents to a divine cause. Such great artists as Abraham Rattner, Umberto Romano, Fred Nagler, Rico Lebrun, William Congdon, David Aronson, Jon Corbino, Seigfried Rinehart, Louis Freund, and others have dedicated their lives to the artistic expression of spiritual beliefs and have reached for the meaning of life after death.

Other artists, such as Philip Evergood, Leroy Neiman, Paul Cadmus, Robert Indiana, and Aaron Bohrod, have utilized the theme of religion as a soothing ingredient in war's effects on humanity.

Although *Crosses and Stars* (1944), by Leslie Lane, is appropriately discussed in a chapter dealing with the war dead, it sustains a loftier level in its relationship to religious beliefs.[1] The fact that the hundreds of crosses designate the graves of those war victims does not erase the fact that the cross symbol itself represents the death of Christ, the beginning of the Resurrection but the end of life on earth.

Crosses and Stars is a pastoral scene, truly peaceful. The tedious rows of white crosses seem endless aisles of sacrifice. The partially sunny skies cast shadowy images on the earth's surface while the partially cloudy firmament suggests the remains of war clouds that seem forever present. Lane constructed three horizontal planes, each of which portrays individual activities, which in turn contribute to the unification of the whole.

The element of religion may be only symbolic, but the numerous crosses nonetheless create a fervor for Christianity. In *Crosses and Stars*, the meticulous handling of the white crosses differs drastically from the suggested rendering of the environmental background.

The author Alexander Eliot has described Aaron Bohrod's painting *Military Necessity* (1943) as follows: "World War II has vastly widened the range of his subjects to include the South Pacific fighting and the liberation of Normandy. His stormy canvas of a Normandy village crucifix strung with Signal Corps wires, aptly titled *Military Necessity*, tells a great deal about the nature of all war, and in eternal terms."[2]

The word "eternal" strongly suggests divine intercession. The symbolism of Signal Corps wires entwining the image of Christ is the interpenetration of the American soldier and divine providence. Bohrod was a master at detailing the unusual and the eerie, and the lone soldier postured at the base of the huge crucifix is a symbol of the war/religion connection, the need for humanity to answer to a greater being than oneself. In a sense, the presence of Christ is overlooking and protecting the security of the lone American soldier and all those who have fought for the freedom of religion and democratic rights.

Even though tanks appear on the landscape of war-torn terrain and the city shows signs of battle, the horizon reflects a coming resurrection. Bohrod

included the essential combination of life and death, and as the title suggests, "a military necessity" is exactly that, as it refers to the subject matter of the American soldier and the crucifix of Christ. The fact that the religious symbol dominates the war-torn landscape places Bohrod's painting in the duality of war and religion, and the fact that the crucifix remains untouched by enemy fire again strongly suggests the victory of life over death, both in a physical sense and in a supernatural sense. Bohrod nominated a religious symbol as dictator over war, and the inner peace that prevails within the hearts of the American soldiers supersedes the fear of death.

The crucifix is also utilized in Thomas Hart Benton's descriptive portrayal *Again* (1945).[3] This differs from Bohrod's painting in that Benton focused on the human image of Christ, whereas Bohrod's Christ figure is a crucifix of stone long before affixed to the landscape. Bohrod's figurative form serves, according to the artist, as a protector of life; Benton's figure of Christ is a victim of the three aggressive powers: Germany, Japan, and Italy.

Benton used the symbol of Christ as the savior of mankind, but he allowed the symbol of eternal life to be demolished by the atheism of the aggressors. Whereas Bohrod utilized an already established religious symbol as a focal point, Benton created and developed a theme within an original environment. Benton's *Again* established a visual activity area, a distance between the source of the event and the final outcome. The crucifixion of Christ was an attempt to stop the spread of his religious teachings. By killing Christ in effigy on his canvas, Benton implies that the Nazis and Fascists hoped to dismantle the spiritual leanings of their countrymen.

Again is an objective painting, although the dramatics are considerably provocative. It is definitely a connection between the past religious dominance and the reckless beliefs of contemporary society since World War II.

Rico Lebrun was noted for his provocative religious paintings and his expressions of human suffering. The outbreak of World War II unleashed strong emotional reactions toward the inhuman acts of war, provoking the need for spiritual guidance. In his color lithograph, *Rain of Ashes* (1945), Lebrun expressed the tragedy of war with a spiritual incentive.[4] The human form, resembling a crucified torso, reaches upward while holding an umbrella to guard against the downpour of ashes.

A second figure, stooped on hands and knees, looks skyward in an anguished hope for survival.

The dynamic expression is pierced with strong diagonals symbolic of thorns, a theme that has occurred in numerous religious works. Since religious themes were expressed by Lebrun throughout his life, the word "ashes" in the title could readily refer to the phrase "from ashes to ashes, and dust to dust." Regardless of religious overtones, the subjectivity of *Rain of Ashes* may well be conceived in terms of the radioactive ingredients of the atomic bomb.

Another Lebrun work, *Man and Armor* (1945), relates a timeless reference to war.[5] The 1945 lithograph reveals the time of execution relative to World War II. Lebrun believed that death was inevitable as long as war was a means of settling human problems. How does an artist react to the war? Lebrun had no options. Other artists ignored the war imagery for nonobjective schools of thought.

Man and Armor translates into centuries of war with the lower segment of the two horizontal planes, symbolizing man wrapped in medieval armor. The upper panel of a grotesque skeletal form represents the death of man. In this intimate manner, Lebrun described his wrath for all wars, whether those of centuries ago or those yet to occur.

World War II had become the motivation for a turn to religious thought. Several artists dedicated their lives to religious themes: Jon Corbino, William Congdon, Umberto Romano, Fred Nagler, Henry Koerner, and Abraham Rattner. The war and the crucifixion of Christ became compatible companions. In his abstract painting *APOCALIPSION* (1943), Rattner considered the ruins of World War II equal to the ultimate destruction of humanity as described in the Bible.[6] The cubistic painting of flamelike spirals of color is inspirational. Angelic forms hover over medieval tools of destruction as the world appears in shattering dimensions of ruin. Castle-like structures are manipulated between demonic creatures representing greed and power, the very ingredients of an aggressive appetite.

In another Rattner combination of religion and war, *Hallucinations* (1943), peace and war are represented by angelic figures.[7] The artist is centrally located, flanked by the angel of war who holds a sword and the angel of peace who stands adjacent to the confused artist. The terrifying realities of a world of uncertainty and the fear of the

unknown created in the personage of Rattner form a series of changing personalities. For the artist, holding palette in one hand while grasping the sword of war in the other, the resulting indecision is registered in the spiritual reflections of facial expressions that flicker across the canvas.

Rattner deepened his emotional reactions to the entire contrast of peace and war by submerging within himself the image of horror at witnessing the sword grasped by the angel of war. The abstract profile view seems to act as a self-conscience or guardian angel. The multiple facial images are typical of Rattner's cubist style that spanned the war years. *Hallucinations* reveals the emotional toil suffered by the American artists who were driven to express the spiritual solutions to the world's war efforts.

Religious beliefs are also symbolized in Lawrence Beale Smith's rendition of World War II. *Sabbath in Combat* (1943) pictures a huge cathedral destroyed by enemy fire while a Red Cross unit defies enemy bombings to assist the wounded. A total of six crosses dominate the scene. Smith, whose paintings of the South elevated the spirituality of the African-American, prescribed a permanent "day of rest," as he carefully arranged stretchers in the shape of a cross in the foreground. Other crosses appear on the Red Cross vehicle and tent and atop the cathedral spires.

A medic works feverishly over a wounded soldier within the Red Cross tent that serves as a temporary hospital. Nearby another soldier digs a grave for a less fortunate comrade. Smith's approach indicates the total disregard for the Sabbath or the spiritual belief of the human condition. There is a stillness prevailing in spite of the swirling smoke spewing from the cathedral's remains. If a message is written in the ashes, it is the irony of the Sabbath being free of man's power to destroy.

As an Austrian native, Henry Koerner was shocked at the destruction of his homeland, but as an American, he was proud to have served the cause of American freedom. He was further anguished by the news of his parents' deaths at the hands of the German army. Koerner expressed the terrifying results of the Nazi bombardment of Europe in his deeply provocative painting *Skin of Our Teeth* (1946).[8] The structural facade of brick formations representing the exterior of buildings envelops naked bodies and partially clothed survivors searching the rubble of the ravaged city.

The brick facade is reminiscent of Shahn's textural expertise while George Tooker comes to mind with the structured rectangular openings through which life is experienced. The number 23, another Shahn trademark, is utilized both as a compositional technique and as a literal identity of a past landmark. The nudity is symbolic of the poor and needy and loss of identity and personal belongings. The heaps of structural debris are not unlike those witnessed in Shahn's World War II perceptions of destruction in such works as *Liberation* and *Italian Landscape I.*

The Tooker-like compartments ironically assumed the roles of merriment and glee as if two different worlds coexisted. And either by deliberate intent or by a strange coincidence, a cruciform separates the two worlds of total destruction and reconstruction. The agonizing of groping figures at the base of the brick cruciform reminds one of the suffering Mary Magdalene and Nicodemus at the foot of the cross at Calvary.

The effects of World War II persisted long after victory. The passage of time aided the artist in terms of emotional control and complexity of composition. War is an immediate event, but the effects of war are of deeper consequence than the action itself.

Koerner's painting *My Parents II* (1946) is a production of World War II.[9] The isolation of each parent is directly caused by the destruction of their native land. Germany had destroyed Austria and in the process delivered Koerner's parents to premature deaths. Koerner's painting shows each parent seeking a separate path to nowhere. The painting envisions a remarkable landscape of desolation. Naked trees line the fallen foliage, which is heaped high, symbolizing shapes of gravesites. The limited palette further accentuates the gloom of the war's devastation.

There is also a loss of spiritual attitudes unless each human form hides its own contemplation. One questions the silence whether it be despair or spiritual quietude.

Bernard Perlin presents a unique display of abandonment of the spiritual outlook on life in *Farewell*. This differs considerably from Raphael Soyer's painting of a similar title. Perlin has followed Ben Shahn's textural approach and Koerner's thematic approach.

All but swallowed up by dense forestry, the parents roam in opposite directions. It differs from Koerner's *My Parents* by the nature of the psychological effects of the dissimilar

Henry Koerner. *Skin of Our Teeth* (1946). Oil on masonite. Sheldon Memorial Art Gallery, University of Nebraska–Lincoln, F. M. Hall Collection.

Henry Koerner. *My Parents II* (1946). Oil on wood. 25 × 30 in. Curtis Galleries, Minneapolis, Minnesota.

environments. Koerner's parents seem lost in a forest of emptiness—nude trees and barren earth—whereas Perlin's *Farewell* exhibits his parents amid a densely, jungle-like atmosphere of full greenery. Koerner has presented the death of an environment in which the human factor does not coexist; Perlin granted the viewer a full-fledged environment in which humans are nonetheless lost because of a lack of spiritual purpose.

As mentioned before, World War II permanently affected those artists who saw action in the service of their country. Some turned to religious subject matter. Others, such as Edward Melcarth, exposed in a single expression the horrors of war. War, death, and destruction are readily available as stimuli for the artist whose emotions are aroused by the futility of mass murder.

In Melcarth's portrayal *God Must Have Loved Them* (1946), a delicate calculation of placement is essential to a symbolic yet realistic imagery.[10] Victims of war have never been more graphically depicted than in Melcarth's interpretation of the evils of aggression. A cruciform anchors and acts as a focal instrument, a crucifixion of eleven foes. Although twelve were initially conceived, the unknown factor, the rope without a victim, fulfills a compositional need as well as a symbolic one. Melcarth had forsaken the child as the twelfth victim in order to lessen the emotional responses of the audience. The figure to the right of the vacant noose is the mother of the orphaned child.

Philip Evergood's grotesque rendition of the crucifixion of Christ is titled *The New Lazarus* (1927–54).[11] Although directly influenced by Grunewald's altarpiece of the same theme, Evergood included those humans responsible for the sins of the world and those who suffered from those sins. A significant role is played by each

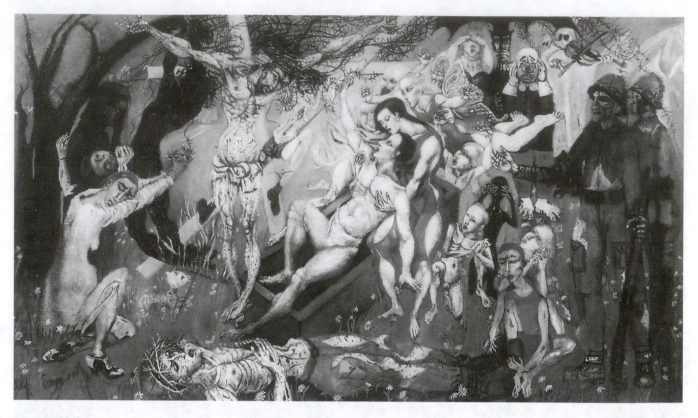

Philip Evergood. *The New Lazarus* (1927–54). Oil on plywood. 48 × 83¼ in. (121.9 × 211.5 cm.) Museum of American Art, Gift of Joseph H. Hirshhorn. Photograph copyright ©1998: Whitney Museum of American Art, New York.

soldier of war. Barbed wire, a symbol of concentration camps, encircles the soldiers and weaves throughout the painting, piercing the Klan figure en route to engulfing the crucified Christ. The devastation of the human condition brought about by man becomes a deadly reminder of man's misuse of life.

It is interesting to note that the Nazis believed that by removing religion from life, the entire world would fall into chaos— except, of course, the German race would be spared. Christ became the focus of destruction. In destroying Christ, the enemies of religious beliefs felt that the world would be theirs. Evergood was always against violence and against wars in particular. Many of his paintings are recollections of past years. He lived in England during World War I while Germany bombarded London. The simple gas mask became a symbol of death in several paintings, such as *The New Birth*, *The New Lazarus*, and *Fascist Company*.

Sometimes the painting represents the lack of religion. Evergood wrote that his *Fascist Company* (1942) portrayed an "ugly, venomous force, searing the earth and leaving physical, spiritual and moral putrefaction in its wake." Although several

descriptions of *Fascist Company* have been written, the artist's own description best typifies the subject matter.

"In the foreground, a greenly, unhealthy, smoothly muscled, latently powerful being holds the futile bridle of a powerful beast with timidity, avoiding with heavy foot and frightened eyes, the venomous lash of his masters. The People, whose corrupt and false leadership has led them into slavery under the domination of the Fascist overlords, spirits broken, poisoned by evil propaganda, are symbolized in this figure which has latent strength and latent beauty but by subjugation has been made a part of this menacing group. The red rearing horse with distended nostrils, pounding with its iron shod hoofs the earth, and leaving in its wake the imploring hands of its victims whose bodies have been beaten into the soil. Their uplifted hands symbolize the germination of revolt that will eventually destroy their oppressors. The nauseous pink bloated rider with arrogant and cruelly effeminate foot, with raised hand holding a many pronged fish hook barbed whip with which to scourge and tear the flesh of the victims. This pompous, physically repulsive and poisonous personality with its shamelessly blatant

conceit and insatiable craving for self-emulation and ceremonial swagger, is a conception of Goering and Mussolini. Accompanying this monstrous rider is his inevitable companion Death whose fleshless bones symbolize Fascism's destiny and his rose adorned coquetry (accompanied by a nightmarish introspection of the cavernous eyes) suggests the mastermind Herr Hitler. The blood red looming factories of Fascist destruction rise in the background."[12]

The Burnt Man (1953–54) is a direct descendant of World War II. Leon Golub identifies the cruciform victim with those who lost their lives for the cause of freedom. In so doing, he identifies the war hero with Christ. *The Burnt Man*, reminiscent of Golub's later war series, focuses on the victim while dramatically forming a cross. His slashing style ranks amid the abstract expressionist movement of the 1940s and 1950s, coinciding with the religious revival in American art.

Golub has said of his work: "*The Burnt Man* reveals the extreme to which modern society has gone to diminish the importance of the Crucifixion. It is not only the agony suffered on the Cross that has caused this intuitively eerie response, but the indifference and callous reactions to this tumultuous event that is even more agonizing to endure."[13]

Although a nonparticipant in World War II, Umberto Romano was shocked by the anguish and devastation resulting from it. His powerfully shocking artistic expressions will long be remembered. An example of his ferocious attack on the evils of mankind is his provocative work *Man Reaches for the Unknown* (1959). Painted a decade after the war's end, the work depicts the fear of the unknown, man's continuing agony as witnessed in the distorted bodily features. Intense agony floods the canvas.

Bony structures are intuitively employed to a diagonally framed cruciform, thus recalling Romano's memorable illustrations for Dante's *Human Comedy*. Contour lines interweaving with appropriately positioned gesture lines coincide with torn flesh.

The intuitive response to the aftermath of human tragedy left mankind in limbo. The lack of spiritual faith created a chaotic future, an unknown venture into the unknown. The image of man became abstract, undefined, and curiously isolated as the unknown consumed the world. Romano's portrayal is terrifying, and yet, as an artistic expression, it is beautiful in its purpose of alerting the human race to its own greed and indifference to peace.

It is difficult to differentiate between foreground and background. Man is consumed by the unknown, and eventually man and the unknown become one. The interpenetration of positive and negative factors creates an abstract solution in terms of composition. The ultimate destination of man remained a mystery as the war's woes continued well into the next decade.

An earlier portrayal by Romano, *The Last Farewell*, was executed in 1942, shortly after the bombing of Pearl Harbor. It resembles in appearance the figure of Christ before his death march to Mt. Calvary. The profoundly intimate and personal human dialogue existing between the two characters is compelling and relates an unforgettable sense of frustration and helplessness. The power emanating from the personal attachment of the two humans demands a genuflective mood. *The Last Farewell* suggests the anticipation of death, whether it be in battle or on the cross. Although location is left unidentified, Romano has made the image one of universality. *The Last Farewell* tied together the divine and the human aspects of life.

Although Edward Reep was a war artist in the midst of battle, his on-the-scene sketches were withheld from view until reflective moments created the proper mood. *The Shrine* (1946) is a carefully arranged, well-conceived portrayal of a collection of mementos of the war. Small photographs are glued or pinned to the brick walls and the flag hung on the wall. Bouquets of flowers flank a wire cruciform, standing forward as a significant segment of the painting while also uniting with the numerous photos. *The Shrine* has a spiritual sense of emotion, an ethereal use of pigment that created a stillness, a sort of contemplative mood.

Although the painting was executed after several spontaneous notes and drawings, the final composition emerged after hours of reflection. Religious overtones stem from the serious nature of life after death of those whose lives were lost during the struggle for freedom. The reflection over serious thoughts usually generates spiritual energies that subconsciously emerge during the creative process. It is best described in the artist's own words: "In the town square of Bologna, where the city jail is located, a collaborator had just been slain beneath the iron barred windows of the jail, his fresh blood still visible on the brick wall below.

Edward Reep. *The Shrine* (1946). Oil on canvas. 30 × 36 in. Courtesy of the artist.

Within minutes an Italian flag was hung on the wall, above and to the left of the bloodstain, the tricolored red, white and green presenting a startling panache of color against the ancient, dull brown bricks. The House of Savoy emblem had been ripped away from the white central panel of the flag; pinned in its place was a stiff black ribbon of mourning. This became a dual gesture; it signified the end of the monarchy and Fascism, and it became a memorial to those who had given their lives in the long struggle for liberation. A derelict green table was then thrust against the bedecked wall, and placed upon it were little mementos, mostly photographs and flowers commemorating the loved ones who had perished; more photos were pinned to the flag. The images of those who had seen service in the Italian army were adorned with delicate multicolored ribbons of red, green and white. Lastly, an ornate filigree cross of black wrought metal was placed toward the front of the table to become the crowning touch in completing the impromptu shrine. Today, in Bologna, a permanent shrine stands on that sacred ground."[14]

An unusual result of World War II was the Berlin Wall, which until recently divided Berlin into two separate countries: West Germany as democratic, and East Germany as communistic.

Opposite: **Umberto Romano.** *Man Reaches for the Unknown* (1959). Oil on canvas. Collection of the Whitney Museum of American Art, Gift of Mr. and Mrs. Jaquin D. Bierman.

Edward Reep. *Idiot's Garden* (1972). Oil on canvas. 24 × 32 in. Courtesy of the artist.

Reep titled his concept *Idiot's Garden*, in which vicious-looking barbed wire is tautly strung atop the wall dividing the two separate forms of government. The artist's own words best describe his portrayal: "Political ramifications aside, one cannot help pondering the uncivilized state of humankind in general when viewing such a macabre 'garden.' To me, the Berlin Wall stands as a stout testimonial to man's idiocy, as well as an exercise in futility and waste."

Compositionally, *Idiot's Garden* (1972) is a strong painting of three vertical planes, each dramatically attuned to religious overtones. The remarkable structure of barbed wire centrally located is an eerie reminder of Christ's crown of thorns before Pontius Pilate. The twentieth-century painter, Hans Moller, is also reflected in Reep's unusual formation of a significant event of World War II.

In conjunction with *Idiot's Garden* is another painting by Reep of the Berlin Wall, *Die Mauer Muss Fallen* (1972). The communistic rule of Russia dominated East Berlin, as explained by the artist: "The painting dealt with a bold slogan that had been applied to the wall by the West Berliners. It read 'Die Mauer Muss Fallen' (the wall must fall) and the motto, or vow, was crudely painted below a bugle signaling a call for freedom. The portion of the wall selected for the graffito brutally cut through a beloved church of historical significance, virtually absorbing the structure and preventing Berliners who had worshipped here for generations from entering. A classic marble sculpture of Jesus Christ remained mounted on the facade of the church to agonize and bait the devout, while bolted above the Christ figure was a sinister looking light, positioned to illuminate the area at night and prevent East Germans from

Edward Reep. *Die Mauer Muss Fallen* (1972). Oil on canvas. 24 × 32 in. Courtesy of the artist.

escaping to the West. Placing the light precisely above the image of Christ seemed the Epitome of cruelty."[15]

World War II edited the lives of hundreds of artists. Because of the sheer horror of war, the inhumanity, and the deliberate torture of humans, the artist was compelled not only to record the tragedies but to send a message to the world. The war also reflected the fragility of life, the finite aspect of humanity forcing the artist to look beyond reality. Religious overtones are inescapable. Several artists focused on religious themes during their waning years. Hans Burkhardt was one of many who combined religious symbolism with the tragedies of war. In *War, Agony in Death* (1940), Burkhardt reflected his hatred toward the European atrocities by attacking his canvas directly knowing in advance the images he was forced to express. The atrocities are marked by graves piled with human debris. Fierce geometric shapes dominate the scene as human and beast converge to form a composition of relentless terror. One is reminded of Picasso's *Guernica* and of Rico Lebrun's series on the crucifixion. The dominant foreground figure becomes the crucified Christ, whose presence represents the salvation of mankind. To the left are geometrically structured human figures reaching furiously for divine guidance. Burkhardt united the forces of evil with the hope for the future in sending a message of acknowledgment in order to combat the wars of the future.

The joy emanating from John McCready's *Repatriated* (1946) is immeasurable. It is a return of the prodigal son, so to speak, to hail the conquering hero. The critic Keith Marshall wrote:

"McCready's greatest tribute to the Negro, *Repatriated* portrays the return of a youth from World War II. The young man, whose return is heralded by the luminous sky behind him, represents all young Americans who fought in the war."

Another critic, Carter Stevens, wrote: "To the mind of this reviewer, McCready has never painted a greater picture than *Repatriated*. McCready is at the peak of his skill as a painter in the color work of this picture which has a beautiful glow. The drama of the scene tugs at the heart."[16]

All human gestures are aimed at the returning soldier. The humble homestead is suddenly filled with pride and thanksgiving. The makeshift shack, with its shedding shingles, blends with the rugged terrain and outdoor bath facilities. Several compositions compose the whole; if dealt with separately, each would suffice as a genuinely compassionate expression of joy.

Religious overtones permeate McCready's painting. The mother and child portrayal mimics the Christian birth; the soldier returning from war reflects the prodigal son image; and the glowing, golden sky reveals the joy of the Resurrection. In spite of the humble imagery, there is a classical look of grandeur. The forms are masterfully executed.

McCready was spiritually affected by Southern blacks and their habits. His message of realism is more symbolic than literal and more basically rooted than transient. In *Repatriated*, McCready combined the classicism of the Renaissance with the realism of the twentieth century, and in the process he created a spiritually motivated masterpiece of compelling reality.

CHAPTER 10

Recreation

Recreation was a forced commodity of the armed forces. The artist Fletcher Martin, noted for his paintings of partially rendered nude women and sporting events, also realized the importance of relaxation. In his famous painting *The Gamblers* (1943), the excitement of the event and the anticipation of the call card lessen the tension of war.[1] *The Gamblers* is a rendition of casual easement of anticipated action. The rectangular composition includes seven American soldiers engaged in a poker game, each sporting a personal injury from the war.

The visual distance between the two prominent card players presents a curious circumstance. Facing the viewer is a seemingly unbeatable poker hand, placing emotional pressure on the soldier in the background. The secondary human figures observe intently as a significant gesture is about to occur. Martin's emphasis on the figurative form is typical of his total production. He used the human element to advantage by the various physical positions and the degree of overlapping. Even though each personality differs in physical positioning, there are common facial expressions that unite the individual soldiers into a team.

With a totally different notion, Martin captured a rare moment of human behavior in *Boy Picking Flowers* (1943).[2] The compelling painting reveals a single American soldier vacating his banged-up jeep to pick wildflowers in a desolate environment. The jeep, damaged extensively from

enemy fire, rests quietly on a lonely hillside. The irony is of being alone in a strange land but reminded of one's homeland by the spread of wildflowers. The recall of home floods the mind of the forsaken soldier, who carefully decorates his helmet with flowers for safekeeping. Martin shared his environment with two major elements. The cause and effect are equally significant. The busted jeep creates the cause of the more pleasurable event and places the viewer in a questionable mood as to the fate of the American soldier.

Ready Room (1947),[3] a painting by William Draper, represents a break from the action.[3] American GIs are illustrated in their attempts to handle boredom before a dramatic event. Even though *Ready Room* is a complex composition, the theme itself demands a quiet atmosphere. The activities of reading, writing, and card-playing occupy the moments of boredom or anxiety, depending on the upcoming war tactics.

Draper carefully arranged the human figures to allow the viewer options for initial departure points. Each singular composition incorporates the anxiety of space existing between the occupant's vision and the objects of focus. The environmental background reflects the crowded quarters. Draper's *Ready Room* is a recording of fact, but a mood of quietude emerges from the personally engaging activities.

Recreation comes in all forms. It is a diversion from the strenuous role of the wartime sol-

dier. Albert Gold translated recreation into a drawing titled *Cat Nap* (1943).[4] It is a restful sight of an American GI totally exhausted. The enlarged view of the sleeping GI consumes the entire drawing surface. The surrounding area is mute, creating a focus on the facial features of the dozing soldier. Background washes are subdued, leaving the habitat undefined.

Although Gold defined certain features, the entire drawing seems to be a preliminary sketch for a future and permanent production. It also represents a slice of a larger picture. *Cat Nap* is a direct and simple portrayal of a commonplace activity.

Soldier Bathing (1944), a painting by Edward Reep, is an image of luxury.[5] Under normal circumstances, Reep's painting would be considered surrealistic, since it defied all sense of reality. But under war conditions, the American GI is considered a clever character to utilize the situation and circumstance.

Again, Reep has factually recorded an eventful occurrence. Speculation is an obvious deterrent to acceptance, even though reality is portrayed in understandable terms. The environment shifts from the foreground of strewn debris to an elegantly painted sky of rich sunlight. The weather is warm and ideal for an outdoor bath, especially in the relaxed medium of a bathtub. Remove the subject matter of the American GI, the tub, and the jeep, and a pleasant landscape emerges.

The subject matter of Reep's painting titled *Truck Ride* (1943) is confined to the inner enclosure of a truck in which sleeping soldiers are lopped over each other. Bodily gestures reflect the total exhaustion of the role-players. The accompanying environment of movement contrasts with the stillness of the exhausted GIs.

Reep insisted on the portrayal of an activated environment in order to reflect the total exhaustion of the American soldiers—that in spite of business as usual, sleep, because of its imperative nature, became essential to the entire scheme. This convoy of trucks were present during the Normandy invasion. The crowded background of the caravan of trucks and the row of buildings make the group of exhausted GIs a paradox of stillness amid movement. The artist has recorded a common incident while displaying the total picture. *Truck Ride* represents an essential form of recreation.

Fletcher Martin's painting *Time Out* (1943) is a satirical exhibit of relief from action.[6] It is a recording of a commonplace theme under unusual surroundings. To mend one's own pants while partially naked and in the midst of a battleground is indeed unusual. *Time Out* is realistically portrayed, a triangular composition of three human figures. It is a direct, simple recording of life. There is an invisible diagonal line drawn from the major role-player's right hand to a kneeling figure positioned to the far right of the painting. A third figure is dimly viewed in the background. This is an activity to occupy time or to soothe the anxious moments of awaiting combat. *Time Out* is an ideal example of relaxation, and yet, what appears to be a carefree, nonchalant moment may well be one of anxiety verging on panic. Fletcher was noted for his articulately rendered physical forms. *Time Out* is such an illustration.

It was not the action on the battlefield that raised Paul Cadmus to the heights of American painting but rather the words of the then secretary of the navy, who said that the painting *The Fleet's In* (1934) was an unwarranted insult to the U.S. Navy. Even though *The Fleet's In* was painted during peacetime, the scene witnessed is typical of the armed forces on leave. Thus, the imagery in Cadmus' portrayal became the sailor's diversionary event. As witnessed in the painting, the only disapproval stems from a senior citizen, whose scowl says it all. However, her contrariness is ignored by the fun-loving sailors and their partners.

Shore Leave (1933), another shocker for the Navy Department, reveals Cadmus' masterful drawing of human anatomy. It resembles a sailor's paradise and identifies with an enlarged segment of a Brueghel landscape with dozens of individual and group activities.

Finally, *Sailors and Floosies* (1938) illustrates a trio of couples engaged in drunken love-making. The erotic behavior is justified in the Cadmus tradition. The floosie lusting over the drunken sailor sports a necklace anchored with a miniature crucifix, adding a sardonic twist to the sensuous activity.

A celebration about to occur is read in the faces of the servicemen portrayed in Aaron Bohrod's painting *Crowd of Servicemen* (1943).[7] One is reminded of the USO tours by celebrated entertainers. The focus of attention is a factor outside the picture plane. The servicemen show smiling faces, inquisitive looks, and frowning glances.

Bohrod's packed audience is not unlike Reginald Marsh's crowded beaches or burlesque houses. Yet, Bohrod's watercolor technique differs

Edward Reep. *Soldier Bathing* (1944). Watercolor. 15½ × 23½ in. Courtesy of the artist.

considerably from his tempera and oil media. The flexible medium of watercolor has allowed Bohrod to unleash a color spread that adheres to most of the figurative forms dominating the working surface.

Segmentized, the portrayal diminished in an overall power play, *Crowd of Servicemen* is a slice of a greater and broader picture. The viewer is witness to what the servicemen are viewing. Bohrod has sustained the mystery, the attraction to which the servicemen are alerted. The swooping circular shape that dominates the upper portion of the painting suggests an enclosure of sorts. Regardless of the entertainment attraction, Bohrod has recorded a segment of the service essential to the well-being of a fighting force.

William Johnson's painting *Soldiers' Morning Bath* (1942) is a further amplification of the routine and regimented style of the American infantry.[8] It further expands the business of racism as a segregated form of service.

Aside from the political and racist implications of Johnson's idiom, his simplification of forms add a certain charm to a commonplace routine, whether that routine is considered recreational or a tedious chore of the infantry's way of life. The unidentified, similar images look like robots in a uniformed army. Regardless of theme, Johnson adhered to an individual stylization of the human form. His is an African-American army, a separate grouping of dedicated men who lack personality. Each figure is similarly treated. With flatly painted, expressionless faces, the army figures follow the leader, only there is no leader.

Johnson applied his usual childlike symbols—earless heads, stereotyped facial features, outlining of objects and figures, flat patterns, and the baseline theory. The flatly patterned shapes indicate the routine lack of freedom of the enlisted man and the isolation of the African-American.

Johnson's paintings are pictures of the African-American culture. He ranks with the greats such as Jacob Lawrence, Romare Bearden, Hale Woodruff, Charles White, Benny Andrews, Archibald Motley, and Hughie Lee-Smith.

Recreation takes many forms. During wartime, the nearest bar became a site to celebrate victory or to console oneself. Fletcher Martin's painting *Friend of Man* (1942) concerns the bartender as the victim of a sailor's woe. The viewer is left to interpret the thoughts of the sailor, who remains unidentified. The arrangement of the dual figurative unit creates an atmosphere of intrigue, although the artist's intent leaned toward an

William H. Johnson. *Soldiers' Morning Bath* (1942). Tempera, pen and ink on paper. 16 × 20⅝ in. National Museum of American Art, Smithsonian Institution, Gift of the Harmon Foundation.

insignificant aspect of social life. Yet one cannot forsake the commonplace that identifies with a broad segment of society. The artist, although ignoring the facial gestures of the sailor, presents the pensive, nonchalant mood of the barkeep.

The title, *Friend of Man*, hails the bartender as the source of consolation for the sailor. And the sensuous female images etched across the bar relief not only are typical of Martin's themes but also blend with the solitude of the sailor's circumstance. The scene echoed throughout the European theater of war was equally prevalent during shore leave on the American continent. Martin was at his best when objective details were absent from his work. Concentration on the major role-players lessened concerns for the surrounding environment. Martin always set the scene or stage for ensuing action, but it was always subordinate to the action itself. Locale merely identified the environment. Although the sailor and bartender are identified as the role-players, a third element is introduced in the form of a mug of beer. This ingredient may well be the "friend of man." It also becomes the third leg of a triangular composition. The draught beer about to be served to the sailor, whose identity remains unknown, suggests a universality of participation. The role of the sailor is appropriate because of the year, 1942.

Recreation from the intensity of battle may be considered in terms of the mundane chores of bed-making, latrine-cleaning, and potato-peeling. William Johnson shows some of those chores in

Opposite: Aaron Bohrod. *Crowd of Servicemen* (1942). Oil on canvas. 12 × 24 in. Private collection, courtesy of D. Wigmore Fine Art, Inc., New York.

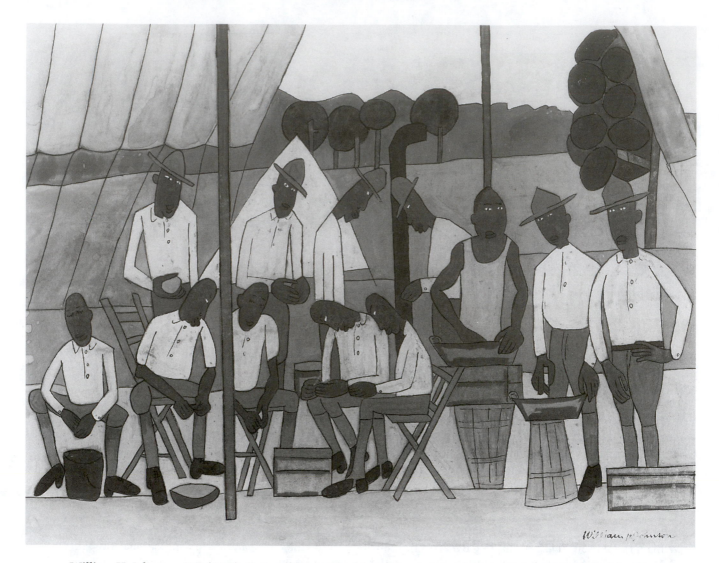

William H. Johnson. *K.P.* (1945). **National Museum of American Art, Smithsonian Institution, Gift of the Harmon Foundation.**

the painting titled *K.P.* In spite of the demeaning character of peeling potatoes, Johnson used the theme as a departure from deliberate bias by the U.S. Army to display his primitive approach of artistic expression.

K.P. (1945) serves a worthwhile cause if artistically approached and not regarded as a mere recording. Johnson's *K.P.* is divided into seven horizontal planes of color. Individual soldiers are flatly painted and outlined in spite of contrast adjacently employed. Johnson's soldier figures are childlike. Noses and other facial details are visible only within the profile images. Lollipop trees stand erect on a distant baseline while a group of potato peelers and dishwashers overlap the horizontal planes. It is strange, however, that there are no dishes and only one potato, thus suggesting a symbolic facade of racism.

One may consider *K.P.* a humorous display of physical beings except for the fact that racial prejudice was outwardly manifested. The monotony of activity is witnessed in the repeat pattern of identical army shirts, disrupted only by an undershirt. Bald heads and army hats are equally divided, as Johnson's *K.P.* unit becomes a satire of his own race. His work of earlier years of abstract expressionism reminiscent of Soutine, van Gogh, and Kokoscha was at full strength. He had already succeeded in the mainstream of art via European study and travel, and since he had been ignored on the American art scene, his work was seldom exhibited. Now his paintings of his personal world are finally being acknowledged and exalted. His painting *K.P.* is such a work.

Barracks (1945), a rendition of army life by Horace Pippin, portrays the segregated army

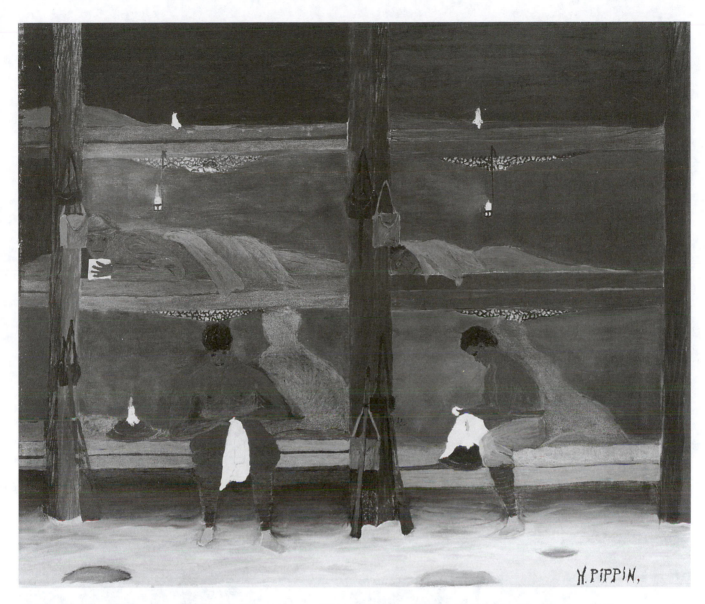

Horace Pippin. *Barracks* (1945). Oil on canvas. 25¼ × 30 in. The Phillips Collection, Washington, D.C.

soldiers in dilapidated sleeping quarters. Pippin has vacated his flatly painted areas in favor of briskly stroked swatches of color that seem to emotionalize the scene quite radically. The technique actually enlivens the scene that would normally reflect a stillness.

The environmental background actually brings into bondage the four army enlistees during moments of diversion. Rifles stand erect against the barracks as knapsacks hang freely from barrack supports. Candles dimly light the sleeping quarters as each of the four figures engage in personal activity. Pippin has echoed his symbolic cracked walls suggesting poverty as each sleeping berth of the barracks adorned with plastered walls was in need of repair.

The segregationist movement in the armed forces was never considered an act of deliberate hatred or indifference. The black was considered a second-class citizen. Although wrong, this was acceptable by American standards of the time. The freedom of democracy that white Americans fought for was the same democratic ideals that black Americans fought for. The difference is that blacks are still fighting for them.

Recreation during wartime is seldom considered recreation under normal conditions. Perhaps diversion from fear is a more suitable description. Edward Reep described his work *Dugout at Anzio* (1944) as follows: "During the long nights at Anzio, soldiers gathered in the most solidly constructed dugouts. Rails and timbers, hauled from

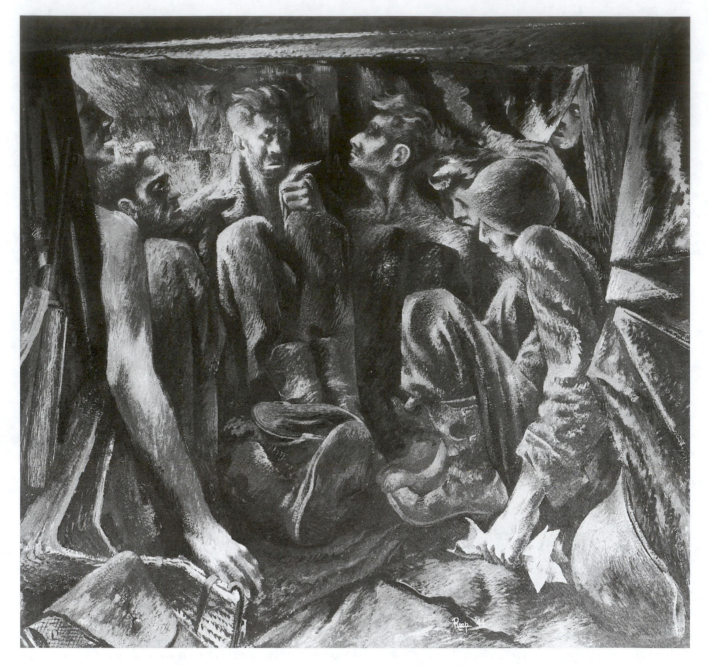

Edward Reep. *Dugout at Anzio* (1944). Pen and ink, 20⅝ × 22 in. Courtesy of the artist.

Anzio and Nettuno, often made the best supports for the two to three feet of earth forming the roof. In this fashion, soldiers were well protected from the constant enemy shelling and bombing. However strong, though, dugouts could not withstand direct hits. When the shells began to land close, soldiers displayed a variety of reactions; contrary to popular belief, most men were frightened. The men I gathered with either played cards, joked, told stories, or sang to the accompaniment of my toy recorder — all this with one ear cocked."[9]

In spite of the close proximity, the American GIs were more concerned with their lives than with discomfort. The rectangular shape of the painting forces the viewer to scan the figures from left to right and to acknowledge the individual suffering and the manner in which each handles personal fear and frustration. *The Dugout* presents a family of lives held together by a common bond and by a tenacity of spirit for life. Reep's portrayal could relate to several chapters, but the unusual circumstances seem to lend themselves to the discussion of recreational or diversionary tactics during wartime.

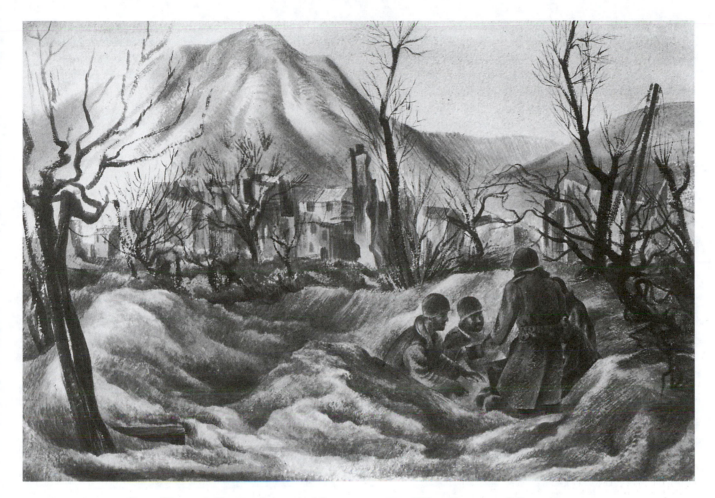

Edward Reep. *Coffee Break* (1943). Oil on canvas. 24 × 36 in. Courtesy of the artist.

Coffee breaks on the front lines of battle differed from those of the homefront. In Reep's watercolor appropriately titled *Coffee Break* (1943), the surroundings ignite visions of death. Skeletal tree forms are a routine symbol of destruction although serving a compositional need. Also symbolic are the thornlike images of prickly tree branches, which seem to illicit a spiritual beckoning. Although the visual focus is on the quartet of soldiers as dominating role-players, the surrounding environment is as restless as the soldiers' wants and needs.

The anxiety emanating from the snow-covered foreground is matched by the spiraling tree forms stretching upward into a mute sky. The on-the-scene painting is tempered with erupting areas of terrain that seem to sustain the uncertainty of the situation. Segments of buildings had already fallen victim to enemy onslaught. The vertically constructed trees unify the three horizontal planes. In spite of the immediacy of the scene, Reep retained its factuality while tempering the

mood with his own emotional reaction. His statement regarding *Coffee Break* offers a personal commentary on physical conditions and expectancies: "My first painting of the war depicted a group of infantrymen from the 3rd Division heating up some coffee while seeking protection in a giant shell crater. They were dressed in those heavy woolen GI overcoats so common in the early going, and they were dirty, tired and unshaven. The landscape about them was virtually barren save for the blackened, leafless trees that I soon discovered were a trademark of the battlefield. In the near distance lay the shell-torn town of Mignano couched against Monte Rotondo, both key objectives of the early fighting in Italy."[10]

Cecil Bell painted the pleasures of life. Not unlike paintings by Reginald Marsh and Paul Cadmus, whose vigorous displays of human flesh revealed moments of visual pleasures, *Cecil Bell with Central Park Mall* (1941) and *Getting Acquainted at the El* (1943) portrayed sailors' interest in female anatomy. Sailors on shore leave

were usually pictured in the roles of pickup artists, a practice that Bell reflected frequently in his work.

In the first painting, families relax to the music of a concert band at Central Park Mall, while a duo of sailors accept flirtatious looks from blonde females. Bell's canvas flourishes with life's pleasures. In *Getting Acquainted at the El*, a geometric environment identifies his role-players.[11] The site is a normally active departure point for human commuters. The shoe-shine boy, the El passengers, the newsboy, the repairman, and even the pigeons participate, along with the sailors and their female companions.

Other works by Bell include *Sailors' Delight* (1945), in which three sailors are pictured ogling a red-headed floozie, and *Passing Shadows* (1942), a one-on-one anticipated meeting between the sailor and the gal. But a work comparable to Paul Cadmus' panoramic view of fun with sailors is Bell's ambitious painting *World War II Invades Central Park* (1943), in which twelve sexual encounters occupy the canvas.[12] There is a roughness to his paintings, a technical application of paint that suggests a similar roughness of activity. Bell's works are brawling episodes of life, with an intensity that propels the viewer onto the scene. It is this directness that manipulates the viewer to scan the scene and interact with each unit of activity. Cecil made Central Park a love haven for sailors on leave.

CHAPTER 11

Victory

A victory is a celebration. Yet, an artistic view of victory may differ considerably from reality. Each artistic interpretation relies basically on the individual artist's sense of victory. A moral victory may be conceived as defeat. A victory may mean nothing more than the defeat of the aggressor. Victory may not consider loss of lives or total destruction of nations. However, coupled with the worldwide freedom of democracy is assured victory. Sometimes the maintenance or retention of a good thing is a victory in itself.

Although victory suggests human involvement, the omission of the human condition from a work of art is nonetheless a victorious representation. Seldom has the artist Fletcher Martin neglected the figurative form in his work. Victory was one of those rare occasions when abstract design became the dominating factor. The theory of interpenetration, which has been suggested frequently in other works, becomes reality. Flags wave freely in a calculated manipulation of geometric shapes. His work *Victory* (1949) incorporates the emblematic symbols of the allied troops that shared in the victorious celebration.[1]

Three-dimensional significance occurs as triangular shapes of color recede and advance on a frontal plane. *Victory* not only relates to the finality of war but presents an artistic freedom as well. There is a loosening of the reins as both technique and composition are considered not so much as recording an event as celebrating a different approach. Emotional elements are considered in terms of color and shape rather than as images of the human condition.

Liberation (1945), by Ben Shahn, is a form of victorious celebration. Children swinging on a makeshift Maypole suggest Shahn's childhood of generations past. Although the children found the ruins of a devastated Europe a playground of freedom, Shahn insisted on revealing the textural nature of the scene. The details of the destroyed building and the horizontal pile of stones seem to overshadow the playful children. Yet, the artist considered the possibility of overplay, so he clothed the children in plain, dark attire to contrast them to the gray-toned environment.

Shahn again introduced the linear aspect as an integral and essential element of the painting, psychologically and compositionally. His use of the tilted verticals was a deliberate attempt to unbalance the segments of the composition in order to arrive at a balanced design. The slashing brushstrokes of the sky area add to the jubilation experienced by the Maypole performers. It was a celebration of victory, a unique sense of relief and achievement, not by the children but by their fathers and brothers who fought for freedom. It was indeed an experience of victory over fascism, even though the scars of war remained.

Whether a victorious celebration or cynical nostalgia, the painting *Duet* (1948), by Philip Evergood, is difficult to interpret.[2] The painting

125

displays, in a burlesque manner, the spoils of World War II. The surreal still life of a human skull and hand grenades is symbolic of the deaths caused by the war. *Duet* is a celebration, a musical episode and dining experience. Evergood's unpredictability, his satirical presentation, and his social commentary are coupled with a disregard for social consequences.

Evergood's painting is difficult to understand because it represents a form of insanity, an unreality that is totally personal. Because of its intimate meaning, the outsider has little chance of understanding the artist's theme, let alone his purpose. Even though clues are forthcoming, they are rendered in a personally symbolic manner so that a wide audience is left unprepared to accept the artist's message.

Peppino Mangravite's paintings have been discussed elsewhere in this book. In a sense, he celebrated memories of the war. He made the pain, suffering, and death a part of the living. He painted the nostalgia of years past to celebrate, in order to ensure that those who died during the war did not die in vain. In his marvelous work *The Song of the Poet* (1943–44), life goes on in spite of disruptive forces that endanger those lives.[3] The poet strumming his guitar and raising his voice to the heavens is surrounded by naked trees and is anchored to a rugged crest of rock. The pastoral scene is enhanced by the farmer plowing his fields. *The Song of the Poet* is an elegant painting. The future is bleak, but only incidentally, since the disruptive forces are insignificantly portrayed. In a sense, Mangravite is victorious in painting his reaction to World War II.

Celebration (1955), by Wynn Chamberlain, represents a victory recalling past wars and memories.[4] It is a joyous dance among the tombstones of death. Races, creeds, and social classes intermingle. The symbolic statue of an American soldier of World War II stands high above the revelers. *Celebration* is a personal approach to a devastating tragedy. Each couple hides its own tale of suffering and despair. It is a circular composition of human activity interspersed with monumental statues of stalwart figures.

Celebration is also remarkable in its visual perspective, a vertical panorama of a rest for life. There is a commonality among the human factors, and yet, each sustains its own identity. One is reminded of Henry Koerner's style of figurative composition, and the distant detail. *Celebration*

was painted several years after the surrender of Japan, which allowed Chamberlain time to assess the war's aftermath and establish intellectual and emotional reactions.

Edward Dancig's *V-J Day: Crowds Cheering at Times Square* (1947; see color section) records a tumultuous response to the American victory over the Japanese forces.[5] In spite of a mass of humanity gathered to celebrate a common cause ,which would lean toward a subjective experience, Dancig's deliberate portrayal of singularly detailed human image sustains a highly objective appearance. The viewer does not accept the mass of humanity as a single unit but rather as hundreds of individual personalities, each to be studied by the viewer. In addition, the artist has purposely exhibited each male celebrant in shirt-and-tie attire and has scattered throughout the crowd "V for Victory" signs to form a pattern of balance. To diversify the composition even further, the American flag and newspapers spread the news of the Allied victory.

The composition is split in two, with the lower segment devoted to the victorious crowd and the upper section to the habitat in which the celebrants are located. The swarms of people hint at a larger audience. Dancig has purposely expanded his crowd to the canvas edges, suggesting a multitude beyond one's expectations.

A different approach from that of Dancig is the one used by John Stuart Curry in *Parade to War* (1945). The enthusiasm of a parade and the patriotic fervor aroused by the circumstances resulted in a seemingly glorious occasion. Yet, hidden behind the excitement and anticipation is a fear of the future, an apprehension of the unknown as soldiers march to a disciplined cadence.

A lighthearted atmosphere is created by the chains of confetti sprawling among the marching GIs as mothers, lovers, and brothers keep company with their heroes, but the usual exuberance is overshadowed by the central figures: a young girl and a soldier with a death's-head face. The skull-like features superimposed on the soldier's face are an obvious symbol of the death to come.

"V for victory" is signaled by two young French girls as an American soldier returns the greeting in *Bon, Bon, Monsieur* (1944), by Fletcher Martin. This painting shows a compassionate response from the occupants.[5] The army truckload of American GIs stops momentarily to observe road signs in a French village. The key to the

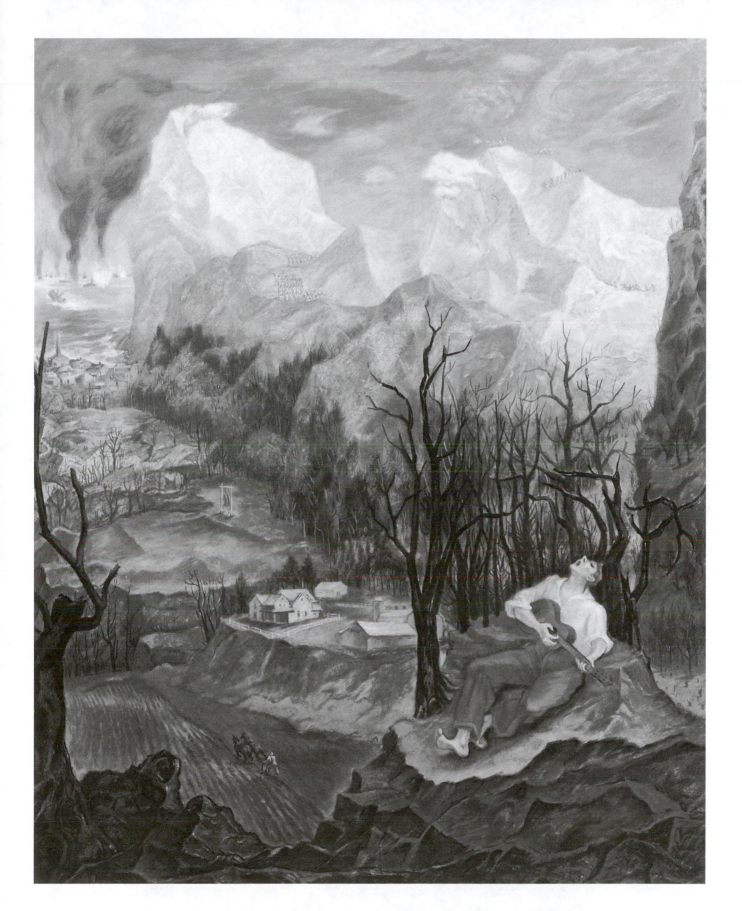

Pappino Mangravite. *The Song of the Poet* (1944). Oil on canvas. 152.4 × 121.9 cm. Art Institute of Chicago, Friends of the American Art Collection; the Goodman Fund. Photograph ©2000, The Art Institute of Chicago, All Rights Reserved.

John Stuart Curry. *Parade to War* (1945). Oil on canvas. Courtesy of the Cummer Museum of Art & Gardens, Jacksonville, Florida.

painting and the message that Martin wanted to communicate is the two French youngsters' relationship with the American army. Compositionally, the role-players act as poles at opposite corners of the painting, in which the distance evident between the two compatible elements becomes activated. Meanwhile, a second visual activity occurs between the truck driver and the road signs in the distance ahead. The two episodes form a dual triangular composition. The surrounding environment is quiet and serene, a war-ending situation in which a victory celebration could soon occur. *Bon, Bon, Monsieur* is a recording of an eventful episode of World War II.

28th Division, Paris, France, 1944, by Harry Davis, is an extraordinary work of detailed realism. The victory march in Paris under the Arc de Triomphe is an appropriate symbolic theme. The rigid facial expressions of the marching survivors seem indicative of something other than victory.

Although incidental, one is reminded of George Tooker's cubicle robots that seem obedient to a higher command. Yet, Tooker's hierarchy is seldom defined, whereas Davis' intent was directed toward the dedication to one's country. The lineup of American troops marching in cadence is difficult to illustrate without avoiding monotony or boredom. Yet, Davis' repetition of helmeted heads becomes an exciting march down one of the world's most famous boulevards. The arch itself becomes enlarged, an anchor for the similarly fashioned helmets of the marching brigade. One is proud to witness such an eventful scene.

Opposite: Wynn Chamberlain. *Celebration* (1955). Egg tempera on a gessoed masonite panel. 55¼ × 28½ in. (140.3 × 72.4 cm.) Collection of the Whitney Museum of American Art, New York. Purchase, with funds from the Pastorale Fund. 59.41.

Davis has utilized the individual personality approach and transformed it into a unit affair. The numerous individuals have a singularity of purpose; they are a team of performers whose combined forces unite for a common cause. Although realistic in approach, there is an element of surrealism, which often occurs when subject matter is rendered in photorealistic fashion.

Victory is frequently preceded by tragedy, and it is the tragedy that creates a love that would otherwise go unnoticed. In the case of Gladys Hockmore Davis' compassionate imagery in her work *The Kiss*, victory is indeed tempered with tragedy, propelling a greater love between mother and child.

The Kiss (1948) is a prolonged, contemplative reflection of the mother-and-child theme, set during wartime.[6] The actual scene was altered, not to relieve one of emotional discharge but rather to ascend the emotional pitch to a loftier level of compassion. Davis' recording of an eventful, intimate scene is enhanced by the masculine female form and the massive and firm grasp of the child. The entire use of the canvas dramatizes the tender movement. The war is no longer present, as victory resides in the hearts of the loving couple.

The victory of democracy over the aggressors of World War II is darkened and slandered in Horace Pippin's painting *Mr. Prejudice* (1943). The symbolic "V" for victory is split down the middle, abolishing in the process any hope for a democratic victory. On the far left of the painting is the image of the Statue of Liberty siding with the African-American branch of the armed forces. To the right of the canvas stands the Ku Klux Klan and the white members of the armed forces. There is an attempt to atone for past prejudices, but both parties seem hesitant.

The obvious disagreement between races was a profound disappointment for Pippin who continued throughout his life to symbolize the loftiest ideals of compassion and humility.

The primitive nature of his work adds to the humble and innocent approach to his craft. Flatly painted figures and childlike facial features compare favorably with the directness and innocence of the young child.

In the painting *Victory Garden* (1942), Pippin pictures an elderly woman seated outdoors adjacent to a bed of red, white, and blue irises. Her hands, busy with needlework, weave in discriminate fashion a duplication of the beauty of the blooming irises. A white picket fence divides the painting into horizontal planes. The elderly lady, although white-skinned, had black facial features, as if Pippin is pressing for racial unity. As a primitive, Pippin disregarded the natural source of light and arbitrarily focused on the figurative form and the white flowers. *Victory Garden* is a joyful painting and is reminiscent of gardens that flourished in urban and rural areas throughout the nation during the war.

The Cobra Smokes (1946), by Edward Reep, illustrates the sense of victory in a war-ravaged town in northern Italy. Besides recording the human emotions associated with victorious celebrations, Reep also shows the sense of achievement. Reep composed several intimate dualities, each contributing to a full-fledged composition. According to Reep: "Brazilian troops frolic while heading down the main street of a devastated city in northern Italy. Drawn from numerous sketches and my vivid recollection of the chaotic events of the war's last weeks. A Brazilian soldier walks toward us, followed by an American GI and his Italian girl friend. Behind them, two priests carry on an animated conversation. The mules loaded on the truck will be transported to the front by Italian Alpine troops. Meanwhile, children are at play on the public pissoir to the right."[7]

Different in technique and composition from Edward Dancig's version of *V-J Day* is Cecil Bell's rendition *V-J Day, Times Square* (1945).[8] Jam-packed with humanity, the painting portrays thousands of hilariously excitable celebrants surrounding Times Square. Injected into the scene is the symbol of freedom, the Statue of Liberty. *V-J Day, Times Square* is a totally subjective expression. The celebration is similar to a Hollywood premiere, different only in the role of the participant.

Bell was an exuberant artist, one who enjoyed life to its fullest and who reflected it in his boisterous display of human anatomy. Revelers display uninhibited gestures of emotions—drinking, kissing, dancing, and noise-making. It is an overwhelming sight of gaiety and frivolity. Police on horseback attempt to control the crowds, but they too become engaged in the celebration. Several dual compositions assert themselves in the foreground as the famous street corner is flooded with merrymakers. Huge floodlights illuminate the scene as thousands join in to form a single unit of inexhaustible celebration.

Sailors for Victory, a woodcut executed in 1943 by Wenonah Bell, is unique in its lack of textural qualities. At the time of Bell's execution of

Horace Pippin. *Mr. Prejudice* (1943). Oil on canvas. 18⅛ × 14⅛ in. Philadelphia Museum of Art: Gift of Dr. and Mrs. Matthew T. Moore.

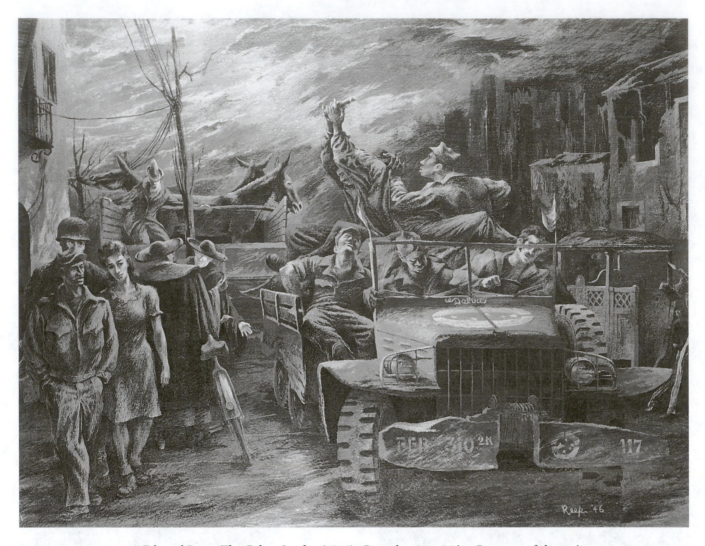

Edward Reep. *The Cobra Smokes* (1946). Gouache. 26 × 36 in. Courtesy of the artist.

Sailors for Victory, an Allied victory was not ensured, but the full dedication of the American populace, both on the warfront and the home-front, far outscored any negative assumption to the contrary.

The artist pictured marching sailors heading directly toward an outside audience. The viewer is treated to a frontal view of the anticipation of excitement. The artist believed that victory was ensured. It was merely a matter of time. Composi-tionally, the artist presented a simple arrangement of similarly attired subjects hoisting overhead identical bundles of paraphernalia and parading in a sense of relaxed unity toward eventual victory.

The overlapping of figures creates a singular-ity, a singleness in purpose as well as a composi-tional oneness. Although each sailor is an individ-ual personality, each is compromised to form a single unit destined and vowed to serve a single

function Bell's unusual approach to an event of apprehension and perhaps anxiety is well served by the sheer determination of the sailors them-selves. Because of the compact union of figures, *Sailors for Victory* takes on a subjective appear-ance. And it is this singularity of purpose that has resulted in a subjective appearance to the viewer. The artist's concept, conceived as a whole, nonetheless experienced individual end results that eventually resulted in an accumulation of figures. But because of the compact overlapping of figures, subjectivity of subject matter also resulted.

Planners for Victory (1943), a serigraph by Charles Keller, pictures a group of civilians listen-ing to an outside source discussing victory plans. It is a peaceful rendition of concern for those serving in American armed forces. Those in the planning committee exposed to the viewer reveal

various facial expressions. The American flag serves as a backdrop to identify the group. The artist treated his theme as a personal approach, and although each role-player accentuates personal attitudes, each also participates as a bonding element for a humane cause, that cause being a victory over aggression and violence and a resolution to a peaceful world.

Planners for Victory represents the concerns of an entire America. No segment of society was immune to the threat of fascism. Although Keller's serigraph is a peaceful message executed in a typically realistic mode of the 1940s, it represents a provocative concern for the freedom of democracy.

Sophia Thanos' portrayal of World War II, *United Knockout Blow* (1945), encompasses both process and product—that is, the process of war and the final victory. The artist's rendition is a complex totality of a universal burst of ammunition aimed at Hitler and the German Gestapo. The knockout punch is a huge bomb surrounded by enemy planes. Thanos' linoleum cut exhibits the human condition as a family unit standing atop the universe awaiting the fall of Hitlerism. Japan is represented by the symbolic rising sun drenching the shoulder of the fictional Hitler. Thus, the knockout punch delivered by American troops and their allies is a simultaneous blow to both Japan and Germany.

CHAPTER 12

War and Symbolism

Unlike artists such as Aaron Bohrod, Joseph Hirsch, Edward Reep, George Biddle, and others whose portrayals were developed from firsthand experiences, some artists expressed in symbolic terms their emotional frustrations that followed World War II. One is Alton Pickens, whose paintings *The Blue Doll* and *Carnival* present eerie revelations of hatred and revenge. Reminiscent of the Nazi holocaust, *The Blue Doll* (1942) exhibits two dwarflike humans whose physical characteristics are grossly exaggerated to feature ancient, wrinkled creatures who dwell in the constant satisfaction of torturing helpless dolls.

The image of the child as torturer and aggressor serves Pickens as an expression of a universally insane form of cruelty. Pickens' bitterness toward the inhumane attacks on the innocent and underprivileged is expressed as a violent display in artistic form. The eerie painting is comparable to the hideous exhibits of German atrocities. The nonchalance with which the creatures dismantle the doll while eagerly awaiting the opportunity to "murder" a second symbolic creature of the human race is not unlike the treatment of American prisoners of war.

In *The Blue Doll* there appears to be a conspiracy between the two symbolic "murderers," which look like creatures from outer space. Pickens succeeded in clarifying the brutality of war.

The gnarly hair styles, protruding noses, enlarged eyes, and projecting chins create a sense of eeriness and a haunting sense of human destruction and decay. Even the doll on the ground, the symbolic victim, reaches an outstretched hand to the murderous duo. Pickens has established three apparent visual activities. The spatial distance created between the gazes of the aggressors is intensified by the unknown aftermath or the unpredictability of the future. A second visual focus is the spear and its piercing of the symbolic doll victim. The diagonal slant of the fatal weapon held by the bony hands of the "murderer" and the point of contact to the doll's body form a visual focal point. And a third point of logical departure is the second possible victim being held by the other aggressor.

Painted in 1949, *Carnival* introduces a spiritual bit of mockery. A monkey seated upon a wooden box is about to be crowned with an object shaped like a halo but made up of steel thongs. It is a remarkable inference to the crown of thorns piercing the brow of Christ. *Carnival* is a display of idotic mockery and ridicule. There is a spiritual attitude in the characters portrayed by Pickens: the woman to the left, swallowing birds; the monkey used as a pawn; the figure on the right blowing fire from her mouth while a book covers her head and her hand grasps her breast. The central and fourth figure is a bald headed demon dressed in formal attire, insidiously preparing to crown the innocent monkey with a halo of pointed steel.

Much of Pickens' work is fantasy — and so is

Alton Pickens. *The Blue Doll* (1942). Oil on canvas. 42⅞ × 35 in. (108.9 × 88.9 cm.) The Mueum of Modern Art, New York. James Thrall Soby Fund. Photograph ©2000 The Museum of Modern Art, New York.

life, he claims. He believed in implying rather than stating his themes, so that the viewer could remain flexible in making a judgment. Although not immediately obvious as a theme in this painting, man's inhumanity to man is suggested — the essence of war and the crux of the murder of Christ. Pickens believed that the torturous treatment of man is a spiritual experience, or lack of. He has always felt deeply the incredible cruelty of human toward human and marveled at humanity's miraculous endurance.

Carnival spares no space. The canvas is thoroughly occupied. No rest periods in which to relax or reflect. The images convey a sense of vulgarity and hate. Pickens has portrayed an eerie, mysterious scene in which to display his disgust with the human being, the victim and the future consequences.

Carnival, like most of Pickens' work, did not end as it was intended to. Pickens admits it has several meanings, each meaning added to or subtracted from the original intent. But what artist hasn't changed a painting in midstream? It adds to the excitement experienced by both artist and viewer.

Since religion and spiritual outlooks had much to do with the salvation of lives during battle, it is not surprising that many soldiers sought out, and tried to follow, the teachings of religion during this time. Likewise some battlefield artists, previously unbelievers, turned to religion during and after the war years. Thus, the image of the cross and specifically the transfiguration of Christ became a symbol of man's inhumanity to man so tragically and agonizingly exhibited by the enemies of democracy.

Umberto Romano, discussed earlier in this book, referred to the sacrifice of Christ to reflect the inhuman treatment of prisoners of war. Christ representing the supreme being, and the omnipotent creature of the universe became the symbol of the futility of war. For many artists, such as William Congdon, Fred Nagler, Rico Lebrun, Abraham Rattner, and William Pachner, Christ became the subject matter of expression in defiance of the enemies of democracy. So even though tanks, missiles, soldiers, and enemy fire often remain outside the picture plane, the image of Christ — made even more powerful and dramatic because of its spiritual need to remind the universe of prayer and love of neighbor including one's enemy — is acknowledged at a time in history as yet to be superseded.

Pickens believed that symbolism follows an artist's work on completion, rather than serving as a motivating force toward creation. Other artists would disagree. Romano, Congdon, and Nagler would insist that Christ, being the omnipotent of all human characters and the apex of love, is the most logical symbol to record the horrors of war.

If symbolism *does* occur on the completion of a painting, then it seems logical to assume that the object itself becomes a factor of the subconscious. It is frequently coincidental to create one object that, on its completion, resembles a totally different object. Symbolism is a direct attempt of the artist. Those outside the realm of creation often speculate and misinterpret images that serve as symbols. A personal intent of the artist to mask his or her images puzzles the outsider, and thus the viewer is confused rather than secure in acknowledging the proper intent and in so doing avoiding the aesthetic appreciation essential to the reception of the expression. Symbolic images are nothing more than objects of mundane or commonplace reference. In *The Blue Doll*, Pickens may well have chosen symbolic slayers of future generations. Then again, to the outsider, *The Blue Doll* may represent children at play although warped in concept.

The crosses that dominate cemeteries throughout the nation are symbols of the dead. The artist, in purposely avoiding the slaughter of human beings during World War II, is forced to use personal symbols that normally are misunderstood by the lay audience and frequently by the authorities of art criticism.

Because the creation of art is profoundly personal, symbols subconsciously employed often elude the artist himself. The artist can never be held accountable for all the images attached to his or her canvas. Wars occur because of differences of opinions and cultures between nations and within nations and even within communities.

Sometimes the essential object of war becomes the symbol of war. A tank, a gun, a sword, or a banner or flag represents an image of war. The lone object of a tank painted by William Pachner is revealed in his work *Thou Shalt Not Kill*. Jasper Johns' emblem of the American flag is a symbol of victory over fascism. The dove as a symbol of peace has been used extensively by artists as a recognition of victory over war. The balloon cloud symbolizing the atomic bomb explosion over Hiroshima and Nagasaki appeared in Philip Evergood's *Renunciation*, Peter Blume's

The Rock, and numerous other American artists' works.

The evils of war are expressed secretly or openly depending on the intent as personal therapy or propaganda. The art form is foremost; that is, self-expression precedes communication. If the artist lacks incentive to communicate, the choice of personal symbols may never be understood or subsequently appreciated.

Abraham Rattner related the spirituality of the last judgment with atomic destruction. His notion of chaos created by mankind will end the world as we know it. Even though Rattner's *The*

Last Judgment (1953–56) reflects a cyclonic disruption of life, a hurricane of sorts, it is man himself who has created the days of reckoning. Within the center of a seemingly chaotic panorama resides the image of Christ controlling the disruptive environment as executed by the artist. This huge masterpiece, measuring eight feet by twelve feet, is a whirlwind of bits of life tossed about in reckless random and yet so complex and intricately designed that impatient observers will not recognize the orderly fashion of execution that lies within the picture plane.

Opposite: Alton Pickens. *Carnival* (1949). Oil on canvas. 54⅝ × 40⅜ in. (138.7 × 102.6 cm.) The Museum of Modern Art, New York. Gift of Lincoln Kirstein. Photograph ©2000 The Museum of Modern Art, New York.

CHAPTER 13

Concluding Remarks

The creative process demands reflection and contemplation on the event or idea being expressed. The artists whose works are reproduced in this volume are both spontaneous and reflective. They have shown the action of the war and the agony that followed. Some artists were noted for their paintings of the war and were known as combat artists—war correspondents with brushes. Instead of reporting the war's events with words, they used their creative efforts to produce on-the-spot recordings. Artists such as Mitchell Jamieson, William Draper, Kerr Eby, and Edward Reep were war correspondents employed by the armed forces or by commercial agencies to record the war as witnessed.

Other artists, whose lives were devoted to art as lifelines to eternity, looked on war as inevitable and subsequently made its evils known to all mankind in order for atonement to replace the greed and power of the war-mongers. Artists whose success did not rely on a single theme or event and whose portrayals recorded the aftermath of the war years included such greats as Ben Shahn, Philip Evergood, Umberto Romano, George Biddle, Henry Koerner, George Grosz, Paul Cadmus, and Rico Lebrun.

Artists whose success stemmed from the WPA Art Projects of the Depression years overlapped the war years. War had become a theme of artistic worth because it disrupted the flow of normalcy. The painting of peace led to monotony and commonplace and eventual boredom. The contrast of war became essential to the creative process, and yet the artist favored peace but had to reflect the evils of humanity in order for society to confront man's inhumanity to man.

This book has been an attempt to include several facets of the war picture—the homefront as well as the battlefront from an intuitive approach as well as a contemplative envisionment.

Artists express their inner thoughts. However, the notion of war may inflame one to the point of total frustration, thus creating a negative response in favor of an abstract or intellectual approach to art. Such artists as Loren MacIver, Doris Lee, Georgia O'Keeffe, Leon Kroll, and Stuart Davis acknowledged the evils of war but preferred to paint the inner joy of the commonplace and to follow intellectual pursuits in a quiet emotional manner. In a sense, these artists were aiding the war effort by diverting America's concerns and frustrations to the beauty of nature that is enhanced and glorified by the artist's touch.

War has also served as an emotional release for the artist whose productions of the events of war were destroyed or left to rot in remote areas of the artist's garret. The psychological release of anguish permitted the artist to direct his energies to the practice of art. This freedom from emotional stress is essential to the creative process. The inhuman acts of war are unacceptable for the artist who believes in the freedom of goodwill and

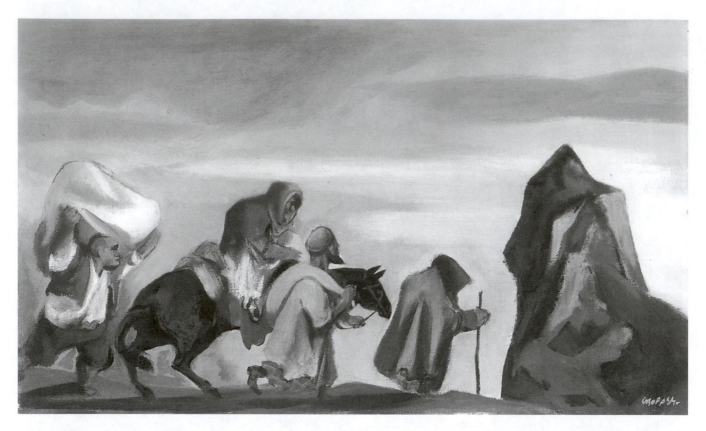

William Gropper. *Refugees* (1938 or 1939). Oil on canvas. 17⅞ × 30⅛ in. The Phillips Collection, Washington, D.C.

the need for individual expression regardless of circumstances.

The recording of an event differs from the artistic expression, unless of course the recording is an intuitive response, a release that responds to emotion rather than a visual acknowledgment. Such is the case with William Gropper, whose satirical portrayals are no match for his paintings *Refugees* and *Hostages*. Both images are strong reflections of the death march. In *Hostages* (1942), prisoners trudge in fear to an unknown death penalty. A trio of prisoners are escorted by a group of enemy soldiers who adhere strictly to the serious task at hand.

In *Refugees* (1938 or 1939), a flight into nowhere, although death is a certainty and the destination of the march remains unknown, one is reminded of the spiritual flight into Egypt. Gropper was noted for his images of suffering, not only physical but mental as well. In spite of the tragic events, a sense of stillness and loneliness prevails.

There are others whose expressions are not severe but hinge somewhat on hope. Joseph Hirsch, for example, blended suffering with hope and prayer. His painting *All Aboard for Home* (1946; see color section) represents an inner joy.

In direct contrast is *The Prisoner* (1942), also by Hirsch. In spite of what the word *prisoner* implies, instead of torturous events, humiliation, and death, the viewer encounters a peaceful form of communication between opposing forces.

Edward Reep combines a bit of dry humor with his portrayal *Christmas in an Aid Station* (1945). In spite of daily death expectations, he has instilled in his images an undisguised morale-building. And yet when action is truly present, he reveals the dramatic aftermath, as pictured in *Salvage Roses* (1945).

And there is Jacob Lawrence, whose warnings are symbolic and primitive in style. Nonetheless the message remains. His *War Series* are examples, as in the case of *Going Home* (1947), an appropriate title on which to conclude these remarks.

His painting *Reported Missing* (1947) continues to remind us of the loved ones who continued to suffer the pangs of loneliness. The terrifying thoughts of indefinite encampment as featured in *Reported Missing* never subside. Memories linger, and hearts yearn for their beloved lost souls. Artists such as Lawrence are essential as a caution to modern military thinking and as a reminder of the aftermath of eternal fear.

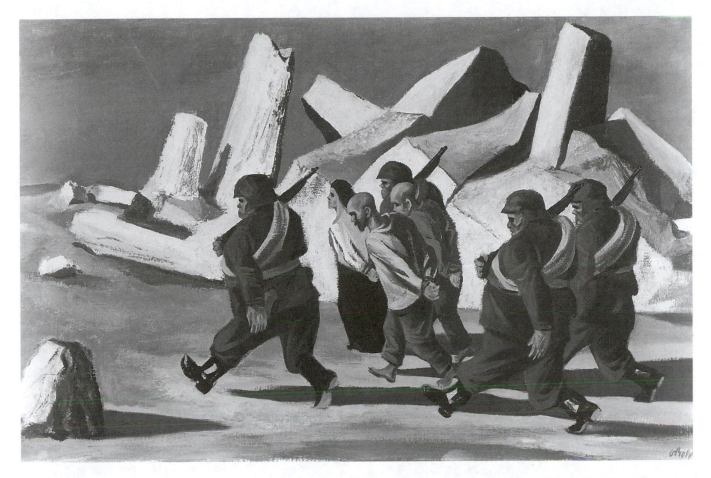

William Gropper. *Hostages* (1942). Oil on canvas. 21 × 32¼ in. Sophronia Anderson Bequest Fund. The Newark Museum/Art Resource, NY.

If nothing else, I hope that this book generates interest by the coming generations. The several approaches picture various recording events including the intuitive expression and the contemplative expression, the former appropriate for on-the-scene activities and the latter proper for the aftermath of the war. Within these extremes are varying gradations of color, composition, and technique. Consequently, differing degrees of emotional responses result.

Regardless of technique or school of thought, artists create in their current styles. For example, the painting *Score Another One for the Subs* is instantly recognized as a work by Benton because his style remained the same throughout his long career. Altering one's style to suit particular theme lessens the potency of the painting from the very start. Because the creative expression demands individual freedom, any approach contrary to the personality of the artist will fall short of his or her ability. The artist should never change style to suit a new idea.

Retaining a style regardless of the idea is seldom wise because if the idea calls for a violent or ugly appearance or a message of importance and the artist's style reveals more of the pleasantries of life, it is difficult to shift from one style to another, especially at a given moment.

To be an effective artist, especially a realist, one must use distortion, an essential tactic to make known the horrors of war. George Grosz, for example, reveals a deeply seeded hatred for the German regime. The gross depiction of rats devouring the remains of a dead soldier as evident in one of his paintings is revolting.

On the other and, World War II had its humorous and melodramatic moments. Edward Reep's painting *The Garbage Collectors* actually suggests and portrays three urchins doing what youngsters at their age do naturally. In spite of the horror or the war, magical charm radiates. For a moment, the war does not exist if the audience will take a moment to enjoy Reep's message.

The horrors of war, like any other tragic

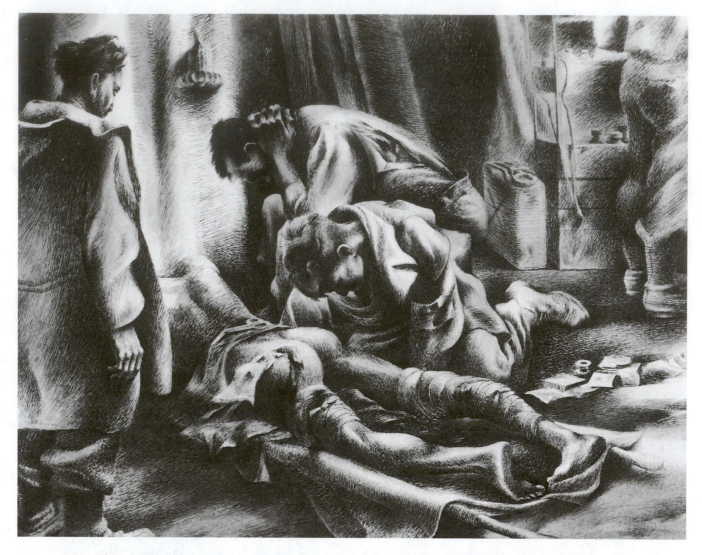

Edward Reep. *Christmas in an Aid Station* (1945). Ink and wash. 15¼ × 22¼ in. Courtesy of the artist.

event, cannot and must not be compromised. The sudden attack at Pearl Harbor is a warning to all democratic nations to be alert to any sudden and unexpected invasion.

Even though World War II was fought throughout the world, this book has purposely focused on the American artists. And , in spite of the limited time element of a single decade, artists were free to record several aspects of the war. The apprehension of the destruction of humanity, the actual horrifying experience of to-kill-or-be-killed, the extreme torture of prisoners of war, and the aftermath, the loneliness brought by the loss of loved ones—all suggest personal convictions and dedication to the war effort.

My hope is that future generations will realize the temporal aspect of our early life and the need to adhere to the principles of morality and dignity.

Mentioned briefly in the chapter "War and Symbolism" was George Biddle's painting *Carnival*. It differs little from *The Blue Doll* in its symbolic meandering during the aftermath of the war. Executed in 1949, its figures are ghastly and distorted to symbolize the different aspects of the decaying body tortured beyond recognition. Each character is a freak of physical development, a human condition that delights the carnival owner-ship when so-called normal humans gasp at the sight. Biddle is careful not to overplay single char-acters, although each character, symbolic in

Opposite: Joseph Hirsch. *The Prisoner* (1942). Oil on canvas. 44 × 30¼ in. (111.8 × 76.8 cm.) Collection of the Whit-ney Museum of American Art, New York. Gift of Edith and Milton Lowenthal. 53.48. Photograph copyright ©1996: Whitney Museum of American Art, New York.

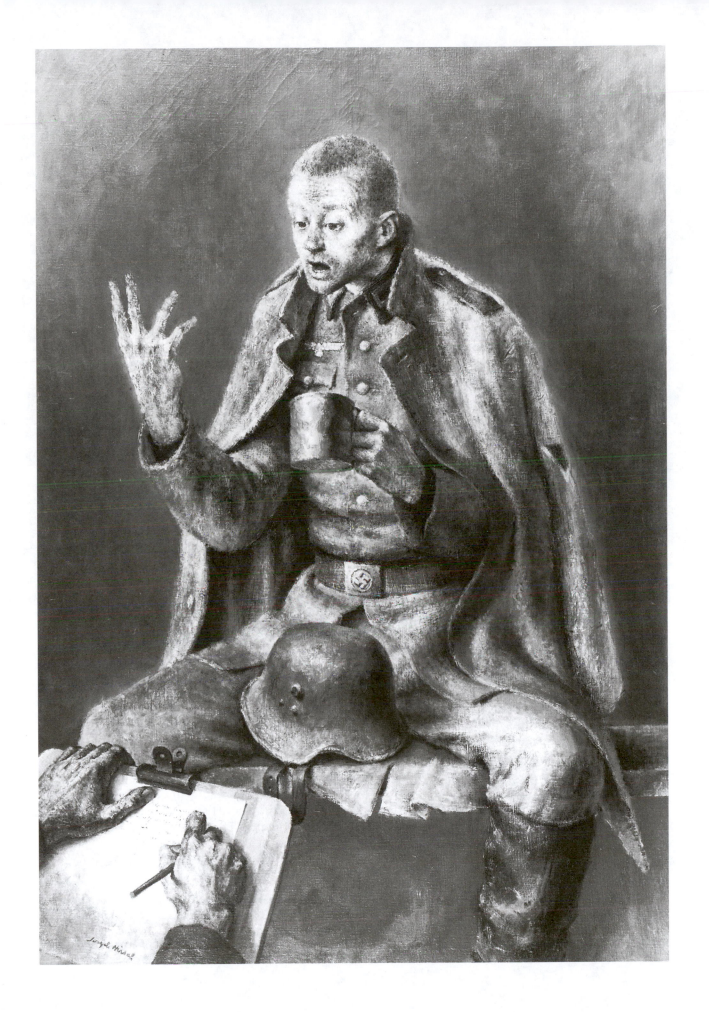

Edward Reep. *Salvage Roses* (1945). Gouache. 16¼ × 22¼ in. Courtesy of the artist.

nature, blends both compositionally and logically with the other.

Theory behind the expression constitutes a symbolic gesture in surrealism as well as in realism as witnessed in *Carnival*. Biddle's freaks, so masterfully painted, create a sense of irony, since they represent Hitler's premise of human unworthiness. A large segment of society would cringe with fear and distrust while a slight number would grasp its meaning and thus enjoy, not the beauty of the idea, but rather the technical exper-

tise. The view may easily overlook any suggestive symbolism in thought and technique. Seemingly helpless and lost and in need of collaboration among the symbolic figures, Biddle's creatures were never intended to communicate, even though they reside in a closely knit environment.

The artist does not paint a character or object. Rather the artist paints the personal image of that stimulus. The paintings in *World War II in American Art* are not, for the most part, representative but rather are the artists' interpretation of

Opposite top: Jacob Lawrence. *War Series: Going Home* (1947). Egg tempera on composition board. 16 × 20 in. (40.6 × 50.8 cm.) Museum of American Art, New York. Gift of Mr. and Mrs. Roy R. Neuberger. 51.17. *Opposite bottom:* Jacob Lawrence. *War Series: Reported Missing* (1947). Egg tempera on composition board. Collection of the Whitney Museum of American Art, New York. Gift of Mr. and Mrs. Roy R. Neuberger. 51.8. Photograph copyright ©1998: Whitney Museum of Art, New York.

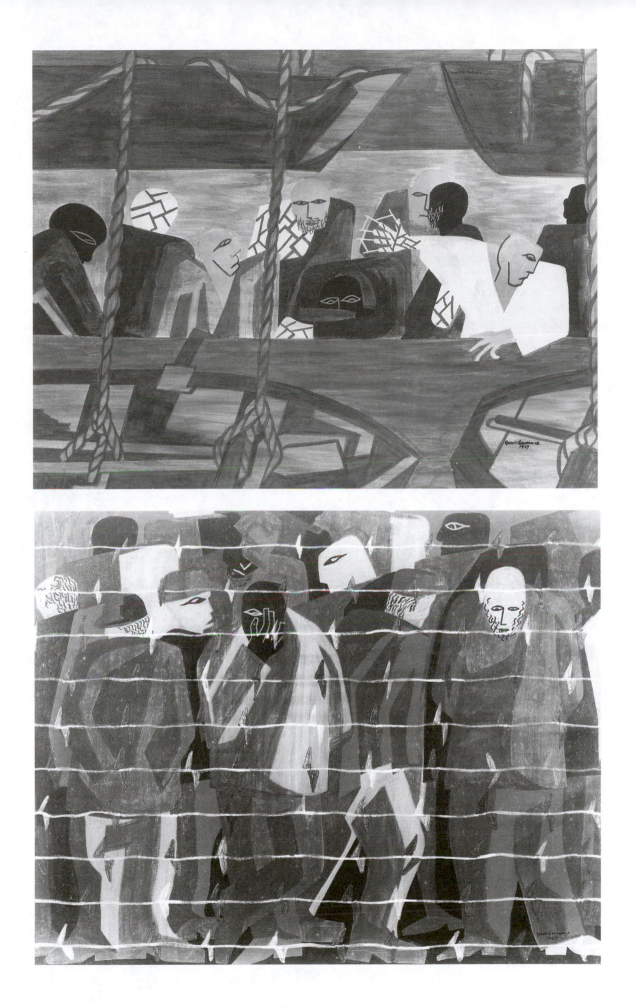

the aspects of war. Even though a painting such as Tom Lea's *The Price* may be accepted as representative of the frailty of the human condition, it is impossible to paint the reality of such a tragedy without some degree of distortion, which then becomes the image of the event.

The Price, although realist by definition, can just as readily be considered symbolic of the war as a segment of the total fighting landscape. Furthermore, the artist is not always accountable for each brushstroke caused by notions of distortion for emphasis, moments of preoccupation, or simply an account of omission or misconception. The artist is in control. Reality, which is forever present, is frequently altered to suit an artist's personality or purpose, be it spiritual, political, or philosophical.

As a whole, the paintings selected for this book deal with the action and the effects that the action has had on the fighting forces and those left behind. Many artists were concerned with the aftermath — the destruction of cities, the countless fatalities designated with tombstones, the soul-wrenching loneliness of being without a soulmate or family, and the hardship of parents whose emptiness had been lessened because of children.

If anything has been gained because of World War II, it is the compassionate unity among all Americans. Hardships were shared. The home-front became a closer-knit relationship. Neighbors were really neighborly. Friendships were born. The war was not in vain. Democracy was upheld. And the United States became stronger and a defender of truth throughout the world.

Notes

CHAPTER 1

1. Quoted in *Significant War Scenes*.
2. Quoted in ibid.
3. Quoted in ibid.
4. *Ghost Trail* is reproduced in McCormick and Perry, *Images of War*, p. 212.
5. *Operation Soapsuds* is reproduced in ibid., p. 267.
6. *War* is reproduced in Landau, *Artists for Victory*.
7. *Pearl Harbor* is reproduced in Freundlich, *William Gropper*, p. 63.
8. *Battle of Hill 609* is reproduced in Cooke, *Fletcher Martin*, p. 56.
9. *Battle of Midway, June 1942* is reproduced in McCormick and Perry, *Images of War*, pp. 202–3.
10. *Score Another One for the Subs* is the cover painting for McCormick and Perry, *Images of War*.
11. McCormick and Perry, *Images of War*.
12. *Tessie's Bridal Shop* is reproduced in Wechsler and Berman, *Realism and Realities*.
13. *Beachhead* is reproduced in ibid., p. 35.
14. Quoted in Genauer, *Best of Art*.

CHAPTER 2

1. *Mercy Ship* is reproduced in *Significant War Scenes*.
2. *Station Stop, Red Cross Ambulance* is reproduced in Powell, *Homecoming*.
3. Powell, *Homecoming*.

4. *Convalescents from Somewhere* is reproduced in ibid.
5. *Hospital Ship Approaching San Francisco* is reproduced in McCormick and Perry, *Images of War*, and in Jones, *World War II*.
6. *He Walks Who Can* is reproduced in McCormick and Perry, *Images of War*, and in Jones, *World War II*.
7. *The Price* is reproduced in Jones, *World War II*.
8. *Protection for the Wounded* is reproduced in Jones, *World War II*, and in McCormick and Perry, *Images of War*.
9. *Flashlight Surgery in Saipan* is reproduced in *Significant War Scenes*.
10. *Hospital Scene* is reproduced in Wechsler and Berman, *Realism and Realities*.
11. *Wounded Crewman* is reproduced in Jones, *World War II*.
12. *Fracture Ward* is reproduced in Wechsler and Berman, *Realism and Realities*.
13. *First Aid Station* is reproduced in *Significant War Scenes*.
14. *Night in Spain* is reproduced in Henkes, *American Women Painters*.

CHAPTER 3

1. *The Twelfth Day* is owned by several galleries and museums including the collection of the Library of Congress, Washington, D.C. Wilson is quoted in Landau, *Artists for Victory*.

2. *Souvenir of Lidice* is reproduced in ibid. The print is dated 1947.

3. Quoted in *Significant War Scenes*.

4. Quoted in ibid.

5. Quoted in Landau, *Artists for Victory*.

6. *Refuge* is reproduced in Landau, *Artists for Victory*, p. 19.

7. *Nearing the End* is reproduced in ibid.

8. *They Suffer Too* is reproduced in ibid., p. 89.

9. *Requiem* is reproduced in Genauer, *Best of Art*, p. 97.

10. *A Piece of My World* is reproduced and Grosz is quoted in ibid., pp. 86–87.

11. Quoted in ibid.

12. *She Walks among the Ruins* is reproduced in ibid., p. 149.

13. *The New Order* is reproduced in Landau, *Artists for Victory*, p. 100.

14. *Praying Mothers* is reproduced in Henkes, *American Women Painters*.

15. *Celebration* is reproduced in *American Artists of the 1930's*, an exhibition catalogue of the Wigmore Fine Arts Gallery in New York.

16. *The Star* is reproduced in Genauer, *Best of Art*.

17. *Requiem* is reproduced in ibid.

18. *In the South Pacific* is reproduced in Landau, *Artists for Victory*.

19. *Farewell* is reproduced and Soyer is quoted in ibid.

20. *Endless Journey* is reproduced in Weller, *Art USA Now*.

21. Quoted in Seldon, *Portrait of the Artist as an American*.

22. Quoted in *Three Hundred Years of American Art*.

23. Quoted in Reep, *A Combat Artist in World War II*.

CHAPTER 4

1. Chapin, Barbara. Author.

2. *Prisoners of War* is reproduced in Wechsler and Berman, *Realism and Realities*.

3. *German Prisoner on Monte Cesima* is reproduced in ibid.

4. Quoted in *Significant War Scenes*.

5. Quoted in ibid.

6. Quoted in Landau, *Artists for Victory*. A reproduction of *The Last Walk* appears in the same catalogue.

7. *The Invaders* is reproduced in Freundlich, *William Gropper*.

8. *P.O.W.'s* is reproduced in Jones, *World War II*.

9. *The Watchers* is reproduced in Wechsler and Berman, *Realism and Realities*.

10. *The Devourer* was considered by the artist as a religious approach as well as a wartime act.

11. *An Italian Town Surrenders* is reproduced in Jones, *World War II*, as well as in Reep, *A Combat Artist in World War II*. Quoted in Reep, *A Combat Artist in World War II*.

CHAPTER 5

1. Quoted in Landau, *Artists for Victory*.

2. Quoted in *Significant War Scenes*.

3. *Havoc in Hawaii* is reproduced in Landau, *Artists for Victory*.

4. *Cleanup on the Road to Tokyo* is reproduced in McCormick and Perry, *Images of War*.

5. *Hiroshima — 1945* is reproduced in Jones, *World War II*.

6. Peter Blume's painting *The Rock* has been reproduced in several art history books.

7. *Nuremburg* is reproduced in Genauer, *Best of Art*.

8. *The Abbey of Monte Cassino* is reproduced in Jones, *World War II*.

9. *The St. Giles Strong Point* is reproduced in ibid.

10. *Greed* is now owned by the artist's estate. It has been shown at the Kennedy Gallery of New York City.

11. Quoted in Reep, *A Combat Artist in World War II*.

12. Quoted in ibid.

13. Quoted in ibid.

CHAPTER 6

1. Quoted in *Significant War Scenes*.

2. *Uprooted Stalk* is reproduced in Landau, *Artists for Victory*.

3. *Hiroshima* is currently in the estate of Edna Reindel, Detroit, Michigan.

4. *Death Camp at Buchenwald* is reproduced in Jones, *World War II*.

5. Levin, Kim. Historian.

6. Ibid.

7. Powell, *Homecoming*.

8. *Ebb Tide* is reproduced and Eby is quoted in Jones, *World War II*.

9. *Direct Hit* is reproduced in ibid.

10. *Civilians* is reproduced in Wechsler and Berman, *Realism and Realities*.

11. *Orderly Retreat* is reproduced in Taylor, *Philip Evergood*.

12. *Normandy, Low Tide* is reproduced in Jones, *World War II*.

13. *Epitaph* is reproduced and Evergood is quoted in Taylor, *Philip Evergood.*

14. Reep, *A Combat Artist in World War II.*

CHAPTER 7

1. *Swing Shift* is reproduced and Barnet is quoted in Landau, *Artists for Victory.*

2. *Labor in a Diesel Plant* is reproduced in ibid.

3. *Through the Mill* is reproduced in Taylor, *Philip Evergood.*

4. Quoted in Landau, *Artists for Victory.*

5. *Drilling Holes* is reproduced in Henkes, *American Women Painters.*

6. *Sleepers* is reproduced in Henkes, *New Vision in Drawing and Painting.*

7. *Home Front* is reproduced in Landau, *Artists for Victory.*

8. *Waves Take Over* is reproduced in McCormick and Perry, *Images of War.*

9. *Rosie the Riveter* is reproduced in Jones, *World War II.*

10. *The Welder* is reproduced in *American Scene Painting and Sculpture.*

CHAPTER 8

1. *The Freedoms Conquer* is reproduced in Landau, *Artists for Victory.*

2. Quoted in ibid.

3. Quoted in ibid.

4. *War Bulletins* is reproduced in ibid.

5. *Bourbon Street, New Orleans* is reproduced in ibid.

6. *Sardines for the Army* is reproduced in ibid.

7. Quoted in ibid.

8. Quoted in Powell, *Homecoming.*

9. Quoted in ibid.

10. Quoted in ibid.

11. *Sixth Avenue* is reproduced in Henkes, *American Women Painters.*

12. *Weeping Girl* is reproduced in Cooke, *Fletcher Martin.*

13. *Outside the City Limits* is currently owned by the estate of the artist.

14. *St. Anthony* is in the permanent collection of the Kalamazoo Institute of Arts.

CHAPTER 9

1. *Crosses and Stars* is reproduced in Jones, *World War II.*

2. *Military Necessity* is reproduced in and Eliot is quoted in Eliot, *Three Hundred Years of American Art.*

3. *Again* is reproduced in Henkes, *The Crucifixion in American Painting.*

4. *Pain of Ashes* is reproduced in Wechsler and Berman, *Realism and Realities..*

5. *Man and Armor* is reproduced in ibid.

6. *APOCALIPSION* is reproduced in ibid.

7. *Hallucinations* is reproduced in ibid.

8. *Skin of Our Teeth* is reproduced in ibid.

9. *My Parents* is reproduced in ibid.

10. *God Must Have Loved Them* is reproduced in Genauer, *Best of Art.*

11. *The New Lazarus* is reproduced in Henkes, *The Crucifixion in American Painting,* and in Taylor, *Philip Evergood.*

12. Quoted in Taylor, *Philip Evergood.*

13. Quoted in Henkes, *The Crucifixion in American Painting.*

14. Quoted in Reep, *A Combat Artist in World War II.*

15. Quoted in ibid.

16. Both quoted in *John McCready: 1911–1968.*

CHAPTER 10

1. *The Gamblers* is reproduced in Cooke, *Fletcher Martin.*

2. *Boy Picking Flowers* is reproduced in ibid.

3. *Ready Room* is reproduced in *Significant War Scenes.*

4. *Cat Nap* is reproduced in Jones, *World War II.*

5. *Field Bath* is reproduced in ibid., and in Reep, *A Combat Artist in World War II.*

6. *Time Out* is reproduced in Cooke, *Fletcher Martin.*

7. Crowd of Servicemen is reproduced in the exhibition catalogue *American Scene Painting and Sculpture.*

8. *Soldiers Morning Bath* is reproduced in Powell, *Homecoming.*

9. Quoted in Reep, *A Combat Artist of World War II.*

10. Quoted in ibid.

11. *Getting Acquainted at the El* is reproduced in Barton, *Cecil C. Bell.*

12. *World War II Invades Central Park* is reproduced in ibid.

CHAPTER 11

1. *Victory* is reproduced in Cooke, *Fletcher Martin.*

2. *Duet* is reproduced in Taylor, *Philip Evergood.*

3. *The Song of the Poet* is reproduced in *American Scene Painting and Sculpture*.

4. *Celebration* is reproduced in Wechsler and Berman, *Realism and Realities*.

5. *Bon, Bon, Monsieur* is reproduced in Cooke, *Fletcher Martin*.

6. *The Kiss* is reproduced in Henkes, *American Women Painters of the 1930's and 1940's*.

7. Quoted in Reep, *A Combat Artist in World War II*.

8. *V-J Day, Times Square* is reproduced in Barton, *Cecil C. Bell*.

Bibliography

"America in the War: Graphic Competition." *Art News*. May 15, 1943.

"America in the War: Prints at Kennedy Gallery." *Art Digest*. October 1, 1943.

American Scene Painting and Sculpture: Dominate Style of the 1930s and 1940s. Exhibition catalogue. New York: D. Wigmore Fine Art, 1990.

Ardery, Philip. *Bomber Pilot: A Memoir of World War II*. Lexington: University Press of Kentucky, 1972.

Arms, John Taylor. "Printmakers' Processes and a Militant Show: America in the War." *Art News*. October 1–14, 1943.

"Artists for Victory Week." *Art News*. April 15, 1943.

Barton, Phyllis. *Cecil C. Bell, 1906–1970*. Kansas City: Book Division, McGrew Color Graphics, 1976.

Boswell, Peyton. "Disband." *Art Digest*. January 15, 1946.

Clarence Carter. Exhibition catalogue. New York: Associated American Artists, 1975.

Clark, Thomas Blake. *Remember Pearl Harbor*. New York: Modern Age Books, 1942.

Cooke, Lester. *Fletcher Martin*. New York: Harry N. Abrams, 1977.

Dumey, H. "National Art Council for Defense Organized." *Design*. February 1942.

Dunn, William. *Fighter Pilot: The First American Ace of World War II*. Lexington: University Press of Kentucky, 1982.

Eliot, Alexander. *Three Hundred Years of American Painting*. New York: Time Incorporated, 1957.

Freundlich, August. *William Gropper: Retrospective*. Los Angeles: Ward Ritchie Press, 1968.

Genauer, Emily. *Best of Art*. New York: Doubleday and Company, 1948.

Goldwater, Robert. *Primitivism in Modern Art*. Cambridge: Belknap Press, Harvard University Press, 1986.

Handleman, Howard. *Bridge to Victory: The Story of the Reconquest of the Aleutians*. New York: Random House, 1943.

Henkes, Robert. *American Women Painters of the 1930s and 1940s: The Lives and Works of Ten Artists*. Jefferson, N.C.: McFarland and Company Publishers, 1991.

_____. *The Crucifixion in American Painting*. New York: Gordon Press, 1980.

Hughes, Terry, and John Costello. *The Battle of the Atlantic*. New York: Doubleday and Company, 1977.

Jones, James. *World War II*. New York: Grosset and Dunlap, 1975.

Keegan, John, and Joseph Darracott. *The Nature of War*. New York: Holt, Rinehart and Winston, 1981.

Landau, Ellen. *Artists for Victory*. Exhibition catalogue. Washington, D.C.: Library of Congress, 1983.

Leckie, Robert. *Challenge in the Pacific: Guadalcanal,*

the Turning Point of the War. New York: Double-day and Company, 1965.

Mathias, Frank F. *G.I. Jive: An Army Bandsman in World War II.* Lexington: University Press of Kentucky, 1982.

McCormick, Ken, and Hamilton Darby Perry, eds. *Images of War: The Artist's Vision of World War II.* New York: Orion Books, 1990.

Miller, Arthur. "Synthetic Venom in Prints for Victory Exhibition." *Art Digest.* October 15, 1943.

Powell, Richard. *Homecoming: The Art and Life of William H. Johnson.* Washington, D.C.: National Museum of American Art, Smithsonian Institution, 1991.

Reep, Edward. *A Combat Artist in World War II.* Lexington: University Press of Kentucky, 1987.

Rodman, Seldon. *Portrait of the Artist as an American.* New York: Harper, 1951.

Schrag, Karl. "Letter to the Editor." *Art News.* November 1–14, 1943.

Significant War Scenes by Battlefront Artists, 1941–1945: A Collection of Reflective Paintings in Which Sixteen Artists Interpret War As They Saw It

Around the World. [Detroit]: Chrysler Corporation, 1951.

Taylor, Kendall. *Phillip Evergood: Never Separate from the Heart.* London and Toronto: Bucknell University Press, 1987.

"10,000 Artists Unite for Victory." *Art Digest.* February 1, 1942.

Terkel, Studs. *The Good War: An Oral History of World War II.* New York: Pantheon Books, 1984.

Three Hundred Years of American Art. Time, Incorporated, 1957.

Walton, Frank. *Once They Were Eagles: The Men of the Black Sheep Squadron.* Lexington: University Press of Kentucky, 1990.

Wechsler, Jeffrey, and Greta Berman. *Realism and Realities: The Other Side of American Painting, 1940–1960.* Rutgers, N.J.: Rutgers University Press, 1982.

Weller, Allen S. *Art USA Now.* Edited by Lee Nordness. New York: Viking Press, 1963.

Werner, Herbert. *Iron Coffins.* New York: Holt, Rinehart, and Winston, 1976.

Index

Numbers in *italic* represent photographs.
Numbers beginning with C- (eg. C-8) represent plates in the color insert.

155